The 20th Century: Europe

LIVES AND WORKS IN THE ARTS
from the Renaissance to the 20th Century

The 20th Century: Europe

Editorial Board

SHARPE REFERENCE
An imprint of M.E. Sharpe, INC.

1997 Library Reference Edition published by Sharpe Reference

Sharpe Reference is an imprint of M.E. Sharpe, Inc.

M.E.Sharpe, Inc.
80 Business Park Drive
Armonk, NY 10504

Library of Congress Cataloging-in-Publication Data

Lives and works in the arts: from the Renaissance to the 20th century

p. cm.
Includes bibliographical references and index.
Summary: Surveys the lives and works of European and American writers, artists, and
composers from the Renaissance into the twentieth century.
ISBN 1-56324-817-4 (set: alk. paper)
1. Arts, Modern.
2. Artists–Bibliography.
[1. Arts, Modern–History. 2. Artists. 3. Authors. 4. Composers.]
I.M.E. Sharpe, Inc.
NX449.5.L.58 1996
700'.92'2–dc20
[B]
96-13236
CIP
AC

Printed and bound in Malaysia by Times Offset (M) Sdn Bhd

The paper used in this publication meets the minimum requirements of
American National Standard for Information Sciences–Permanence of
Paper for Printed Library Materials.
ANSI Z 39.48-1984.

Editorial director: Ellen Dupont

Project editor: Tim Cooke

Senior editor: Sarah Halliwell

Editors: Andrew Brown, Alice Peebles, Tom Folley, Jen Green

Senior designer: Richard Newport

Designers: Simon Wilder, Melissa Stokes

Picture administrator: Vimu Patel

Production: Craig Chubb, Jo Wilson

Index: Indexing Specialists

Contributors: Simon Adams, Neil Armstrong
Achim Borchardt, Andrew Brown, Josie Bryant,
Rachel Cowgill, Ian Chilvers, Audrey Cooke,
Anita Dalal, Andrew Hadfield,
Robert Hamilton, Sue Harper,
Alice Peebles, Martin Schuebel,
Denise Silvester-Carr, Arabella Sim,
Michael Sullivan, Ian Zaczek

Contents

Introduction

At the turn of the 20th century, Europe dominated the world in almost every sphere of artistic endeavor. The continent's writers, composers, and artists were admired throughout the world. To be German, French, Italian, or British in 1900 was to believe in unbroken progress toward a future that would forever be European. By the second half of the century, however, that future had become an illusion. The European empires lay in ruins. Two world wars, economic depression, and massive social upheaval saw the continent eclipsed as a world power by the United States and the Soviet Union. In little more than 50 years, Europe had fallen from political, economic, and cultural dominance.

Such developments would have been hard to believe in the confident mood in which the century began. At the start of the 20th century, Europeans everywhere felt optimistic about the future – and with good reason. In the previous century, the Industrial Revolution and the technological progress it brought had provided the basis for massive economic growth throughout the continent. The establishment of nation states ruled by men of merit – rather than by the divine right of kings – gave the world a model of democracy that would lend political stability to ever-growing world trade. Colonies in less developed parts of the world continued to give European industry cheap sources of raw materials for their factories and new markets for their products.

THE AGE OF SCIENCE

Rapid technological and scientific change was a hallmark of the age and provided new insights into how the world worked and how it might be manipulated. In 1901, Marconi demonstrated his radio, opening up a new age of communication. Albert Einstein presented his theory of relativity in 1905, changing the science of physics forever, and in 1909,

Louis Blériot flew across the English Channel, proving that powered flight between countries, even continents, was possible. In Vienna, meanwhile, Sigmund Freud was developing the science of pyschoanalysis, helping people understand the hidden workings of their subconscious.

THE CELEBRATION OF MODERN LIFE

Writers, artists, and composers alike became obsessed with this rapidly changing world. Joseph Conrad drew on the distant European empires in his novels. The composer Béla Bartók used the "primary colors of folksong" in order to "depict a modern soul." Painters like Henri Matisse portrayed the pulse of life in the city. Umberto Boccioni and his fellow artists, meanwhile, were obsessed with depicting speed, and called themselves Futurists to signify that their world was different from that of the past. They created a fast-moving art for a fast-paced world. The machine became a metaphor for all that was progressive in society and art.

The machine aesthetic came to dominate the artistic thinking of the first decade of the 20th century. In all the arts, the modernist movement fixed its eyes firmly toward the future. In 1911, Boccioni described the essence of this philosophy: "In our art we give importance to everything that forgets the past and the present to aspire toward the future. Only becoming – moving forward – has value for us."

But Europe was not moving forward with a single, coherent purpose. Already, the seeds of its downfall had been planted. The continent was made up of nation states, each with their own fierce brand of nationalism. Some were old and established, such as Britain and France; others, such as Germany and Italy, had existed as countries for a relatively short time; still others, such as Austria-Hungary, were vast empires crumbling under the nationalist aspirations of their subjects. To the east, Russia remained a poor country which had largely missed out on the

advances of the Industrial Revolution. As Europe expanded further, competition between countries grew ever more combative. After a triumphant decade of unparalleled progress, cracks began to appear in the facade of European civilization.

ON THE VERGE OF WAR

All the governments of Europe were faced with increasing demands from domestic, political, and social forces. On the right, nationalists wanted expansionist foreign policies which would seize territory or resources. Meanwhile, leftists sought social justice for all classes in the name of communism. Germany in particular responded to these forces by pursuing an aggressive foreign policy which brought her into conflict with her neighbors, and united Britain, France, and Russia against her.

No one wanted war, but by the end of the first decade of the century, many European nations were bracing themselves for it. Then in 1914, a Serbian student assassinated the Austrian archduke Franz Ferdinand in Sarajevo, now in Bosnia. Austria-Hungary declared war on Serbia; Germany joined the Austrian allies and, fearing the intentions of its neighbors, declared war on Russia and France. Then German troops marched into Belgium and Britain entered the conflict to protect its allies. Nearly the whole continent was at war.

World War I was the first industrial war – all the industrial means of production were used to make new weapons. The very technology that had been seen as the savior of humankind was now being used to destroy it – and on an unprecedented scale. More than ten million people were killed and twenty million wounded in a murderous war in which the casualties were twenty times the number of any earlier conflict. The four-year-long slaughter was brought to an end by the intervention of the United States on the side of the Allies to defeat a stubborn but war-weary Germany.

The effect of the war on European culture and civilization was devastating. From 1918 onward, Europe's political and economic domination ebbed away. Germany was punished for its aggression by the Treaty of

Versailles, in which it was forced to pay massive war reparations to the Allies. This placed the German economy under enormous pressure. Far from ending the war, it laid the foundations for future conflict.

A period of uncertainty followed. World War I shattered Europe's confidence forever. Some Russian soldiers were so shocked by the incompetence of their leaders that in 1917 they gave their support to a revolutionary communist party, the Bolsheviks, led by Vladimir Ilyich Lenin. The Bolsheviks began a revolution to overthrow the czar's regime and create the first workers' state. Artists experimented with new forms of art to express their ideals. In the 1920s, the Communist government established a policy called socialist realism, which stated that all art must conform to the role of propaganda for the Bolshevik party.

A NEW ERA IN ART

Meanwhile, in Germany, France, and Britain, political and economic insecurity led to a period of artistic experimentation. The war destroyed the rigidity of the machine aesthetic and allowed artists to pursue different avenues of creativity. Marcel Duchamp satirized the very idea of European culture through parodies of past art; for example, he made fun of the Old Masters by drawing a mustache on a print of the Mona Lisa. Others reduced their art to its essence, creating abstract forms. Arnold Shoenberg removed melody from his music to create atonal scales, while Wassily Kandinsky developed abstract art by banishing all recognizable reference to the external world and concentrating purely on color and form. Marc Chagall, Paul Klee, and Béla Bartók explored folk traditions for new sources of inspiration.

THE ROLE OF WOMEN

Fresh views and original voices came from women. As a result of their war efforts, women had a taste of greater freedom and independence than they had ever known before. The concerted push toward women's suffrage and equality enabled writers such as Katherine Mansfield and

Virginia Woolf to create an artistic voice of their own and be taken seriously as authors in their own right. In the decade after the war, women won the right to vote in more than 20 countries, including the United States and Great Britain.

A Social Maelstrom

Despite all the creative energy and innovation of the 1920s, the diversity of the arts only masked the further political and social disintegration of Europe as a world power. As it entered the 1930s, Europe was faced with a new and terrifying specter. The continent was in the grip of a debilitating economic depression – made worse in Germany by the effects of reparations payments. Unemployment, civil unrest, and political repression were rife as governments attempted to control their increasingly volatile domestic political situations as they lurched toward civil war. The economic failure of liberal democracy and a widespread fear of Russian communism gave birth to a new, menacing kind of right-wing political extremism – national socialism, or fascism. Its main architect was a former German Army corporal, Adolf Hitler, who expounded his beliefs in his book, *Mein Kampf (My Struggle)*.

Hitler formed the National Socialist Labor party, known as the Nazi party, which boasted the promotion of traditional German values. He believed that the new Germany – a master race of pure Aryans – would dominate the world for a thousand years. Through a mixture of astute propaganda and ruthless terror – and by trading on the resentment caused by the Treaty of Versailles – Hitler became *führer*, or leader, of Germany in 1934.

Exodus from Germany

As part of Nazi propaganda, Hitler promoted the idea of German culture and suppressed modern art, which he claimed was the "degenerate" creation of Jews or communists, or both. This policy forced many artists to leave Germany. Thomas Mann and Arnold Schoenberg went

to the United States and, as Europe collapsed into World War II in 1939, many followed. Piet Mondrian, Igor Stravinsky, and Salvador Dalí all joined the exodus across the Atlantic. Klee and James Joyce moved to the neutral safety of Switzerland. Pablo Picasso and Henri Matisse stayed where they were, believing that their artistic reputations would save them from Nazi interference. Albert Camus stayed in Paris and risked his life throughout the war to work for the French Resistance. Few artists were left unaffected.

THE FINAL SOLUTION

The war, which was the most deadly and destructive in history, involved nearly every nation of the world. When it ended in German defeat in 1945, a stunned world discovered the horror of the Nazi "Final Solution." The Nazis had sought to rid themselves of European Jewry through the systematic genocide of six million Jews in death camps such as Bergen-Belsen and Auschwitz. The Holocaust ended the illusion of European moral superiority forever. America and Russia emerged as the new superpowers in the postwar era, with Europe reduced to a buffer zone between the competing forces of capitalism and communism in the age of the Cold War.

World War II was also a watershed for European culture. With so many artists fleeing to America and Russia in the grip of Joseph Stalin's Socialist Realism, New York rapidly became the cultural capital of the world. The American writer John Peale Bishop declared: "The center of Western culture is no longer in Europe. It is in America. It is we who are the arbiters of its future ... The future of the arts is in America."

The golden age of 20th-century European culture was over. But as great art so often grows out of periods of conflict, the era has left us with the rich and profound work of many creative geniuses.

Robert Hamilton

Department of Art History
Manchester Metropolitan University
Manchester, England

Béla Bartók

Inspired by the traditional folk songs of his native Hungary, Bartók composed music which for much of his life was condemned as being "too difficult" for his audience.

A renowned researcher into folk music, Bartók drew on its elements to create music which is a powerful expression of his Hungarian nationalism. For years, his music was little performed; Bartók was an uncompromising man, determined to have his music played exactly as he wished.

BOYHOOD AND STUDENT YEARS

Béla Bartók was born in 1881 in the small town of Nagyszentmiklós, then in southeast Hungary, part of the vast Austro-Hungarian empire, but today in Rumania. Bartók's father was director of the town's agricultural college and an amateur musician. His mother, Paula, had been a teacher, and gave her son his first lessons on the piano.

When Bartók was only three months old he became sick: for five years he suffered a painful and disfiguring skin disorder. He hid from visitors and led a lonely, introverted life. Later, he wrote: "I prophesy that this spiritual loneliness will be my fate. Although I search for an ideal companion, I know I do so in vain." He turned to music for consolation. By the age of four, it was said, he could pick out 40 folk songs on the piano.

In 1888, when Bartók was seven, his father died. The family moved several times as his mother tried to find work and a music teacher for her son. In 1894, Paula found a job in Pozsony, where Bartók attended high school and continued his musical studies. When he finished school in 1899, he was offered admission to the prestigious conservatory in Vienna, capital of the Austro-Hungarian empire. Instead, Bartók decided to study in his homeland at the Budapest Academy of Music.

The decision was an important one, which exposed Bartók to the influence of Hungarian nationalism. His teachers saw him as a brilliant pianist, but when he graduated in 1903, he completed the symphonic poem, *Kossuth*, which became his first success as a composer. The work was based on the life of the Hungarian hero Lajos Kossuth, who in 1848 had led a revolution against Austrian rule. The piece's blatant nationalism made it a great success, particularly its irreverent parody of the Austrian national anthem. But this was to be Bartók's only public recognition for many years.

FOLK MUSIC

In the years after his graduation, Bartók seemed set for a career as a concert pianist. Although he composed a number of works, none showed much originality. But Bartók was unsuited to the demanding life of a touring artist. Repeated bouts of pneumonia as a young man had left him frail. He refused to promote himself or to act with the flamboyance audiences expected of virtuoso performers. From a tour of Spain he wrote to his mother, "This kind of forced labor is dreadful."

Béla Bartók
An anonymous photograph taken late in Bartók's life.

876

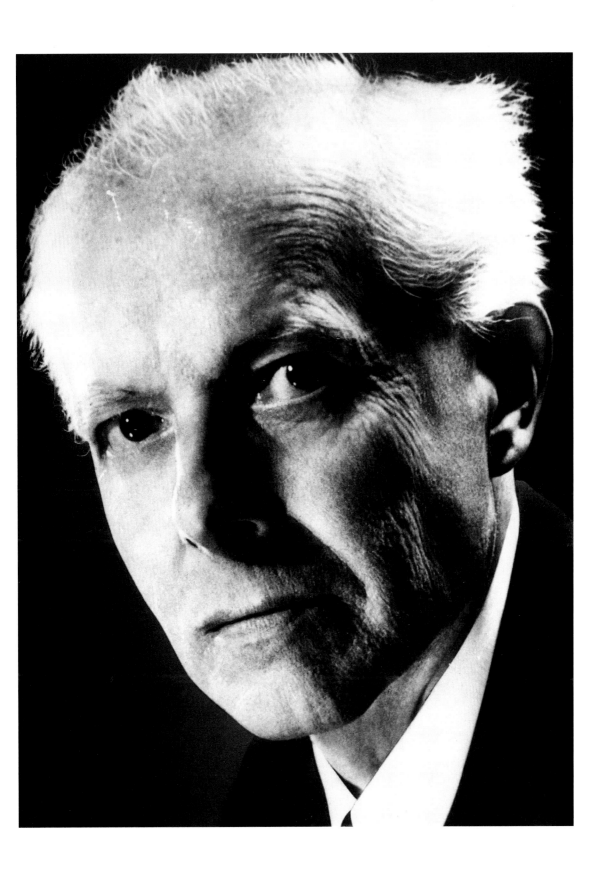

In 1904, Bartók made a discovery that changed his life. While staying with his sister in the Hungarian countryside, he heard a young girl singing traditional folk music. Bartók enthusiastically decided to collect as much similar material as he could and prepare it for publication.

The next year, Bartók met with Zoltan Kodály, a young musicologist and composer who was already collecting folk tunes. Kodály introduced Bartók to the Edison phonograph, which they used to record peasants singing. Folk music gave Bartók's composition a new direction. He felt he had explored classical tonality to its limits; the melodic and rhythmic novelty of the folk idiom offered him a new way forward.

In 1907, Bartók was appointed professor of piano at the Budapest Academy, a great honor for a young man of 26. The post allowed him time for both his research into folk music and for composing. Bartók's compositions, however, met with a hostile reception. A Budapest paper described his First String Quartet as "tortured and repulsive." In 1911, the Budapest Opera rejected his opera, *Bluebeard's Castle*. Bartók wrote to a friend in 1912, "I have resigned myself to writing only for my desk drawer ... I am tired of it."

Bartók's private life was no happier than his career. When he was 26, he had an unhappy affair with the violinist Stefi Geyer. He dedicated his First Violin Concerto to her, but she never played it. Shortly afterward, in 1909, Bartók married a pupil, Márta Ziegler, who was then 16 years old. Their son, also named Béla, was born in 1910. The marriage was not a success, however, though they stayed together for 14 years. Bartók's idealism and integrity made him difficult to live with.

WORKS FOR THE STAGE

The outbreak of World War I in 1914 brought a stop to Bartók's folk-song collecting. He was declared unfit for active service and remained at the academy. He was utterly opposed to the war, predicting that it would end in disaster for Hungary. It was perhaps the emotional stress of the war that spurred him to return to composing.

BACKGROUND

Musicians in World War II

Bartók was only one of many musicians whose lives were caught up in the upheaval of World War II. Many composers and musicians did not fulfill the Nazi criteria of pure Aryan, or German, descent. In Hitler's Germany, their music was banned and they were forced to flee.

Composers such as Arnold Schoenberg (*see page 978*) and Paul Hindemith, and the conductors Bruno Walter and Otto Klemperer, were compelled to seek work abroad. Although the conductor Wilhelm Furtwängler was of German descent, he was nevertheless forced to resign his position after he had conducted the premiere of a new work by Hindemith, who was married to a Jewish woman. The ban even extended to the dead: no music by the 19th-century composer Felix Mendelssohn – who was Jewish – could be performed. Jazz was banned from the radio for being "impure," because of its origins in black music. Many non-German musicians protested publicly against this political interference with art. Some conductors and musicians refused to perform in Germany while such conditions existed.

The director of the Budapest Opera wanted to stage a ballet version of "The Wooden Prince," a fairytale by the poet Béla Balázs. Balázs had written the libretto of Bartók's *Bluebeard's Castle* and was deeply interested in using folklore. Despite his reputation as a "modernist," Bartók was the obvious choice for composer.

At first sight, the dancers and orchestra declared Bartók's piece undanceable and unplayable. But the Italian conductor, Egisto Tango, persisted. After more than 30 rehearsals, the work's premiere was a great success. The next year, 1918, Tango conducted the premiere of *Bluebeard's Castle* to equal acclaim. Both works explored the psychological subtleties of folk tales. Balázs said, "I wanted to depict a modern soul in the primary colors of folksong." Bartók lovingly used his entire palette of modal tonalities and rhythms based on patterns of speech.

Bartók wrote his third stage work, *The Miraculous Mandarin*, in 1918 and 1919, but it was not performed until 1926. In mime and dance, the work tells of a prostitute and three thugs who rob men they lure from the street. Finally, they encounter the mandarin and find he has a power beyond their control. Although not strictly a folk tale, the pantomime setting and stylized characters allowed Bartók to work in a similar idiom to his earlier works.

After the end of World War I in 1918, Hungary was declared a Soviet republic. The new communist government, however, soon disintegrated into chaos. Although Bartók claimed that he was not interested in politics, he too was caught up in the turmoil. Instability threatened his post as deputy director of the academy. As violence spread, Bartók and Márta were forced to flee the home in Budapest, where they had lived since 1912, and seek the safety of a friend's house.

CRISIS AND RECOVERY

Along with political instability, Bartók was suffering a personal crisis. His marriage was failing, and in 1921, he fell in love with another student, Ditta Pasztory. Little is known of the circumstances of Bartók's marriage before this meeting, but in

KEY DATES	
1881	born in Nagyszentmiklós in Hungary
1899	enrolls in the Budapest Academy of Music
1904-05	discovers folk songs; meets Kodály
1909	marries Márta Ziegler
1911	composes Bluebeard's Castle
1923	divorces; marries Ditta Pasztory
1927	composes Third String Quartet
1934	retires from teaching and prepares folk song collection
1940	emigrates to America
1945	begins Third Piano Concerto; dies in New York before completing it

1923, Márta herself suggested a divorce to allow Bartók to marry Ditta. Bartók and Ditta had a son, Peter, born a year later.

The next few years were happier and more productive for Bartók. In 1927, he toured the United States; the next year, his Third String Quartet won joint first prize in a Philadelphia competition. In the winter of 1928 to 1929, he toured Russia where his music was greeted enthusiastically. In 1934, he gave up teaching – but not composing – and agreed to prepare the vast folk song collection of the Hungarian Academy of Sciences for publication.

But the respite from political activity was short. The 1930s saw the rise of Fascism in Italy and Nazism in Germany. Like other Hungarian musicians, Bartók protested against right-wing extremism. The political situation had personal repercussions. In 1938, Germany's invasion of Austria put Hungary in direct danger of attack; Bartók's Viennese music publishers were taken over by the Nazis and ceased to pay his royalties.

Bartók forbade the performance of his music in Germany or Italy, and sent all his manuscripts

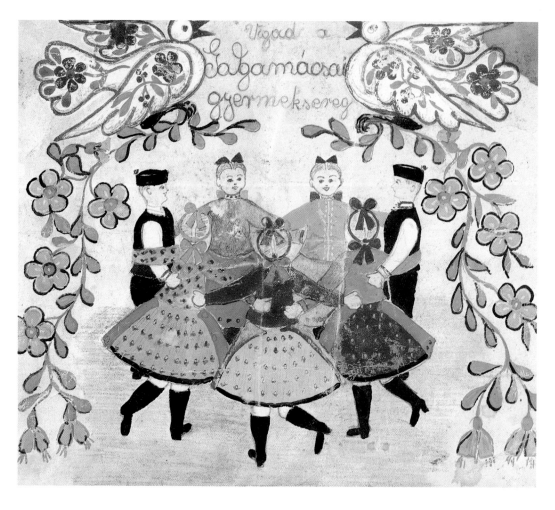

The Children of Galgamasca Dancing: Julie Dudas (1970)
Hungarian children in national costume dance to folk songs in a painting by a celebrated "naïve" artist.
Bartók's research did much to preserve the wild and exciting traditional dance music of Hungary.

to neutral Switzerland. But he could not bring himself to leave Hungary while his mother was still alive, even after World War II broke out in August 1939. Paula Bartók died three months later, at 82, and her son arranged a concert tour of America for early in 1940. Although in ill health, he was thinking of emigrating.

In October 1940, Bartók and Ditta left Budapest for good. He received a two-year appointment at Columbia University to work on its collection of Serbo-Croatian folk songs. The grant was not renewed in 1943, however, and money became a problem. Although many friends tried to help, Bartók was too proud to accept charity. He even refused to take money sent by his son Peter, by now serving in the U.S. Navy.

By 1943, Bartók had polycythemia, which left him no hope of recovery and no prospect of finding any work. The American Society of Composers, Authors, and Publishers paid for hospital treatment, and sent him to rest at Saranac Lake in New York State.

Despite his disease, Bartók was still composing. He wrote his last great works, the Concerto for Orchestra and a Sonata for Solo Violin, and virtually finished his Third Piano Concerto. Before it was completed, Bartók went into a hospital in New York; he died on September 26, 1945.

The Folk Music Revival

Bartók was at the forefront of the rediscovery of folk music. Before the pioneering fieldwork he did with Zoltan Kodály, Hungarians only knew the music of nomadic gypsy bands prettified for the Budapest salons. But Bartók's lifetime coincided with a growing nationalistic awareness throughout Europe, especially in the eastern part of the continent. Hungarians, Poles, and Rumanians had long been forced to speak the language of their despotic Austrian rulers. Traditional folk music provided a channel for their reawakened national consciousness.

But eastern Europe was only part of an international folk music revival. In 1913, Bartók traveled to North Africa to collect Arab folk music, and, in 1936, to the Anatolian desert in Turkey, where he recorded the music of nomads on his Edison phonograph.

In England, meanwhile, the key figure was Cecil Sharp. He collected music in the Appalachian Mountains in America, where he discovered many early versions of songs which had been carried there by immigrants some 200 or 300 years earlier. Sharp worked tirelessly to record local traditions before the industrial age and urbanization destroyed the way rural life had been for centuries.

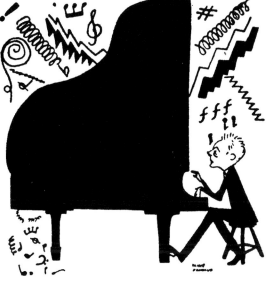

Bartók at the piano (1928)
A caricature from a New York publication during Bartók's first visit to America characterizes the reception given to his "difficult" music.

The research of Bartók and his contemporaries forms the basis of the discipline of ethnomusicology, which explores the roots of humankind's music-making. Modern scholars go further afield to study the music of tribal peoples in Asia and Africa. They believe that they may soon understand the kind of music made shortly after the Stone Age.

Some collectors of folk music were composers rather than scholars, eager to revitalize their musical ideas with the "unusual" melodies, rhythms, and harmonies of folk songs. Granados in Spain, Grieg in Norway, and Dvořák in Bohemia made use of their native music. In England, Benjamin Britten was just one composer who used folk songs extensively. In America, Arthur Farwell and others turned to African-American and Native American sources.

The modes, or scales, of folk music perhaps presented the most exciting challenge to young composers. Classical music mostly used only two of the many scale patterns once current in Western music – the major and minor. By the late 19th century, some composers felt that classical tonality was exhausted. To such artists, the sounds of the neglected modal scales often found in folk music offered a potent source of inspiration.

Umberto Boccioni

The outstanding figure of the Italian Futurist movement, Boccioni excelled as a painter and a sculptor. He was also Futurism's chief spokesman, promoting its cause with energy and flamboyance.

During his brief career, Boccioni gave direction to the Futurist theories of the Italian poet Filippo Marinetti. Speed, modernity, and violence were its watchwords, expressing the excitement of the new industrial era. Such qualities could describe Boccioni's own character: ambitious, aggressive, and restless for change and experiment.

Umberto Boccioni was born in Reggio Calabria, on the southern tip of Italy, on October 19, 1882. His father was a government official whose job involved extensive travel within Italy. During Umberto's early years, the family lived in the north, in Genoa, Padua, and Forlì. He was educated at the Technical Institute of Catania, Sicily, in the south, and displayed an early promise in both literature and drawing. Boccioni took his time in choosing between these two fields. In 1900, he wrote a novel which was never published.

FAMILY FRICTION

Once he had decided to make art his priority, Boccioni received support from his mother and sister. His father was less encouraging. According to the artist, he refused to let Boccioni take a formal academic course and instead pressed him into training as a commercial artist. It seems likely that it was this family friction which persuaded Boccioni to leave home and settle in the capital, Rome, in 1898.

The decisive event of Boccioni's years in Rome was his encounter, in 1901, with the artist Giacomo Balla, whose studio was a meeting place for the city's literary and artistic avant-garde. At the time, Balla was working in the fashionable Divisionist, or pointillist, style, a technique of painting in dots of pure color, and he liked tackling modern themes concerning urban life and work.

Boccioni studied with Balla for several months, and probably frequented his studio while in Rome. Also studying there was Gino Severini, who later joined the Futurists. He and Boccioni became close friends, sharing an interest in the writings of the philosopher Friedrich Nietzsche, and the political theories of Karl Marx and Friedrich Engels, the founders of communism.

Boccioni remained in Rome until March 1906, when he left abruptly for Paris. Although he had enjoyed the artistic environment at Balla's studio, he felt despondent about his lack of money and the continuing need to make his living from commercial designs for magazines. Paris, however, intoxicated him. He wrote home excitedly about the trams, the subways with their electric lights, the women with their gaudy make-up, and the crazy dancing at the Moulin de la Galette. Such a sudden shift of mood was typical of Boccioni. At times, he was egocentric, aggressive, and ambitious—Severini caustically dubbed him "Napoleon come back to life;" at others, he was racked with self-doubt. He loved being the center of atten-

Umberto Boccioni
A photograph of the artist taken in 1912.

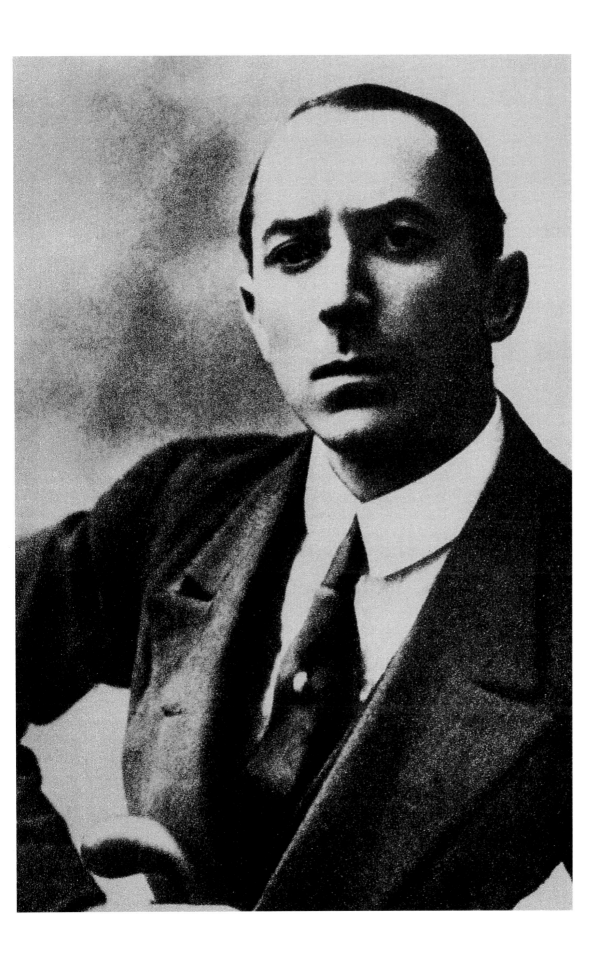

BACKGROUND

Italy and World War I

In common with many of his fellow countrymen, Boccioni was appalled by Italy's neutrality at the outbreak of World War I. The reasons for his country's stance were complex, dating back more than 30 years. In 1882, the German chancellor, Prince Otto von Bismarck, had cemented a Triple Alliance between Germany, Austria, and Italy, which stipulated that if one of these powers became involved in a war, the others would maintain a benevolent neutrality.

The agreement was invoked by Austria in 1914, when it declared war on Serbia. But a longstanding dispute between Italy and Austria over a region of the South Tyrol enabled the Entente forces – France, Russia, and Britain – to undermine this accord. At the Treaty of London in April 1915, they promised Italy huge territorial gains if she withdrew from the Triple Alliance. Italy therefore declared war on Austria on May 24, 1915, and on Germany on August 27, 1916, a few days after Boccioni's death.

tion. It is likely that for him much of the appeal of the Futurist movement lay in its theatrical and self-advertising character.

In July 1906, Boccioni made a brief trip to Russia and, a year later, settled in Milan, living with his mother and sister in the suburb of Porta Romana. This was to be his principal base until 1915. Boccioni was still working for various magazines, such as *Illustrazione Italiana*, but he was now developing a clearer notion of the course he wished to follow. In his diary he wrote, "I feel that I want to paint the new, the fruit of our industrial age." All he lacked was a precise idea about how to achieve this purpose.

THE FUTURIST MANIFESTO

The answer to Boccioni's problem came out of the blue. On February 20, 1909, the Italian poet Filippo Marinetti published *The Founding and Manifesto of Futurism* on the front page of the prestigious French newspaper, *Le Figaro*. This was a savage attack on established culture, couched in language guaranteed to cause offense. "We affirm that the world's magnificence has been enriched by a new beauty, the beauty of speed ... We will

glorify war ... [and] destroy the museums, libraries, and academies of every kind."

Marinetti's article was not primarily concerned with the visual arts, but shortly after its publication, he teamed up with Boccioni and two other painters, Luigi Russolo and Carlo Carrà, to rectify this. One night early in 1910, the four men met in Marinetti's house to draft *The Manifesto of Futurist Painters*, which was completed the following morning in a milk bar near Porta Vittoria. The manifesto was published as a leaflet by Marinetti's magazine, *Poesia*, on February 11, 1910. In March, Boccioni declaimed it from the stage of Turin's Chiarella Theater. Balla and Severini also put their names to the document.

From this point onward, Boccioni's life was caught up in the development of the Futurist movement. Together with the other Futurists, including poets and musicians, he set up exhibits, issued a string of manifestos, and participated in Futurist evenings held in theaters all over the country. More specifically, the movement gave a firm direction to his own art. By the end of 1910, he had produced his first identifiably Futurist painting, *Riot in the Galleria*, and was at work on *The City Rises*. The essence of Futurism was its rejec-

tion of the art of the past and its emphasis on speed, movement, and modernity. This was made clear in Marinetti's famous declaration that "a roaring racing-car ... is more beautiful than the *Victory of Samothrace*," a famous classical statue.

Any attempt to reproduce dynamic movement in a still image on canvas presented obvious technical problems. Boccioni found part of the solution in the theories of the French philosopher Henri Bergson, who had defined time as a succession of conscious states, intermingling and unmeasured. For the artist, this "intermingling" could be represented by a "synthesis of what one remembers and what one sees." It could also be applied to physical objects which, Boccioni argued, were in constant motion, both within themselves and in relation to the space around them. This motion could be conveyed by what he called "lines of force," which demonstrated an object's trajectories in space.

THEORY INTO PRACTICE

The City Rises provides a perfect illustration of these theories. On one level, it is a synthesis of several scenes of a modern industrial city coming to life, with people setting about their work. On another, the central image of a rearing horse with its rider and cart, whose "lines of force" form a seething vortex, constitutes a dynamic symbol of the harnessed force of industry.

The experience of Cubism was another important influence for Boccioni, enabling him to bring greater solidity to his forms. In *The Laugh* (1911), for example, he depicted the explosive effect of laughter by using expressionistic "lines of force" and fragmented Cubist forms.

In April 1911, the first major exhibit of Futurist painting opened in Milan. A year later, the same show was put on in Paris, which was still regarded as the center of the art world. It did not meet with universal approval. The critic Apollinaire dismissed Boccioni's ideas as "sentimental and puerile," but the show was a popular success, receiving extensive press coverage. The exhibit then toured London, Brussels, Amsterdam, The Hague, Ber-

KEY DATES

1882 *born in Reggio Calabria, southern Italy*

1898 *moves to Rome*

1901 *meets Balla and works in his studio; begins friendship with Severini*

1906 *moves to Paris and travels to Russia*

1907 *settles in Milan*

1909 *Marinetti publishes* The Founding and Manifesto of Futurism

1910 *co-writes and publicizes* The Manifesto of Futurist Painters

1910-11 *paints* The City Rises

1911-12 *first Futurist exhibit opens in Milan and tours Europe*

1912 *experiments with sculpture*

1913 *one-man exhibit in Rome*

1914 *outbreak of World War 1*

1915 *volunteers for war service with the Lombard Volunteer Cyclist Battalion*

1916 *dies after a riding accident*

lin, and Munich, so establishing the international reputation of the Futurist movement.

It did little to inspire Boccioni's own painting, however. In 1912, he devoted himself principally to sculpture and he began to work and exhibit alone. His solo exhibit in Rome in 1913 inaugurated a permanent gallery of Futurist art there. Increasingly, Boccioni's egotism and ambition isolated him from his colleagues, while his art became overshadowed by his growing interest in politics.

In the summer of 1914 World War I broke out. Boccioni was involved in demonstrations at the Opera, where an Austrian flag was ceremonially burned in protest at Italian neutrality in the war. Boccioni was arrested, but treated exceptionally

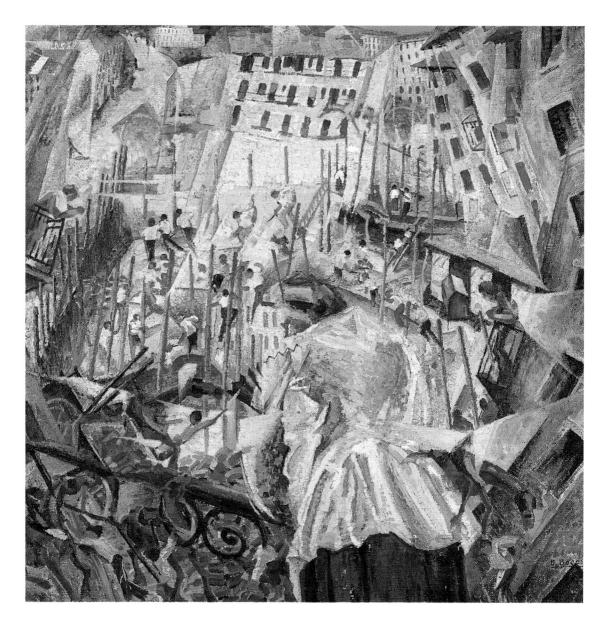

The Street Enters the House: Umberto Boccioni (1911)
*In this vividly colored work, Boccioni wanted the dominant sensation to be "that which one
would experience on opening a window: all life and the noises of the street rush in ..."*

well. "I am in a paying cell," he wrote to his mother, "and lunch brought in from outside is excellent."

When Italy did enter the conflict, Boccioni joined the Lombard Volunteer Cyclist Battalion in 1915. As he set off, his mother followed him and his fellow volunteers in a carriage shouting, "Long live the Futurists, long live Italy, long live the volunteers." The constant danger appealed to his restless and aggressive nature. He described his days on active service as the happiest of his life. In 1915, Boccioni wrote home from the Front: "War is a beautiful, wonderful, terrible thing. And in the mountains, it seems like a battle with the infinite." Ironically, he did not die in action. He fell from a horse during a routine exercise and died the following day, on August 16, 1916.

Boccioni's Sculpture

The Futurists believed that their principles were valid for most branches of the arts, including sculpture. They thought that sculpture, like painting, was too dependent on the past and was ripe for renewal. Boccioni voiced this view with his customary authority when he wrote to a friend in 1912: "I am obsessed these days by sculpture. I think I can perceive a complete revival of this mummified art."

His plans for this revival were based on the Futurist definition of space. The 1910 manifesto argued that objects, even if apparently static, extended into their surrounding space. Human figures and objects were never truly isolated, therefore, but were perpetually interacting with their environment. "Our bodies penetrate the sofas upon which we sit, and the sofas penetrate our bodies." The aim of the Futurists was to capture these "interpenetrating planes" in their art.

For Boccioni, this raised the fundamental problem of how to portray moving objects without dissolving them completely into unrecognizable forms. It was particularly difficult to achieve this on a two-dimensional canvas. Boccioni's "lines of force," describing the direction of movement, never provided an entirely satisfactory solution for him. In 1912, he explored the question further in a remarkable series of sculptures, recording his findings in the *Technical Manifesto of Sculpture*, published in the same year.

> ## The fundamental problem was how to portray moving objects without dissolving them completely

Once again, the main emphasis was on the relationship between objects and their surroundings. "We break open the figure and enclose it in environment," Boccioni declared. The difference was that, in a three-dimensional medium, this directive could be followed quite literally.

"Thus the wheel of some piece of machinery might project from a mechanic's armpit," read the manifesto; "thus the line of a table could cut right through the head of a man reading; thus the book with its fan of pages could slice the reader's stomach into cross-sections."

Boccioni made several sculptures in this vein, of which the best surviving example is *Anti-Graceful*. This portrait head of his mother has part of a house protruding from her skull. His finest sculpture, however, went beyond a simple fusion of separate elements. In *Unique Forms of Continuity in Space*, Boccioni used a striding figure to show lines of force in three-dimensional form. Here, the flame-like extensions of the figure's limbs represent the "absolute" movement of each part of the body as they surge beyond their normal physical limits.

In 1912, Boccioni showed some of his sculpture in Paris, where it was well-received. He consolidated this success the following year by participating in the first exhibit of Futurist sculpture in Paris, and also with a solo exhibit held in Rome.

Albert Camus

Expressing the unease of a generation after a cataclysmic world war, Camus wrote novels and plays dealing with the loss of traditional codes of living, and with the irrational nature of the external world.

Probably the most widely read of postwar French novelists, Camus is often regarded as the finest commentator on the mood of disillusion pervading Europe after World War II. He helped to popularize the important modern philosophy of Existentialism, which centered on the freedom and moral responsibility of each individual. His view was that the world was an absurd, irrational place baffling to rational humans. This idea gave rise to the theater of the absurd, with which many avant-garde playwrights are associated, including Samuel Beckett (*see page 923*) and Harold Pinter.

EARLY LIFE IN ALGERIA

Albert Camus was born in the Algerian village of Mondovi on November 7, 1913. The following year, his father died in action at the beginning of World War I. Albert was brought up by his mother, who was illiterate, and spent his childhood in acute poverty. The memory of this hardship haunted him for the rest of his life. Albert, his brother Lucien, his mother, and grandmother all had to share a one-bedroom apartment. Camus was an intelligent child and, helped by his primary school teacher, Louis Germain, won a scholarship to the Lycée in Algiers in 1924. Camus enjoyed reading, soccer, and swimming, which plays an important part in his work, notably *The Outsider*, where the significant action takes place on a beach.

In 1930, Camus suffered a severe attack of tuberculosis and had to stay with his uncle to recover.

He went on to study philosophy at the University of Algiers, but not before his doctor had told him that he was going to die. This experience, noted in his second book of essays, *Nuptuals* (1939), had a profound influence on him and may have triggered the obsession with death evident in his mature work. The tuberculosis returned at intervals throughout his life.

In 1935, Camus joined the Communist Party and became committed to left-wing politics. He turned down his uncle's suggestion that he follow him in the butcher's trade and make a comfortable life for himself. He married Simone Hié, but the marriage ended disastrously in 1936, when Camus discovered that she was sleeping with one of his friends to pay for her morphine habit.

EARLY FAME

By the mid-1930s, Camus was busy with various literary projects. He contributed political articles to a left-wing Algerian newspaper; he helped found a theater, for which he wrote his first play in 1936; and he wrote essays and works of fiction. In 1940, Camus married again. His new wife was Francine Faure. He volunteered for military service, probably because of his hatred of Nazism, but was rejected on the grounds of his health. When the newspaper he worked for had to close,

Albert Camus
This photograph was taken in 1959.

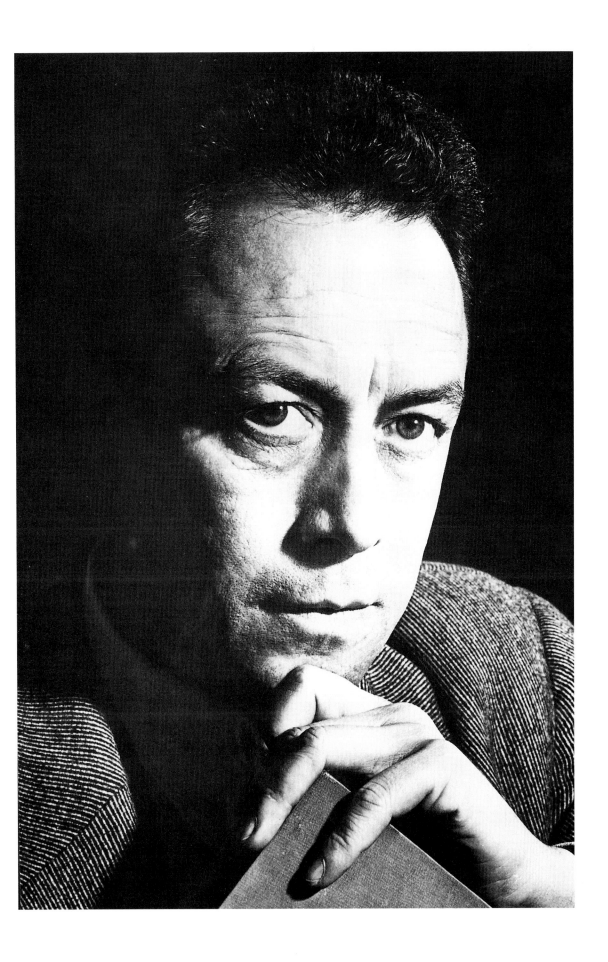

partly because of censorship, he left for France. He returned to Algeria soon after, in January 1941.

Camus' novel, *The Outsider*, and his pioneering essay on the concept of the absurd, *The Myth of Sisyphus*, were published in 1942. *The Outsider* tells the story of Meursault, a clerk in Algiers who kills an Arab with whom he has quarreled. He is condemned to death, mainly because he makes very little effort to defend himself at his trial. Meursault is a man who is notable mainly for his indifference to social norms and accepted morality. For example, he shows no emotion at his mother's funeral, the starting point of the novel. On death row, he tries to reconcile himself to his impending fate.

The novel is a troubling one. Many readers, encouraged by Camus' own comments on the book, have seen Meursault as a hero who refuses to play society's hypocritical games of false, showy morality. He simply responds as he feels. But it can also be read as a condemnation of its hero. He is shallow though intelligent, and passively accepts the absurdity of contemporary life, which he finds incomprehensible because of the collapse of the west's traditional moral and religious codes.

THE IDEA OF THE ABSURD

The question of absurdity is also explored in *The Myth of Sisyphus*. This takes as its central image the legendary hero who challenged the gods. His punishment was to spend eternity pushing a rock up to the top of a mountain, letting it roll back to the bottom, and beginning the whole process again. This image of futile labor characterizes the absurdity of mankind's plight in the 20th century. The essay argues that life may be pointless, but that true rebellion consists in continuing to live rather than performing the more logical act of committing suicide. Camus' early work was as much a statement of hope as an act of rebellion.

Camus' essay publicized the philosophical idea of an absurd universe, and this idea was to be taken up by many other European and American playwrights who wrote for the genre known as the theater of the absurd. The theater was the ideal setting for isolated characters to voice perplexity and engage in odd, disjointed dialogue. Comic elements from other theatrical traditions, such as miming and clowning, were also used.

WAR YEARS

Back in Algeria, Camus began work on *The Plague*, but returned to France to fight for the French Resistance in 1942. This underground organization formed after the Nazi occupation at the end of 1940. Though Camus was later reluctant to talk about his involvement, he became an important and active figure in the Resistance. He also edited their newspaper, *Combat*, and continued to write

KEY DATES

1913 *born in Mondovi, Algeria*

1914 *father dies*

1930 *first attack of tuberculosis*

1935 *joins Communist Party; marries Simone Hidé*

1940 *marries for the second time; leaves Algeria for Paris;*

1942 *active in French Resistance; edits* Combat; *The Outsider and* The Myth of Sisyphus *published*

1944 *liberation of France at the end of World War II; Camus becomes disillusioned with the French left*

1945 Caligula *published*

1947 The Plague *published*

1951-2 *public quarrel with Jean-Paul Sartre following publication of* The Rebel

1956 *publication of* The Fall

1957 *wins Nobel Prize for Literature; collection of short stories published*

1960 *killed in a car crash in Petit-Villeblevin, Yonne, France*

BACKGROUND

Algeria

In 1836, France annexed Algeria, which became its most important colony. The population consisted of a huge majority of Arab and Berber peoples, who spoke Arabic and practiced the Islamic faith, and a small minority of French colonists. The French attempted to integrate the Arab population into the French way of life, particularly through its rigorous education system, but the two groups remained separate and hostile. In 1954, a bloody war broke out between Arab nationalists, led by the National Liberation Front, and the French government. In the course of the war, 100,000 Muslims and 10,000 French were killed, but fierce Arab resistance finally gained independence for Algeria in 1962.

Often, the most hostile opponents of Algerian independence came from the French working class. Camus himself opposed the use of violence by the Arabs specifically because his mother might be a victim of their actions. Algeria haunted Camus' creative imagination. It is arguable that his work is as much concerned with the problem of a dying colonial culture, and the ethical choices it forced individuals to make, as with the Existential philosophy he studied intently.

and work for a large Parisian publishing house, Gallimard. Camus had become well-known in literary circles with the publication of *The Outsider* and *The Myth of Sisyphus*, but he now emerged as a national figure.

In 1944, France was liberated from Nazi occupation. The slogan of *Combat* had been "From Resistance to Revolution," but after the war, Camus became convinced that the totalitarianism of the left could be just as repressive as the right-wing authoritarianism he had helped to defeat.

This is one of the principle themes of *The Plague*, published in 1947, which tells the story of a plague devastating the Algerian coastal town of Oran. The novel explores the problem of human suffering and forces the reader to wonder if God exists. As the plague rages and the inhabitants die in rapid succession, the Jesuit, Paneloux, preaches that the plague is a punishment from God for the city's sins. When the innocent daughter of the town's judge dies, he revises his views in a second sermon suggesting how important life is, and how one should cling to it at all costs. The answer

Camus gives to the question of suffering appears to be that it is unfair, absurd, and that a just God would not permit it.

THE POLITICAL PLAGUE

The plague is symbolic, both of France under German occupation and of other forms of political oppression such as the continuing French occupation of Algeria. Camus explores the responses of the characters to their situation, some collaborating, some surrendering to fate, and some resisting in a humane and kindly way, as does Dr. Rieux, the narrator. He concludes that the plague will never disappear but may at any time return and unleash its terror. It is, however, in the power of the ordinary citizen to resist by being a "doctor" rather than a saint.

Camus was now a significant figure in French intellectual life. He continued to edit *Combat* until 1947, and the success of *The Plague* confirmed that of *The Outsider*, making him one of France's most celebrated novelists. His reputation as a play-

wright was cemented by the first performance of *Caligula* in 1945. This play dealt with life under the tyrannical Roman emperor. Caligula himself is partly a hero for his hatred of hypocrisy, and partly a bloodthirsty monster.

A SHIFT IN ATTITUDE

Camus gradually withdrew from his former political position. He lost sympathy with his allies in the Communist Party for abandoning liberal values in the name of social revolution. Camus himself became increasingly liberal in outlook — his staunch opposition to the death penalty became his main political cause in these years. As a result, during the years 1951 to 1952, he quarreled with his friend and fellow-writer Jean-Paul Sartre, whose existential philosophy had influenced his own work so strongly. As the Algerian War of Independence developed in the late 1950s, Camus refused to side with the Algerians and explicitly condemned their use of violence against the French government. This alienated him still further from his erstwhile political allies.

In 1951, Camus published *The Rebel*, which tried to reconstruct the concept of political rebellion as a liberal ideal. It praised the Scandinavian democracies above those regimes more obviously appealing to the left.

Camus' second marriage had been more successful than his first, but that too broke down in the early 1950s. He now lived on his own in Paris, where his job with Gallimard meant that he had enough money to pursue other projects. Nevertheless, he appears to have been unhappy, unable to settle down to domestic life, involved in bitter in-fighting with other intellectuals, and exiled in a city he could never regard as home.

THE FALL

Camus published *The Fall* in 1956. It was the last of his three major novels, and the only one not to be set in Algeria. The book is written as the first-person narrative of a disillusioned Parisian lawyer, Jean-Baptiste Clamence, who lives in Holland. The action takes place in a bar, where Clamence tells his life story to another lawyer. He had witnessed the suicide of a young woman who jumped from the Pont Royal in Paris, but told no one about the incident. After this, he feels unable to continue with his former life and even contemplates suicide himself. Eventually, he finds a role for himself as a "penitent judge," confessing his sins to others and encouraging them to see his life as a mirror of their own. The book deals with many of Camus' familiar themes — the absurdity of human existence, the problem of human suffering, Christian forgiveness, and the rights and duties of individuals to take action. Many consider it his finest work.

THE PRIZE

Despite his lucid style, Camus is a strange and difficult writer who both deals with paradoxes and creates them in his writings. On the one hand, he sought political commitment and the certainty of moral rightness; on the other, he was convinced of the oddity of human existence and of the difficulty of ever knowing that an individual can do any good. Camus has been claimed by readers looking for either message, just as he has been defended by critics of opposing political persuasions. Perhaps his works are best read as explorations of these contradictory problems.

Much to his and everyone else's surprise, Camus was awarded the Nobel Prize for Literature in 1957. He himself felt it should have gone to his fellow countryman André Malraux. When receiving the award, Camus made a speech in which he paid tribute to his primary school teacher, Louis Germain, without whom he would never have been able to follow his chosen career.

In 1957, a collection of short stories, *Exile and the Kingdom*, came out. This was his last significant work of fiction, for Camus began to suffer from a sense of artistic sterility in the 1950s. He was killed in a car crash in Petit-Villeblevin, Yonne, France on January 4, 1960, at 47.

Existentialism

This school of philosophy reflected the modern spirit of disillusion and so gained widespread popularity in Europe around the mid-20th century. It suggests that personal experience is of paramount importance. Existentialists start from the premise that all philosophical inquiry should arise from the consciousness of the individual. This idea runs counter to previous systems of philosophy in which theories and abstractions were applied to individuals. Existentialism sees humans as shaping themselves. It considers are the state of the individual's being and how he or she can think or perform any action.

Existential philosophy had existed earlier, but its greatest exponent in the 20th century was Jean-Paul Sartre (1905– 1980), Albert Camus' contemporary and sometime friend. Sartre managed to turn the doctrines of Existentialism into an intellectual vogue, and had a huge influence on Camus. For Sartre, the individual had no greater responsibility than to him- or herself. Such a responsibility, however, involved political commitment to changing the world through performing virtuous actions.

Sartre's first published novel, *Nausea* (1938), illustrates the problem of an individual trying to act virtuously and the penalties of failing to do so. His great war trilogy, *The Roads to Freedom* (1949), emphasizes the need for human beings to exist within a wider community and the imperative of commitment to a worthy cause. In his philosophical work, most importantly, *Being and Nothingness* (1943), Sartre developed the political aspect of Existentialism, emphasizing the importance of commitment. He argued that mankind has no essential nature but is determined by the forms of existence available. It follows from this that there is no objective standard from which to devise moral guidelines, which in itself overturns all certainties of religion and traditional moral codes.

Instead, individuals are alone and must take responsibility for themselves. Sartre's theories grant great freedom to the individual, which can seem exciting, but they also take into account the cost of such freedom.

Existentialism reflected the modern spirit of disillusion

A tremendous burden of responsibility and an aching sense of loneliness remain the individual's lot, and Sartre frequently considers these problems in his work. The individual can only overcome such isolation and moral inaction through involvement in a political cause. This seems to draw the Existential individual into a situation where firm values are lacking but much needed in a godless world. Sartre conceded that an individual who desired to relate to the outside world and to act within it would be caught in a contradictory position.

Camus explored the problems of individual commitment and responsibility in his writings. Though never a professional philosopher like Sartre, his career can be seen as an attempt to follow through the implications of the Existential philosophy he helped to popularize.

Marc Chagall

One of the most original and popular European painters of the 20th century, Chagall is renowned for his dreamlike images, which have a strong Russian and Jewish identity, and for his distinctive use of color.

Drawing inspiration from his memories and dreams, Chagall firmly believed that painting should reflect the state of one's soul. He described his work as, "An extravagant art, a flaming vermilion, a blue soul flooding over my paintings." Although the ideas of avant-garde movements influenced Chagall's work, he dismissed both the growing trend toward abstraction and the Cubists' interest in scientific exploration.

JEWISH UPBRINGING

Marc Chagall entered the world amid great drama and excitement on July 7, 1887. At the moment of his birth in the Russian town of Vitebsk, a fire broke out in a nearby building, and both mother and child had to be carried to a safer part of town. Chagall was born into a poor Jewish family; his father was a fishmonger's assistant who struggled to support his ten children on his meager wages. Chagall later likened him to "one of those men in Florentine painting with an untrimmed beard, eyes that are brown and ash gray, and a complexion of burned ocher furrowed with lines and wrinkles."

Despite such humble circumstances, it seems that Marc enjoyed a happy childhood. Relatives and elders at the synagogue ensured that the boy was taught to play the violin and given singing lessons, and from an early age he spent time drawing pictures and writing poems. He also received a good education at a school where Jews were not

normally admitted because his mother, ambitious for her son, bribed the schoolmaster.

Chagall bitterly disappointed her when he decided, while still at school, to become an artist. Chagall explained later that becoming a painter seemed "like a window through which I could have taken flight to another world." He spent a short time with a local artist called Jehuda Penn, but soon after began an apprenticeship as a photographer's retoucher. He soon abandoned this, and after an argument with his father, who was also dismayed at his decision, Chagall fled to the Russian capital with just a few roubles in his pocket.

LIFE IN THE CITY

At this time, Jews were not allowed to live in St. Petersburg unless their profession made it absolutely necessary, and Chagall was forced to indulge in a series of charades to avoid the suspicions of the authorities. Although he pretended to be a business representative for the merchants of his home town, and later posed as a footman for a wealthy Jewish household, this did not prevent him from being thrown into jail on one occasion. Too poor to afford his own room, Chagall rented an alcove in a room with several others. This was a period of hardship for the impoverished artist. He apprenticed himself to a signwriter,

Self-portrait: Marc Chagall
An undated portrait of the artist at work.

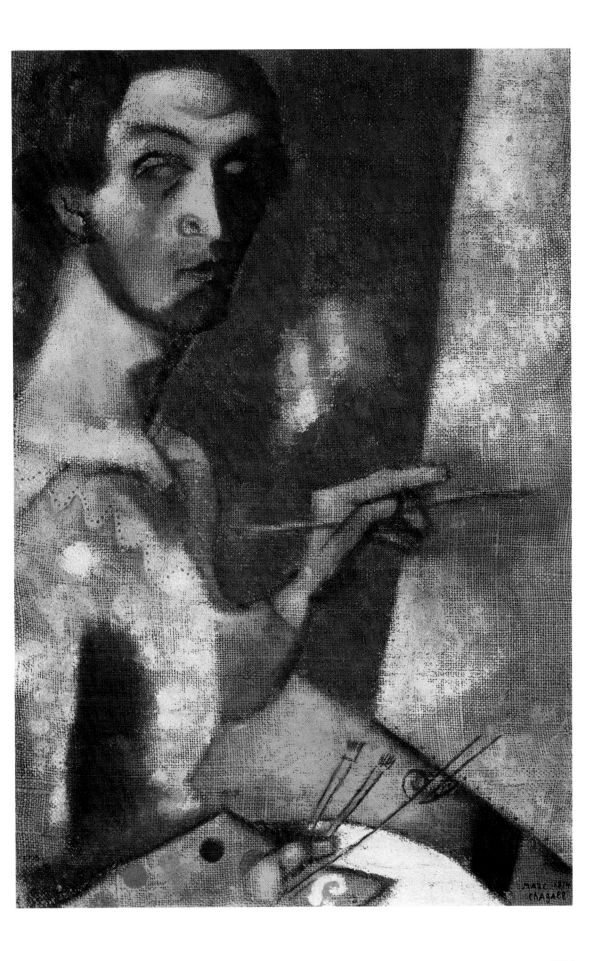

but was appalled at the idea of taking exams and, as before, quickly gave up his apprenticeship.

Despite these initial obstacles, Chagall finally secured himself an artistic training. He began at the School of the Imperial Society for the Protection of Fine Art in 1906, but soon found the teaching boring, the atmosphere depressing. "It was cold in the classrooms," he complained, "the smell of damp combined with the smell of clay paints, pickle and cabbage and stagnant water in the Moyky Canal."

Having endured two years of this stifling environment, he decided to enroll at the Avantseva School run by Leon Bakst, whom Chagall described as "refined and sometimes decadent." The college was reputed to be "the only school animated by the breath of Europe." Sharing a studio with Tolstoy's daughter Vera and the dancer Nijinsky, Chagall enjoyed the lively atmosphere. He learned little from Bakst, but the school was important for his development since he was exposed to the current avant-garde movements which had originated in Paris. Consequently, Chagall yearned to visit Paris, and an opportunity soon came his way. A Jewish lawyer who had bought some of his paintings offered to pay his fare and give him an allowance to study in the city. He moved to Paris in 1910.

A BOHEMIAN LIFESTYLE

Paris, its people and atmosphere, enchanted Chagall. In 1912, he moved into a studio called "La Ruche" – the "Beehive" – which was occupied by artistic bohemians from all over the world. This environment inspired Chagall with its energy and interesting characters, and he began working in a frenzy of excitement. He often worked right through the night, and reputedly could be seen painting stark naked in front of his canvases.

Money was still scarce for the artist. Despite gaining the nickname "the Millionaire," since he had more money than most at La Ruche, food was in short supply, and Chagall used to long for someone to take him out to lunch. Buying art materials was also difficult: sometimes the painter had to resort to painting on tablecloths, sheets, and

KEY DATES	
1887	*born in Vitebsk, Russia*
1906-10	*studies in St. Petersburg*
1910	*moves to Paris*
1914	*offered one-man show in Berlin; returns to Vitebsk*
1915	*marries Bella Rosenfeld*
1916	*birth of Ida*
1918	*appointed commissar of art in Vitebsk*
1920	*moves to Moscow*
1923	*returns to Paris; travels to Palestine, Egypt, and Syria*
1941	*moves to New York*
1944	*death of Bella*
1948	*permanently returns to France*
1950	*moves to Vence, southern France; takes up ceramics and stained glass*
1952	*marries Valentina Brodsky*
1985	*major retrospective in London; dies at Saint-Paul, southern France*

nightshirts. But Chagall was too wrapped up in the abundance of new ideas around him to worry over the lack of funds. In particular, he was inspired by the experiments that some of his friends, the Delaunays, were carrying out in color and form, as well as the new concept of space being explored by the Cubists, which he found exciting but limited. He was constantly dismayed by the Cubist tendency toward abstraction. For him, painting was not a suitable subject for dry, scientific analysis. "Let them choke themselves on their square pears on their triangular tables," he wrote about them. With so many new challenges and influences, Chagall began painting at a prodigious rate. He began sending work to the Salon des Indépendants and to avant-garde exhibits in Russia, although he sold few paintings.

In 1914, recognition at last seemed imminent for Chagall when he was offered an exhibit in Berlin. En route he decided to visit his home town, Vitebsk, but with the outbreak of war in August, his exhibit was put on hold and he was forced to extend his vacation. This disappointment, however, was tempered by his marriage to his childhood sweetheart, Bella Rosenfeld, in 1915. The following year, they had a child, Ida. The couple enjoyed idyllic happiness for the next 30 years. The artist's work took on a new feeling of joy, as seen in his colorful depictions of Bella and of his home town.

A NEW ROLE

But political events soon disrupted Chagall's life once again. In 1917, the Russian Revolution broke out, and despite the fact that he was not a man of strong political opinions, Chagall was drawn into the events. He was appointed commissar of art for Vitebsk in 1918, and put in charge of an art school and museum. Although he was an energetic organizer, Chagall did not enjoy his new role. He disliked having to negotiate money from the Soviets for the Vitebsk art school, and he was profoundly distressed when the artist Malevich came to the school and stirred up a rebellion against him and his teaching methods. Disillusioned with the whole experience, he fled to Moscow in 1920 to face a terrible winter of hardship with no work. Eventually, commissions to decorate two Moscow theaters and a job teaching war orphans in nearby children's colonies rescued him from utter poverty.

He returned to Paris in 1923, to find that all his paintings had disappeared from his studio. Chagall was only distracted from this misfortune by a string of new commissions, one of which gave him the opportunity to travel to Palestine, Egypt, and Syria to gain a first-hand impression of the Holy Land. It appeared that the artist's talent was at last being recognized.

WORLDWIDE FAME

By the 1930s, Chagall was the subject of worldwide fame and admiration. But his success was marred by the growing political turbulence in Europe with the rapid rise of the Nazis. In 1933, the Nazi leadership ordered some of Chagall's paintings to be burned. This episode, and the artist's concern for the fate of his fellow human beings, injected a mood of gloom and despondency into his works such as *White Crucifixion*, in 1938. In an attempt to escape the perils of war, the Chagalls

BACKGROUND

Hitler's Invasion of Russia

In 1941, Chagall, like many other artists, sought refuge from Nazi-dominated Europe in the United States. The European struggle, however, was now turning into a world war. Hitler invaded Chagall's native Russia in a devastating surprise attack on June 22, 1939. At three o'clock that morning, 3,500,000 Axis troops poured into Soviet Russia. Smolensk and Kiev fell, Leningrad was surrounded, and the German armies moved on toward Moscow. But the aggressors were not prepared for either the harshness of the Russian winter, or the tenacity of the Russian people. In December, the bitter winter stopped the invaders in their tracks, and by the year's end, the Soviets were counterattacking. Chagall was deeply upset by his Russian countrymen's fate, and during this time his work took on a sad and melancholy tone.

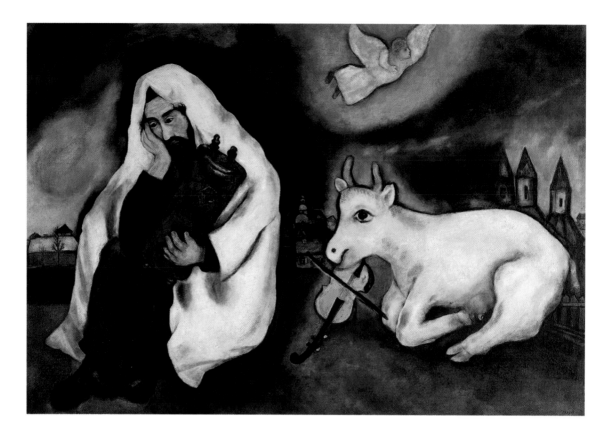

Solitude: Marc Chagall (1933)

Chagall does not use straightforward symbols in a conventional way, but here he seems to express the longing of the pious Jew for faraway Palestine. The placid-looking cow perhaps alludes to the idea of the innocent victim.

went to live in the south of France in 1939, the year World War II began, but as the Nazis advanced through France, the artist accepted in 1941 an invitation from the Museum of Modern Art in New York to leave for the U.S.

Until the end of the war in 1945, Chagall was busy with commissions for theatrical and ballet designs, but shortly before peace was declared, disaster struck when Bella died suddenly in 1944. Devastated, the artist stopped painting for months. It was only with the help of a love affair and an invitation to design costumes and sets for a production of Stravinsky's *Firebird* (*see page 990*), that he emerged from his depression.

In 1948, Chagall felt it was safe to return to France, and after an initial period in Paris, he went back to the south, settling in the pottery center of Vence in 1950. This move, together with his second marriage, to Valentina Brodsky two years later, heralded a new era of happiness for the artist.

CHAGALL'S LAST YEARS

For the remainder of his life, Chagall received commissions from all over the world. He devoted more time to the applied arts, presiding over his craftsmen, glassmakers, and weavers like the master of a Renaissance workshop. He completed a vast selection of projects, including stained-glass windows, paintings, tapestries, and mosaics. He also found time to experiment with ceramics, attracted by the radiance of color shining through the glaze.

His energy remained with him until the end of his life. He was 98 when he died in 1985, just as a retrospective of his work was closing in London.

Chagall's Imagery

Chagall created a uniquely individual style based on two rich sources of imagery: memories of Jewish life and folklore in his native Russia, and the Bible. Chagall's reliance on his personal experience of both places and people was paramount throughout his work. He wrote in his autobiography: "The soil that nourished the roots of my art was Vitebsk, but my art desired Paris as a tree desires water."

Chagall's gift was blending the real and the imaginary. Flouting the laws of time, space, and gravity, he conjured up his own personal world. The element of fantasy prominent in the artist's work was derived from his own experiences, memories, and dreams.

A characteristic feature in his imagery is that his figures and objects rarely stand firmly on the ground. Instead they appear to float in space, giving them a dreamlike quality. His skies are filled with seemingly unconnected images such as fiddlers, cows, garlands, candles, and angels. Conventional methods of portraying space were of little interest to him.

Chagall used images of peasants, animals, musicians, Jews, and lovers drawn from his own life. He said that he used such elements because they belonged to his childhood and had made a deep impact upon his visual memory. But although Chagall's pictures were rooted in his own experiences, he was adamant that his work went beyond a purely autobiographical content. Yet he made little effort to enlighten the viewer as to the real meaning of his work. He expressed the desire for his images to be seen as part of a jigsaw, rather than be subjected to over-specific interpretation. "For me," he wrote, "a picture is a surface covered with representations ... in which logic and illustration have no importance."

> "For me a picture is a surface covered with representations ... in which logic and illustration have no importance."

Chagall's subjects should not always be taken at face value, because the artist sometimes used the images to mean the opposite of what the viewer might imagine. For example, when asked about his seemingly joyful theme of the circus, he unexpectedly said: "I have always regarded clowns, acrobats, and actors as tragic figures, which for me resemble the figures in certain religious paintings." He went on to declare that, "a so-called subject ... should not, in fact, exactly resemble that which it intends to express, but rather make an allusion to something else in order to achieve that resemblance."

Chagall often worked on the same picture for decades, and similar images recur throughout his life. Despite the mystery behind many of his images, Chagall ultimately wanted to create a universally understood language. As he said: "I work with no express symbols, but, as it were, subconsciously. When the picture is finished, everyone can interpret it as he wishes."

Joseph Conrad

Writing in English instead of his native Polish, Joseph Conrad turned his experience of life at sea into novels of high drama which also explore the inner journey of the self.

By the time Conrad began writing at the age of 32, he had seen more than most people experience in a lifetime. He had left a secure home for a tough life at sea, and traveled to Europe, Asia, and Australia. The sights, characters, and experiences he encountered became the raw material of many of his most famous novels, in which adventure is paralleled by an exploration of the human psyche and the "inspiring secret" of life itself.

EXILED AND ORPHANED

Joseph Conrad was born Józef Teodor Konrad Korzeniowski on December 3, 1857, in Berdichev, Poland, now in Ukraine. The country was under Russian domination and Conrad's father, Apollo, was a fervent nationalist. He passed on his hatred of the Russians to his young son, along with his love of literature and his pessimistic nature. The family was aristocratic but this did not bring them any privileges. In 1861, Apollo was arrested for political activities and, a year later, the family was exiled to northern Russia.

Apollo's description of the place might have come from one of his son's novels: "Everything [is] rotting and shifting under one's feet ... The population is a nightmare: disease-ridden corpses." Conrad's mother, Evelina, whom he later described as "the ideal of Polish womanhood," died in 1865. For the next three years, Apollo tried to protect Conrad from illness, but it was almost impossible. Both father and son were continually sick,

and by the time they were allowed to return to Poland late in 1868, Apollo had contracted tuberculosis. He died early the following year. His young son was inconsolable.

The parental gap was filled by Conrad's uncle, Thaddeus, to whom the young Joseph quickly became devoted. Thaddeus believed in the importance of education, but Conrad was less sure. Another relative wrote that while Conrad "was intellectually well developed, he hated the rigors of school ... he used to say that he had a great talent and would become a great writer."

By the time Conrad was 15, it was getting harder to keep him in school. Fired by adventure stories, and fearing conscription into the Russian army, he pleaded with his uncle to allow him to go to sea. After two years, Thaddeus gave in and Conrad went to Marseilles in the south of France in 1874. For the next four years, he lived a wild life. He sailed to the West Indies, but an irregularity with his work permit prevented other voyages. By this time, he had spent all his money. He tried to make a quick fortune by smuggling, but instead lost a lot of money. His attempts to recover his losses at the gambling tables of Monte Carlo were a disaster. In despair he attempted suicide, but the bullet missed his heart and he survived.

Thaddeus came to his financial rescue. The 22-year-old Conrad left Marseilles for England, even

Joseph Conrad: Walter Tittle
This was painted in 1924, the year Conrad died.

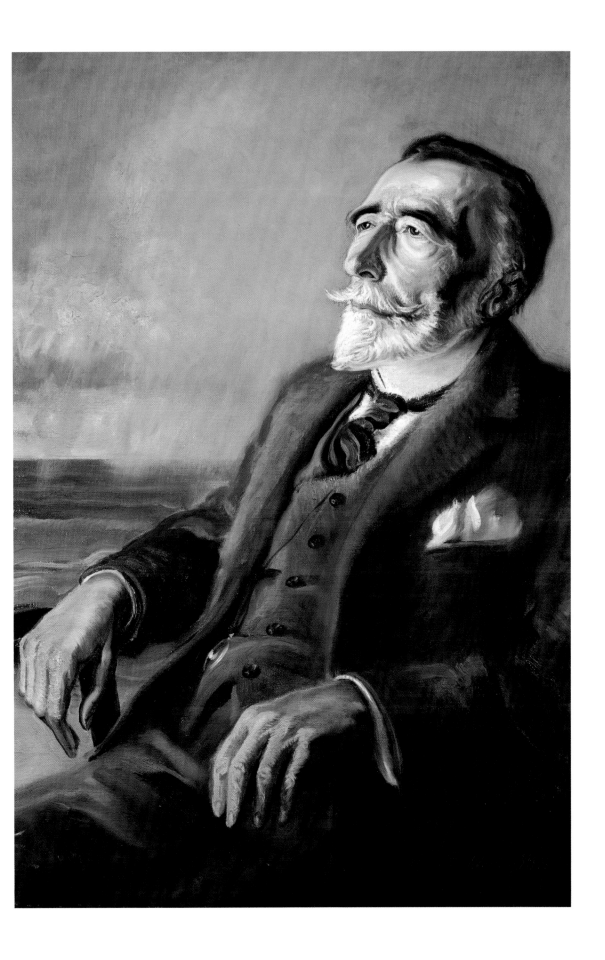

BACKGROUND

The Rape of Africa

The colonization of Africa is one of the bloodiest episodes of 19th-century imperialism, the combined work of governments and businessmen who coveted Africa's rich resources. Conrad called it "the vilest scramble for loot that ever disfigured the history of human conscience," and exposed it in *Heart of Darkness*. Colonized in the space of 20 years, almost the whole of Africa was under European control by 1900.

In the beginning it was the work of one man, King Leopold II of Belgium, ruler of a tiny European state. Under the pretext of "Christianizing" and "civilizing" the local people, he satisfied his greed and desire for overseas power by seizing the Congo. He wanted the ivory from elephant tusks and, more importantly, rubber for the expanding industries of Europe. Since African slaves were used in the labor-intensive processing of the rubber, there were huge profits to be made.

Leopold's greed was responsible for the deaths of between five and eight million Congolese, often in brutal circumstances. When his motives and methods were finally exposed to the world, he was taken from power. Before his death in 1909, he had lost his private African estate – an area 77 times larger than Belgium.

though he could barely speak the language. He continued his seafaring life, entering the Merchant Navy in 1878, but he often quarreled with the ships' captains on trips he made to the Mediterranean and Australia. During his voyages, he studied for his master's certificate to enable him to become a captain himself, achieving this at the age of 29. Although he regarded this as a personal triumph, he was growing disillusioned with life at sea, "sailing for little money and consideration," and was tempted to become a businessman. Conrad loved all things British – the language, politics, and freedom – and in 1886, he became a British citizen. English was the third language he had learned after Polish and French.

JOURNEY INTO HELL

Conrad returned to London in 1889, after a trip exploring the Far East. He had experienced all sorts of adventures, but was penniless. Despite having never written anything longer than a letter, and then usually in French, he began his first novel in English, *Almayer's Folly*. Later that year, he returned to Poland to visit his uncle. On the way, he met Marguerite Poradowska, his cousin's widow. They immediately became friends and corresponded regularly over the next few years. It was Marguerite who organized his next voyage. It was to take him to Africa, into the "heart of darkness."

Conrad knew at the outset it would be a dangerous trip. The captain he was replacing had been brutally murdered by villagers, his hands and feet cut off and his clothes removed, and was left unburied for three months. For Conrad, sailing up the Congo River "was like traveling back to the earliest beginnings of the world, when vegetation rioted on the earth and the big trees were kings...."

His crew was sick, racked with fever and dysentery. Conrad himself was forced back to England prematurely when he was struck down by acute fever. He stayed in the hospital for six weeks, and he was left with a tendency to malarial gout, which afflicted him on and off for the rest of his life. His generally pessimistic outlook on life was fueled by the Congo journey and by the death of his

uncle in 1894. He decided to give up the sea, turning instead to writing. His first task was to finish *Almayer's Folly*. The book, set in the romantic "Eastern Archipelago," won good reviews, as did the follow-up, *An Outcast of the Islands*. At the same time, Conrad's personal life changed.

A NEW PARTNER

In 1896, he married Jessie George, a typist 16 years his junior. Her calm personality complemented his restless and intense temperament. They started married life in northern France, where he wrote and she typed out the manuscripts. But his malarial gout and depression drove them back to England. Here he began work on *The Rescuer* and finished his long seafaring tale, *The Nigger of the Narcissus*. This and other novels, such as *Youth* and *Typhoon*, made use of the real events and people encountered in his seafaring days, but he reworked them to bring out their universal significance. The nearer a piece of writing approached art, he wrote, "the more it acquires a symbolic character."

Conrad had chosen to write in his third language, and described the process as "hauling English sentences out of the black night." He frequently had writer's block, when he might sit down for a day's work, complete three sentences, which "I erase before leaving the table in despair." Lack of money was also a problem during most of his writing life, but this was made bearable by having a quiet home and good friends. He rented a farmhouse – Pent Farm in Kent, southeast England – from his fellow writer Ford Madox Ford, from 1898 to 1907. This brought him into contact with authors such as H. G. Wells, Henry James (*see page 6:792*), and Rudyard Kipling, who all lived nearby.

When he married Jessie, Conrad had insisted that they would not have any children. But a son, Borys, was born in 1898. Conrad was not always a dutiful father, but he and Borys became close. At Pent Farm, Conrad produced some of his finest novels, including *Lord Jim* and *Heart of Darkness*, and many short stories. *Heart of Darkness* was inspired by his disturbing journey up the Congo to a place beyond the reach of civilization.

After six years at the farm, events turned against him. He had hoped that his novel, *Nostromo*, set in an imaginary central American republic, would bring in money at last, but the public shunned it on its publication in 1904. The strain of writing it had made him sick, and Jessie was semi-crippled after injuring her knee. When he lost part of his savings in a banking disaster, his nerves were stretched to their limit. His depression was temporarily alleviated by a government grant, however.

With *The Secret Agent*, Conrad attempted to hit the best-seller list. But the book's structure and language were too complex for the general public. Meanwhile, his need for financial security had been increased by the birth of a second son. Conrad moved his family three times between 1907 and 1910, fell out with his friend Ford Madox Ford, and had such a violent argument with his agent that he collapsed on his return home. He suffered a complete nervous breakdown.

Gradually he recovered, but his pessimism deepened and his creative powers started to wane. Ironically, however, he now began to reap the

KEY DATES

1857 *born in Poland*

1862 *family exiled to Russia*

1865 *mother dies*

1869 *father dies*

1874 *leaves Poland for Marseilles, France*

1878 *enters British Merchant Navy*

1886 *passes master's certificate; gains British citizenship*

1889 *starts writing*

1896 *marries Jessie George*

1900 Lord Jim *published*

1902 Heart of Darkness *published*

1913 Chance *published*

1924 *dies in Kent, England*

Master Mariner's Certificate
In 1886, after the second attempt, Conrad gained his master's
certificate, which enabled him to captain a ship.

rewards of his long and arduous labor. An admirer persuaded the editor of the *New York Herald* to serialize Conrad's novel, *Chance*, in 1913. It was a sensational success and Conrad suddenly became famous on both sides of the Atlantic.

In 1914, he went back to Poland, but the trip was curtailed by the outbreak of World War I. Initially he was enthusiastic about the war, but this soon turned to disillusionment. He dedicated *The Shadow Line* (1917) to his son Borys and all his fellow-soldiers then serving in the trenches. When the war was over, Conrad rounded off 23 years of intermittent work by completing *The Rescue*.

In 1923, at the age of 66, Conrad made his first visit to the United States as one of Britain's most distinguished writers. He was a reluctant celebrity, who shunned the cameras and preferred to give private talks rather than public lectures. His audience was hypnotized by his powers of storytelling.

Back in England, he sat for the sculptor Jacob Epstein, and was offered a knighthood, which he rejected. Epstein noted he was "crippled with rheumatism, crotchety, and ill. He has said to me, 'I am finished.'" Years of worry and malarial gout had taken their toll, and Conrad died of a heart attack on August 3, 1924, in Kent. He had chosen his own epitaph, a quotation from the Elizabethan poet Edmund Spenser: "Sleep after toil, port after stormy sea, / Ease after war, death after life, does greatly please."

Conrad's Philosophy

Readers are enthralled by Conrad's tales of high drama but sometimes find the bleak philosophy that underlies them hard to understand.

Conrad used his experiences of life at sea to explore life's inner meaning. For him, the novelist's calling was as difficult as the seaman's. He considered art "a single-minded attempt to render the highest kind of justice to the visible universe, by bringing to light the truth … underlying its every aspect." It was this high conception of art that made writing such a torment for Conrad. He imposed strict controls on his style, continually searching for the sentence that perfectly expressed his ideas.

> "There is nothing in the world to hold on to but the work that has to be done …"

He was looking for "the perfect blending of form and substance," and took endless pains with the "shape and ring of sentences." At the same time, his very difficulty perhaps gave rise to the characteristic "voice" of a Conrad novel, captivating the reader with its intimacy as well as the tension of the story. His narrator in *Lord Jim* and *Heart of Darkness* is the seaman Marlow, whose spirit seems to be "speaking through his lips" while his body acquires a strange stillness. Conrad's single-mindedness also demanded strict working methods. He insisted on complete silence when he was writing.

Conrad inherited his bleak view of life from his father. The universe had no intrinsic meaning for him. Within the universe, human civilization represented a definite achievement, but one which was temporary and constantly under threat. Human virtue was equally at risk in Conrad's eyes, particularly when the "good" man or woman departed from the path of civilization. Jim in *Lord Jim* and Kurtz in *Heart of Darkness* are two examples of men with admirable qualities whose downfall occurs because they venture into savage places and are drawn into extreme situations, which reveal their lack of inner strength. Marlow is powerfully drawn to Kurtz, but the difference between them is that Marlow has to keep his boat on course, and in the heart of darkness that is the key to sanity and survival.

Conrad was able to withstand his own profound pessimism because he believed that inner strength and discipline can save humankind. In the conclusion of *Heart of Darkness*, he ponders on what makes people carry on in a meaningless world: "There is nothing in the world to hold on to but the work that has to be done on each succeeding day. Outside that there is nothing … but what each man can find in himself." For Conrad it was his seafaring and then his writing which carried him through.

Although his material was often romantic, Conrad's sophisticated treatment of it disconcerted contemporary readers and restricted his appeal in his own time. He used techniques of irony and shifts in time, and often ignored the most thrilling moment of a narrative. Although he did achieve late success, his philosophy and modernist literary approach were more in tune with a later generation, who accorded him lasting popularity and classic status.

Salvador Dalí

Salvador Dalí, the most flamboyant artist of the 20th century, claimed to be the only authentic member of the Surrealist movement. His writings and statements were often as controversial as his paintings.

Salvador Dalí was a dandy and a self-publicist. He claimed: "It is difficult to hold the world's interest for more than half an hour at a time. I myself have done so successfully every day for 20 years." The bizarre, dreamlike images he painted with great technical skill rank among the unforgettable works of 20th-century art.

AN EXTRAORDINARY PERSONALITY

The son of a prominent notary, Salvador Dalí was born on May 11, 1904, in Figueras, Catalonia, in northeast Spain. As a young boy, his bizarre behavior and refusal to learn anything at school suggested that he was an extraordinary but abnormal personality. Anything strange or out-of-the-ordinary that happened was always attributed to him. "He is really mad," his teachers would say, an assessment which Dalí savored all his life. He was later to say: "At the age of six, I wanted to be a cook. At seven, I wanted to be Napoleon. And my ambition has been growing ever since."

By the time he entered the School of Fine Arts in Madrid in September 1921, he had produced a number of paintings and won two prizes. He studied, sketched at the Prado museum, and devoted himself to perfecting his technique. He familiarized himself with the new art movements that were blossoming in Paris, discovering the Cubist works of Picasso (*see page 972*) and the strange, deserted Italian squares, arcades, and towers in the paintings of Giorgio de Chirico.

Dalí read Sigmund Freud's *Interpretation of Dreams*, which explores the unconscious. The psychoanalyst's theories convinced him that his wildest dreams and nightmares made sense. The standard of teaching at the School of Fine Arts failed to live up to his expectations. In 1923, he was suspended for a year for an act of insubordination. On his return, he continued his previous lifestyle, buying expensive clothes and jewelry which he charged to his father. His rebellious attitude again brought him before the disciplinary committee, and he was permanently expelled.

During his years as a student, he made friends with two remarkable compatriots, Federico García Lorca, the poet, and the movie director Luis Buñuel. He subsequently collaborated with Buñuel on the first two Surrealist films, *Un Chien Andalou* and *L'Age d'Or*. These ensured Dalí a place in the first rank of the Surrealists when he eventually settled in Paris.

THE SURREALISTS

Initially, Dalí was influenced by the work of the Italian Futurists. Then he tried his hand at painting in the style of the Dutch artist Vermeer (*see page 2:276*), before turning to the unsettling dream imagery of de Chirico. Inspired by Picasso, whom he met on a brief visit to Paris in 1926, he also

Salvador Dalí: Sam Schulman
The artist in a typical self-publicizing pose in 1942.

BACKGROUND

Surrealism

The Surrealist movement flourished in France in the years between World War I and World War II. One of the most controversial aesthetic movements of its day, it was characterized by a fascination with the bizarre and incongruous. Its subject matter was satirically described by the novelist Evelyn Waugh in *Put Out More Flags* as "bodiless heads, green horses, and violet grass, seaweed, shells, and fungi, neatly executed, conventionally arranged in the manner of Dalí."

The first theoretical foundations of the Surrealist movement were laid in 1924, under the direction of André Breton, the French poet. Heavily influenced by Sigmund Freud, the Surrealists began to explore the depths of the unconscious as the source of all art. Dreams and free association became the means to discover a new reality. In the *First Surrealist Manifesto*, Breton described Surrealism as "pure psychic automatism … intended to express, verbally, in writing or by other means, the real process of thought; thought's dictation, in the absence of all control exercised by reason, and outside all aesthetic or moral preoccupation." Intuition ruled. The stream of consciousness could manifest itself in automatic writing, in fantasies, and in dreams. By 1925, Breton's interpretation had altered slightly, and he believed that visual art could also be an instrument of discovery.

Breton and the Surrealists were anxious to promote artists of the past whose work had traditionally been neglected or misunderstood. They looked on some of them as forerunners of their movement, and considered the Flemish artist Hieronymus Bosch (c.1450–1516) as the most important of the visionary painters. Bosch's work revealed realms of the imagination that they were intent on exploring as a means of undermining the repression of reason. Surrealism broke up as an organized movement during World War II. But its spirit lived on, inspiring subsequent movements such as Abstract Expressionism.

produced a number of Cubist canvases. But he found the discipline of painting in the Cubist style restricting. He had an overwhelming desire to unite his painting with his inner visions. Surrealism was to be the answer. When he went to live in Paris in 1929, Dalí was immediately accepted into the social life of the city. He joined the Surrealists and met André Breton, their founder. He read their manifesto and attended their discussions.

When he was offered a Paris exhibit, he returned to his parents' home in the village of Cadaqués, where his impulse was to capture the strange images that were taking possession of his mind. He was determined to reproduce his disturbing visions with absolute clarity. Dalí's mental state was the cause of some concern. The Surrealist poet Paul Eluard and his Russian-born wife Gala, who were visiting Cadaqués, were distressed by his convulsions and bursts of hysterical laughter. It was suggested that Gala could help him. This was the beginning of a great love affair between Dalí and Gala, and when Eluard left, she remained behind. She became Dalí's constant inspiration and the couple married in 1934.

When Dalí's new works arrived in Paris, there was no doubt that he brought fresh insights to Surrealism. Breton wrote: "It is perhaps with Dalí that all the great mental windows are opening." The imagery that he was producing had its origins in psychoanalysis. For the first time, Dalí used both the dream narrative and the automatism that had dominated the early years of Surrealism. With ceaseless invention, he rediscovered Art Nouveau and evolved what he called the "paranoiac-critical method" of looking at art. He recognized hidden meanings in religious works such as Jean François Millet's painting, *The Angelus*.

Dalí's inventive humor kept the Surrealist movement in an uproar throughout most of the 1930s. He was always the dominant figure in major Surrealist exhibits in various capital cities. On the occasion of the International Surrealist Exhibit in London in 1936, he gave a lecture in a diving suit while holding two Russian wolfhounds on a lead. His words were inaudible and he nearly suffocated before someone removed the helmet. The following year he painted one of his most famous images, *The Metamorphosis of Narcissus*.

THE WRITER

Dalí involved himself in every aspect of creative thought. Apart from poems and essays, he wrote a book every two years. The writer George Orwell described his *Secret Life of Salvador Dalí* as "a striptease act conducted in pink limelight."

As the political atmosphere of the 1930s developed, Dalí, who had expressed admiration for Hitler, resolved to stay aloof from the left-wing Surrealists' opposition to Fascism. At the same time he painted a picture of a nurse sitting in a pool of water wearing a swastika armband. Outraged, Breton called a meeting of the Surrealists. Many of the group were inclined to expel Dalí, but not everyone agreed. The scandal petered out. Thereafter, Dalí ceased to attend official meetings or contribute to exhibits.

Around 1938, he began to react against his early work. He announced he was returning to classicism. From now on, it was not to be exper-

KEY DATES	
1904	*born in Figueras, Spain*
1921	*enters the School of Fine Arts, Madrid*
1926	*visits Paris; meets Picasso*
1929	*officially joins the Surrealists*
1931	*paints* The Persistence of Memory
1934	*marries Gala*
1936	*represented in the International Surrealist Exhibit, London*
1937	*paints* The Metamorphosis of Narcissus
1940	*goes to America*
1982	*created marquis of Pubol by King Juan Carlos of Spain*
1984	*burned in a fire at his home*
1989	*dies in Figueras*

imentation, but tradition. The sensational publicity surrounding the Surrealists in Paris ensured that Dalí had been made much of when he made his first visit to New York in 1934. His showmanship was the talk of the city. He and Gala returned to the U.S. in 1940, after the fall of France during World War II, and he worked in a variety of jobs. He undertook commissions for window displays, lectured, and developed film scenarios. He created the dream sequence in Alfred Hitchcock's 1945 movie *Spellbound*, and floated an entire orchestra out to sea in a Marx Brothers' film.

Many of the Surrealists who had opposed Nazism also reached America. They resumed their attacks on Dalí. Breton even coined an anagram of his name, "Avida Dollars" (greedy dollars), in protest against his money-making antics. Although he claimed that "the difference between the Surrealists and me is that I am a Surrealist," Dalí had by then turned away from the movement. He embraced Catholicism, and embarked on a series of religious paintings that brought him a wider public.

The Persistence of Memory: Salvador Dalí (1931)

Dalí said he had the idea for these watches when he was eating a ripe Camembert cheese. He wrote that
"the famous soft clocks are merely the soft, crazy, lonely, paranoiac-critical Camembert of time and space."

Dalí and Gala returned to the seaside resort of Cadaqués in the mid-1950s, and paintings continued to emerge from his well-publicized seclusion. Further volumes of his autobiography were published, and fashionable society figures were received at his home.

Dalí was always a controversial figure who defied convention. His father had been a staunch left-wing Republican, opposing the fascist General Franco in the Spanish Civil War, and Dalí had reacted by becoming a fervent monarchist. On one occasion, he even went as far as to seek the approval of the pope for one of his paintings. His devotion to the monarchy was rewarded in 1982, when King Juan Carlos created him marquis of Pubol in recognition of his "exceptional contri-bution to Spanish culture." In his youth, Dalí had adopted a distinctive mode of dress and style. In old age, he was to become a dandified gentleman dressed in old-fashioned clothes.

After the death of Gala in 1984, Dalí's life took on an increasingly weird and tragic cast. He was ill and there were contradictory reports about whether he still painted. After a fire in his bedroom at Pubol Castle, in which he was seriously burned, questions were raised about the people who were supposed to be caring for him. His last years were also marred by allegations about a highly lucrative trade in forged Dalí paintings and drawings. He finally went to live in the tower of the Dalí Museum in Figueras. He died on January 23, 1989, aged 84.

Images from the Psyche

When Salvador Dalí joined the Surrealists in 1929, he was to lead the movement in a new direction. Declaring that his art evolved from a constant, hallucinatory energy, Dalí proposed to paint like a madman rather than a sleepwalker recording his dreams. "The only difference between myself and a madman," he remarked, "is that I am not mad."

Dalí agreed with the Surrealists' use of a form of free expression inspired by dreams. But he saw that the full potential of the strange and often violent images that came into his mind could only be developed in a fully conscious manner. He did not censor the free association of what he saw – but he gave it a concrete reality by applying to it his considerable artistic skill. He was, he declared, painting "handmade photography." By using a photorealist technique, he captured and recorded his inner visions. With meticulous attention to detail, Dalí portrayed a nightmare world in which commonplace objects are changed or deformed to become incongruous and bizarre.

The artist's deep and lasting preoccupation with the writings of Freud and with psychoanalysis led him to develop what he called the "paranoiac-critical method." This was a form of image interpretation which depended on the imagination of the onlooker.

Many of Dalí's obsessions surface in his paintings, for instance his horror of grasshoppers and his traumatic sexual fears. He enjoyed designing objects whose appearance belied their true

> "The only difference between myself and a madman is that I am not mad."

purpose and function. Perhaps the most famous example of this is the sofa he made in the shape of Mae West's lips.

During 1937 and 1938, Dalí produced a number of disturbing paintings in which he explored the use of multiple images, and simulated the disordered mind of the paranoiac. One of the best-known works from this period is *The Metamorphosis of Narcissus*. It draws on the Greek myth of Narcissus, a beautiful youth who fell in love with his own reflection and pined away. Dalí also made his own versions of pious paintings such as Millet's *The Angelus*, transforming the figures of a couple bowed in prayer into a monstrous image of repression.

Dalí made a number of visits to Italy in the late 1930s, strengthening his ties with the Italian tradition. The influence of Botticelli and Raphael (*see pages 1:18 and 114*), as well as his earlier idols, Vermeer and Leonardo (*see page 1:84*), became noticeable in his work: his compositions were now rigidly based on a classical formula, reflecting a more conscious art. Yet, for all his commitment to the Old Masters, he continued his search for new ideas and pictorial experiments.

During the late 1940s and 1950s, Dalí painted a number of religious works which recast traditional devotional images in a radical way. The most famous of these is *Christ of St. John of the Cross*, painted in 1951. It is a startling and moving portrayal of the crucified Christ seen from above, looking down on a barren landscape.

Marcel Duchamp

One of the most influential figures in 20th-century art, Marcel Duchamp radically changed the way people thought about art by liberating it from its conventional boundaries.

Early in his career, Duchamp gave up painting and other conventional forms of artistic expression. Instead, he devoted himself to provocative works that wittily questioned all traditional assumptions about art. A man of great charm, he helped to bring about a revolution that redefined the work of art and put a new emphasis on the role of the artist's creative and mental – rather than physical – processes.

AN ARTISTIC FAMILY

Henri-Robert-Marcel Duchamp was born on July 28, 1887, near the small town of Blainville in Normandy, northern France. His father was a successful lawyer. Marcel was one of six children; he had three sisters and two elder brothers, both of whom became artists. Their father would have preferred his sons to become lawyers, but he accepted their artistic ambitions. He did not object when his youngest son went to join his brothers in Paris in 1904, at 17. For the next two years, Marcel studied painting at the Académie Julian, one of the most famous art schools in the city.

There could hardly have been a more exciting time to be an art student in Paris: Fauvism burst on the world in 1905, and Braque and Picasso (*see page 972*) began creating Cubism in 1907. These and other movements overturned the traditional idea of painting as something that imitated what is seen in the real world; the artist could now create something that was more the fruit of the imagination than of observation. From the beginning of his career, Duchamp was interested in art as a vehicle for ideas. He had little interest in the manual aspect of painting – in skilled craftsmanship or precise brushwork.

In his early paintings, Duchamp experimented with various styles, particularly Post-Impressionism and Fauvism. He first exhibited his work in public in 1909. By 1911, he was painting in a Cubist style, and in that year, he produced his first truly original work, *Nude Descending a Staircase, No. 1*. This shows a stylized, semi-abstract, machine-like figure represented in motion, in the manner of high-speed, multiple-exposure photography. The following year, he made a more dynamic and sophisticated version of the subject.

Nude Descending a Staircase, No. 2 (1912) was the work that established Duchamp's reputation as a controversial artistic figure. After being rejected by an exhibiting society in Paris, it created a stir in New York in 1913, when it was displayed at the Armory Show. This massive exhibit received enormous publicity and put modern art on the map in America. Duchamp's picture was probably the most discussed work in the show: one painter and critic, Guy Pène Du Bois, said that this was because "it was the most incomprehensible. It was the most incomprehensible because its title was misleading. There were plenty of equally

Marcel Duchamp: Hans Bellmer
This 1955 portrait shows the artist at 68.

BACKGROUND

BACKGROUND

Dada

Duchamp was an original founder of Dada, one of the strangest but most influential artistic movements of the 20th century. Dada broke with traditional ideas of what constituted art and delighted in things that were irrational, absurd, or shocking. The movement arose more or less simultaneously in New York and Zurich, Switzerland, in about 1915. Both cities were in countries that were not then involved in World War I, and many artists and intellectuals took refuge in them. The anarchic spirit of Dada has been seen as a response to the despair caused by the horrific carnage of the war. It was deliberately antagonistic and nihilistic: at an exhibit in Cologne in 1920, for example, an axe was provided for spectators to smash up the exhibits.

mysterious pictures, but none in which the promise of the title was so definitely unfulfilled."

Predictably, there were some sarcastic remarks made about the painting; two of the most quoted comments were that it looked like "an explosion in a shingle factory" and "a pack of brown cards in a nightmare." There were also more appreciative views, however, and the picture's fame quickly spread. It was so controversial that a dealer in San Francisco bought it for $324 without even seeing it. Suddenly, Duchamp was a name to be reckoned with, and much better known in America than he had ever been in France.

In 1915, during World War I, Duchamp left France and moved to New York. He was greeted by reporters when he arrived and was warmly received in intellectual circles. Various dealers wanted to handle his work but he refused their offers, showing disdain for money-making as an end in itself. He supported himself by giving French lessons and worked in a studio provided by a wealthy art-collecting couple, the Arensbergs.

Duchamp's friends in America included Man Ray, an American artist who became known as a highly original photographer, and Francis Picabia, a French painter. These three formed the nucleus of the Dada movement in New York. Dada, which lasted from about 1915 to 1922, was intended to shock and scandalize.

While Dada artists in Europe were often violent in their approach, Duchamp and his colleagues in America tended to be more whimsical. Duchamp had by now virtually given up painting. His great contribution to Dada was the "ready-made," a term he coined for works in which he chose a mass-produced article and displayed it as a work of art. Duchamp began producing such works in 1913, when he exhibited *Bicycle Wheel* — a bicycle wheel mounted on a kitchen stool. The "ready-made" was to prove an enduring influence on modern art. Less than 50 years later, many Pop artists would include household products in their works.

FOUNTAIN

Duchamp's most famous — or notorious — ready-made was *Fountain*, exhibited in 1917, which consisted of a factory-made urinal bowl that he signed "R. Mutt," based on the name of the manufacturer. Duchamp submitted it to the Society of Independent Artists — an association he had helped to found in New York to give progressive artists a place to show their work — but it was rejected. Duchamp defended his creation, writing: "Whether Mr. Mutt with his own hands made the fountain or not has no significance. He chose it. He took an ordinary article of life, placed it so that its useful significance disappeared under a

new title and point of view … [He] created a new thought for that object."

In 1919, Duchamp produced another of his infamous works debunking the values of the art world: he drew a mustache and beard on a reproduction of Leonardo da Vinci's *Mona Lisa (see page 1:84)*, and added a rude inscription. It expressed his view that art had become too rarefied and expensive. Duchamp revived this joke years later, when he signed a print of the *Mona Lisa* that was unaltered apart from the fact that he had inscribed it with *rasée* – the French word for "shaved."

A RADICAL WORK

In 1920, Duchamp returned to New York, where he lived until 1923. During this period, he worked mainly on a large and enigmatic construction entitled *The Bride Stripped Bare by her Bachelors, Even,* also known as *The Large Glass*. Plans for this work went back to 1912, but Duchamp always worked at his own unruffled pace. "I've never been able to work more than two hours a day," he once said. In 1923, he abandoned the work as "definitively unfinished," but it was shattered while being transported in 1926. Ten years later, Duchamp repaired it, incorporating the cracks as part of the image.

The Large Glass is a window-like structure of upper and lower glass panels embellished with oil paint, lead wire, and tinfoil. Duchamp uses elaborate machine imagery to express his vision of the futility of sex. One scholar wrote that it "holds a substantial claim to be the most complex and elaborately pondered art object that the 20th century has yet produced" – but to many others, it is an incomprehensible joke.

In 1923, Duchamp moved back to Paris. Both his parents died in 1925, leaving him a legacy that made him even less inclined to work. Instead he devoted himself to chess, which became an overwhelming passion. In 1927, his obsession with the game ruined his first marriage. Man Ray wrote of the shortlived union with Lydie Sarzin-Lavassor: "Duchamp spent most of the one week they lived together studying chess problems, and his bride, in desperate retaliation, got up one night when

he was asleep and glued the chess pieces to the board. They divorced three months later."

With his aristocratic looks, charm, and wit, Duchamp was attractive to women, and one of his friends wrote that he "could have had his choice of heiresses." He had a long relationship with a wealthy American, Mary Reynolds, that lasted until her death in 1950, and in 1954, he made a happy second marriage to Alexina Sattler.

Although Duchamp seemed to have abandoned artistic work, in fact he had been experimenting with rotating colored discs that anticipated both Kinetic art – based on the idea that light and movement can create a work of art – and Optical art, in which the artist creates optical effects that persuade the spectator to see visual illusions. He also organized exhibits of avant-garde art in both Europe and America. In 1920, with Man Ray and the wealthy patron Katherine Dreier, he had founded the Société Anonyme – "incorporated corporation" – in New York for the promotion of contemporary art. It organized exhibits and lectures, and amassed a collection of modern art.

KEY DATES

1887 *born in Normandy*

1904-06 *studies painting at Académie Julian, Paris*

1911 *paints* Nude Descending a Staircase, No. 1

1913 *exhibits* Nude Descending a Staircase, No. 2; *exhibits first* "ready-made," Bicycle Wheel

1915 *moves to New York*

1917 *exhibits* Fountain

1927 *marries and divorces Lydie Sarzin-Lavassor*

1942 *settles permanently in New York*

1954 *marries Alexina Sattler*

1955 *becomes U.S. citizen*

1968 *dies in Neuilly, near Paris*

L.H.O.O.Q: Marcel Duchamp (1919)
Duchamp drew a mustache on this reproduction of Leonardo's Mona Lisa
(c.1500) in an act of irreverence which added to the artist's notorious reputation.

Duchamp settled permanently in New York in 1942, and became an American citizen in 1955. By this time he was nearly 70 and had long ceased to be a central figure in the art world. From about 1960, however, his work and ideas were rediscovered by progressive artists, and he spent his final years honored as a kind of patron saint of modern art. Near the end of his life, Duchamp revealed that he had been engaged for the past 20 years on a major work, *Given: 1. The Waterfall, 2. The Illuminating Gas.* This construction features a painted sculpture of a nude woman holding a gaslamp, with a simulation of a waterfall behind.

During a visit to France, Duchamp died on October 2, 1968, in the Parisian suburb of Neuilly. He was 81, and was buried in Rouen.

Constantin Brancusi (1876–1957)

After Duchamp virtually gave up producing art himself in 1923, he turned instead to promoting the work of other artists. One of the contemporaries he most admired was the Romanian sculptor Constantin Brancusi, who settled in Paris in 1904.

Brancusi had walked to Paris from Munich because he was so poor. He endured several more years of hardship before his career began to take off. He was initially influenced by the great sculptor Auguste Rodin (*see page 5:672*), but declined an offer to work in his studio. By 1904, he was more concerned with abstract shape.

Like Duchamp, Brancusi made a breakthrough at the Armory Show of modern art in New York in 1913; six of his sculptures were shown and they helped to establish his reputation. The following year, Alfred Stieglitz, a photographer and art dealer who was one of the major supporters of avant-garde art, gave him a one-man show at his New York gallery.

Brancusi believed that "What is real is not the external form but the essence of things," and in his work he simplified the shapes of objects and smoothed their surfaces so that they became almost completely abstract. He worked in stone,

Mlle. Pogany: Brancusi (1912–13)
"What is real is not the external form but the essence of things."

bronze, and wood, and was a masterful craftsman. He made several versions in both bronze and marble of his most famous works, *Mlle. Pogany* and *Bird in Space*.

In 1926, Duchamp helped to organize an exhibit of Brancusi's work at the Brummer Gallery, New York. This show gave rise to one of the most famous scandals in modern art. When Brancusi's sculpture *Bird in Space* entered the country, the U.S. Customs Office refused to recognize it as sculpture because it was almost completely abstract. While sculpture was duty-free, tax had to be paid on raw metal, which is what the Customs Office insisted it was. Brancusi paid the tax in order to get the sculpture released for the exhibit, but later he successfully sued the Customs Office. The victory helped bring about the acceptance that abstract art was indeed art.

By the end of his career, Brancusi was regarded by many people as the greatest sculptor of the 20th century. He had an enormous influence on other sculptors. One of them – the Englishman Henry Moore (1898–1986) – said of him: "It has been Brancusi's special mission to … make us once more shape-conscious."

James Joyce

Virginia Woolf described Joyce's work as that of "a queasy undergraduate scratching his pimples," but he has a strong claim to be the most important 20th-century novelist writing in English.

Joyce was recognized in his lifetime as a major writer by many of his contemporaries, including W.B. Yeats, Ezra Pound, T.S. Eliot, and Ernest Hemingway (*see pages 8:1040, 638, and 1074*). His subsequent influence has been enormous, even on writers who write in a completely unrelated manner. The novelist George Orwell commented that he wished he had never read *Ulysses* because it gave him "an inferiority complex."

Joyce's influence on the development of the novel in the English language has been crucial in determining the possibilities of style and forms of writing ever since. Increasingly experimental in style, his novels challenge the certainties of most readers and push the form to its limits.

EARLY LIFE

James Augustine Aloysius Joyce was born in Dublin on February 2, 1882, one of ten surviving children of John and Mary Joyce. John Joyce was a feckless character who gradually frittered away the family fortune, necessitating a series of stealthy moves to escape debt collectors. Nevertheless, Joyce was indulgent toward his father in his fiction, and commented in a letter: "I was very fond of him always, being a sinner myself, and even liked his faults."

Joyce attended a number of Jesuit schools. He went to University College, Dublin, graduating in 1902. He was a brilliant linguist, but performed erratically at college, only studying what interested him. He cultivated the company of the Dublin literati, including W.B. Yeats. Growing weary of the insularity of Irish intellectual life, however, he left for Paris after graduation.

In Paris, Joyce read widely, and started to develop his interest in experimental prose techniques, notably the "stream-of-consciousness" which was inspired by his reading of the French novelist Édouard Dujardin. This important modernist literary device involves the novelist representing the characters' thoughts as if they were occurring without interference from the writer and simply appearing on the page. Ordinary logic or sentence structure is generally abandoned.

Joyce returned to Dublin in 1903, when his mother died. There, he met the woman who would be his lifelong partner, Nora Barnacle. Thereafter, his visits to Ireland were infrequent. His last trip was in 1912, some 28 years before he died.

Joyce and Nora left Ireland in the fall of 1904, eventually settling in Trieste, Italy, where Joyce taught English at the Berlitz school. He started work on a number of projects, including Stephen Hero, the first draft of a novel which was to become *A Portrait of the Artist as a Young Man*. Joyce was also writing a number of poems which were collected in his first publication, *Chamber Music*, in 1907, and some short stories which developed into the controversial *Dubliners*.

James Joyce: Jacques-Emile Blanche
A portrait of the writer painted in 1935.

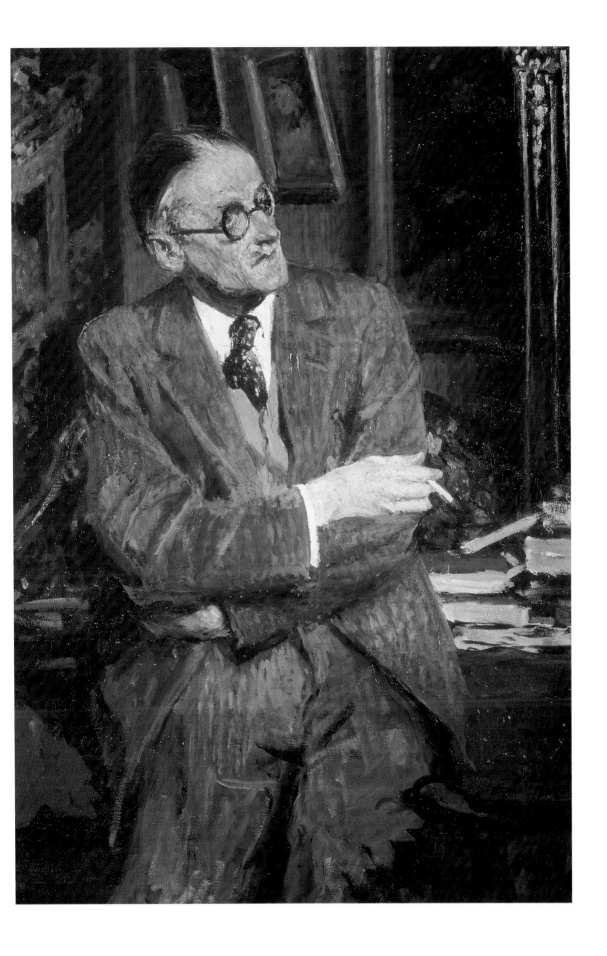

Dubliners saw the first of Joyce's many battles against censorship. It was published in 1914, after nine years of controversy. The publisher feared prosecution because of Joyce's references to female sexuality – in the form of a woman crossing her legs a number of times – the use of the oath, "bloody," and some unflattering references to the British royal family.

The Joyce family was now growing, with the birth of two children, Giorgio and Lucia, the arrival of Joyce's brother Stanislaus, and later, his sister Eva. Joyce and his brother were often at odds: the more level-headed Stanislaus often became infuriated by James's habitual disregard for money, punctuality, and other people.

Joyce had a brief interlude in Rome, where he worked as a bank clerk, before returning to Trieste. He lived there until the outbreak of World War I. He was revising *Stephen Hero* and developing it into *A Portrait of the Artist as a Young Man*. He also met Ezra Pound, the foremost American modernist poet, who was enthusiastic about Joyce's work.

A Portrait of the Artist tells the story of Stephen Dedalus, a bright but sickly child, and his attempts to break free of the conventionality which threatens to blight his intellectual development. Although Joyce, like Stephen, left Ireland in disgust, it is significant that all of his works are set in his motherland, and can be read as attempts to forge "the uncreated conscience of his race." This was probably the least experimental of Joyce's works, being a fairly straightforward autobiographical novel.

ULYSSES

Joyce was now experiencing the most productive stage of his life. Ezra Pound reviewed *Dubliners* enthusiastically in the literary magazine, *The Egoist*, and went on to publish *A Portrait of the Artist* in installments between February 1914 and September 1915. Joyce was inspired by the success he had always believed would come his way. He started work on a play, *Exiles*, eventually published in 1918. He also started a new, incredibly ambitious novel, *Ulysses*, which was to turn him into a major literary celebrity.

Ulysses charts one day – June 16, 1904 – in the life of a Dublin Jew, Leopold Bloom. The date is

BACKGROUND

Paris

It is probably no accident that Joyce found Paris the easiest place in which to work, and that the French capital excited him most of all the European cities in which he lived. He described it as "the last of the human cities," a welcome contrast to the restrictions of his home town, Dublin.

In the 1920s, Paris was the capital of European intellectual life, full of expatriate artists and philosophers, receptive to new ideas and tolerant of rebels and iconoclasts. Joyce was able to find people who would support his lifestyle, as well as publish and read his work. Sylvia Beach, who ran the Shakespeare Head Press from her bookshop, was a notable help to many avant-garde writers such as Joyce.

Joyce especially enjoyed the café lifestyle he was able to lead in Paris. The café was the center of literary life, and Joyce was able to consort with many influential writers including Gertrude Stein, Marcel Proust, Ford Madox Ford, and F. Scott Fitzgerald (*see page 8:1056*), who were also attracted to Paris's bohemian atmosphere.

now celebrated as "Bloomsday" by Joyce enthusiasts. It compares Bloom's travels throughout the city to those of Odysseus in the most famous epic in Western literature, Homer's *Odyssey*. The effect of casting common people in the mold of classical heroes showed the limitations of Bloom, his wife Molly, and Stephen Dedalus—hero of *Portrait of the Artist*, who appears again – but at the same time, it made them appear heroic. The style of the novel, which varies from the fantastic to the realistic, is full of literary parodies. It put *Ulysses* at the forefront of the literary avant-garde.

GAINING SUPPORT

After the outbreak of war, Joyce and his family were no longer safe in Trieste, so in 1915 they fled to Zurich. Pound and Yeats were instrumental in obtaining a grant from the Royal Literary Fund to enable Joyce to continue writing – something of an irony considering his constant battles with the authorities over what he wrote.

Joyce was supported by Harriet Shaw Weaver, a wealthy publisher and editor of *The Egoist*, who had been bold enough to publish *A Portrait of the Artist*. She was to keep an eye on the chaotic affairs of the Joyce family over the years.

Thanks to these efforts, Joyce was able to give up teaching. He had completed the first three chapters of *Ulysses* by the end of 1917. They were serialized in the *Little Review*, an American literary periodical. Joyce also had to undergo the first of many eye operations, due to a severe attack of glaucoma. Some critics have suggested that his fondness for aural rather than visual imagery in his novels may have stemmed from his exceptionally poor vision.

FINNEGANS WAKE

After the war, Joyce returned to Trieste where he continued to work on *Ulysses*. In 1920, Pound persuaded the Joyces to move to Paris where they lived for the next 20 years. That same year, a court case prevented the *Little Review* from continuing its serialization of *Ulysses*, but the novel was even-

KEY DATES	
1882	*born in Dublin*
1902	*graduates from University College, Dublin; leaves for Paris*
1904	*meets Nora Barnacle; leaves for Trieste*
1914	Dubliners *published*
1915	*moves to Zurich*
1916	A Portrait of the Artist as a Young Man *published*
1920	*moves to Paris*
1922	*publication of* Ulysses *in Paris*
1923	*begins work on* Finnegans Wake
1931	*marries Nora*
1933	Ulysses *published in New York*
1939	Finnegans Wake *published*
1940	*flees to Zurich*
1941	*dies in Zurich*

tually published in Paris in 1922. Joyce now began to work on a new project, simply titled "Work in Progress," which was to become *Finnegans Wake*. This long novel tells the story of one night in the life of H.C. Earwicker, a Dublin shopkeeper, and his wife, Anna. It pushed Joyce's experimental techniques to their limits, to say nothing of even his most enthusiastic readers' patience, and relies on a series of puns, "portmanteau" words – ones which combine two other words to create a new word – and sophisticated literary allusion.

The major theme of *Finnegans Wake* is the inevitable cycle of life, death, and resurrection, and the book contains some of the most accomplished writing in English. It could also lay claim to being the most difficult work in the language. In *Ulysses*, Joyce had started to break down the ordinary, conventional rules of English sentence structure; in *Finnegans Wake*, he turned his attention to individual words.

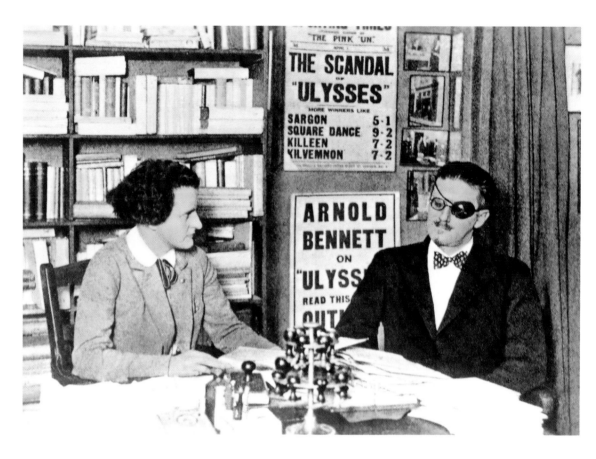

Sylvia Beach and James Joyce (c.1922)
Sylvia Beach published Ulysses *in complete form in 1922 from Paris. Copies of two English editions were burned by the English and American authorities. America declared that* Ulysses *was not obscene in 1933.*

The Joyces lived a relatively orderly life in Paris. Joyce himself was hard at work on his *magnum opus*, which was being serialized in the magazine *transition*, stopping only to enjoy Parisian society, where he indulged in drinking bouts with artistic friends such as the Irish playwright, Samuel Beckett (*see page 923*). A small volume of poems, *Pomes Penyeach,* was published in 1927. Joyce finally married Nora in London in 1931.

DECLINING HEALTH

Joyce's health was deteriorating and he had many eye operations for his rapidly failing sight. In 1932, his daughter Lucia had a mental breakdown; her problems were to occupy much of Joyce's time and money for the rest of his life. Like his father,

Joyce lost what financial security he had once had. In 1933, however, the American courts finally allowed *Ulysses* to be published, and Lucia entered a Swiss hospital. In 1939, *Finnegans Wake* was published in London and New York.

With the outbreak of World War II, the Joyces were forced into exile for the second time, and returned to Zurich in 1940. Joyce's fragile health finally gave out, and he died after an operation for a perforated ulcer on January 13, 1941, aged 58.

Although Joyce and Nora's relationship had often been stormy, and although she disapproved of what little she had read of his works, she was their stout and loyal defender. She missed him badly after his death, complaining: "Things are very dull now. There was always something doing when he was about."

Samuel Beckett (1906–1989)

Joyce's most important influence was upon Samuel Beckett, the Irish playwright and novelist who won the Nobel Prize for Literature in 1969, and who has been one of the most important writers in postwar Europe. Beckett graduated from Trinity College, Dublin, in 1927, and spent almost all of his subsequent life in Paris. He worked as Joyce's assistant. In the course of their relationship, Joyce's daughter, Lucia, formed an unreciprocated passion for the young writer.

Beckett shared with Joyce the desire to experiment with language and literary form. Beckett's early work, such as *More Pricks than Kicks* (1934), shares much of his mentor's allusive richness and delight in linguistic tricks like puns and neologisms – a new word, usage, or expression. Beckett's later development of a economical and spartan style is indicative of his need to escape from the influence of Joyce.

Like Joyce, Beckett remained in obscurity for much of his early life. In 1938, his first novel, *Murphy*, sold poorly, and it was not until the 1950s that he became a dominant literary force. Beckett's most ambitious fictional project was his trilogy: *Molloy* (1951), *Malone Dies* (1951), and *The Unnameable* (1953). He produced other significant works, notably *How It Is* (1961).

Samuel Beckett
The writer attending a first night performance in 1970, at 64.

Beckett's plays are better known, and he is most famous for *Waiting for Godot* – first performed in France in 1953, and in England two years later – which brought him to the attention of a wider public. The play depicts two tramps, Vladimir and Estragon, who wait beside a tree for Godot to arrive, believing that his presence will give meaning to their empty lives. Two acts later, they are still in exactly the same situation.

Beckett's plays are often classified as examples of the theater of the absurd, which shows men and women alone in a hostile universe, whose events they have no hope of understanding. He invariably replaces conventional stage designs with bleak settings, intended to emphasize the ridiculous nature of human existence. *Endgame* (1957), for example, has its protagonists buried inside trashcans. Beckett's other notable plays include *Krapp's Last Tape* (1958), *Happy Days* (1961), and *Not I* (1973). He became notorious after the production of *Footfalls* (1976), which lasts less than a minute.

Although seen by many as a gloomy philosopher detailing the misery of humanity struggling against the meaninglessness of life, Beckett's work, like Joyce's, contains much humor. Samuel Beckett died in 1989.

Wassily Kandinsky

One of the first abstract artists of the 20th century, Kandinsky only began to paint at the age of 30. The new style he created changed the history of modern art.

The first artist to consciously reject the object in his art, Kandinsky spent his life working out a different means of expression in painting. His work altered the course of 20th-century art. But at the time, his efforts to create abstract art were met with distrust, even ridicule, and the widespread assumption was that his art was meaningless. Despite such criticism, Kandinsky continued to refine and perfect the language of abstraction.

THE MAGIC OF MOSCOW

Wassily Kandinsky was born on December 4, 1866, in Moscow, where he spent his early childhood. The city's color and atmosphere haunted him for the rest of his life. Later he fondly recalled "the hard red, unshakeable, and silent ring of the Kremlin walls," and "the slender-white, gracefully devout, and serious bell tower of Ivan the Great." His father was a prosperous tea merchant, and his mother a beautiful Muscovite whom Kandinsky referred to as "golden-haired Mother Moscow."

In 1871, the family moved to the Ukraine. His parents divorced shortly thereafter. The boy's aunt took his schooling in hand, and he received a good classical education. Despite revealing a talent for music and painting, the young Kandinsky decided on the more acceptable profession of law. At Moscow University from 1886, he proved to be an exceptionally bright student. After graduating in 1892, he was immediately given a teaching appointment at the Moscow Law School. Yet in the back of his mind, he always suspected that he would find more fulfillment in art than in the mental discipline of his law studies. In 1896, he married his cousin, Anja Chimiakin.

THE PAINTING STUDENT

Despite his respectable legal career, in 1896, at the age of 30, Kandinsky made a momentous decision – to commit himself wholeheartedly to painting. The previous year, he had been stunned by Claude Monet's *Haystacks (see page 5:660)* at an exhibit of the French Impressionists in Moscow. Ignorant of this exciting new style of painting, Kandinsky had scarcely recognized the subject matter of Monet's paintings, but they revealed to him the expressive power of pure color.

This event proved to be the inspiration Kandinsky needed, and in 1896, he set off to study in Munich, then a thriving artistic center. "The drudgery is behind me," he declared, "before me lies the kind of work I like." With a private income from his father, Kandinsky enrolled as a student at Anton Azbe's school. He found the study of anatomy tedious, however, and would frequently skip classes to paint from memory at home, or to sketch city scenes. In an attempt to discipline himself, he joined Franz von Stuck's class at the Munich Royal Academy, but Stuck despaired of

Wassily Kandinsky: Gabriele Münter
Kandinsky's partner painted him around 1910.

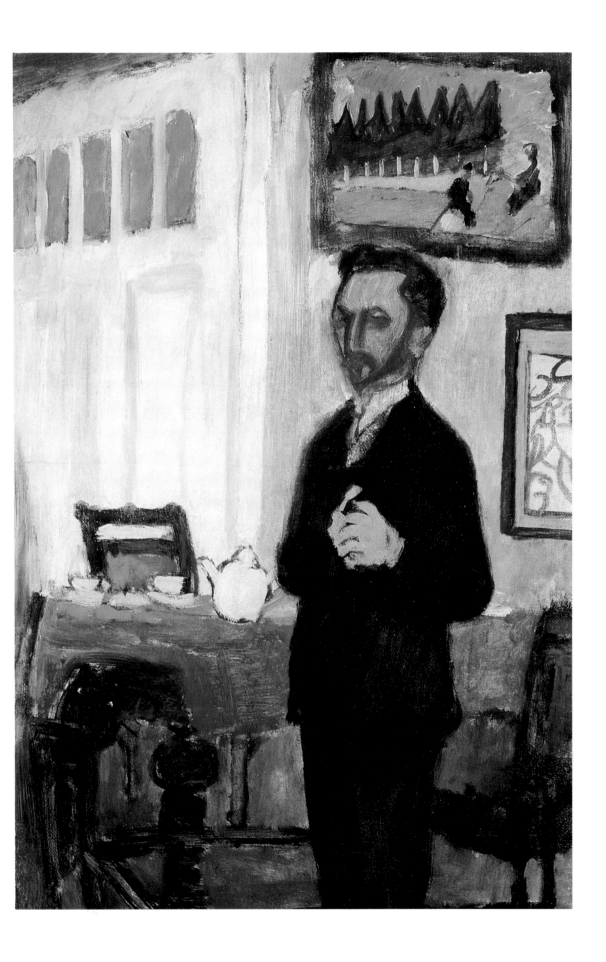

Kandinsky's strident, bold colors and exaggerated effects. At Stuck's class, Kandinsky met the artist Paul Klee (*see page 930*), who was to become a close friend. Klee recalled of their student days: "Kandinsky was quiet and used to mix his colors on the palette with the greatest diligence and, it seemed to me, with a kind of scholarliness...."

Many of his friends described Kandinsky as a reserved man with an aristocratic and scholarly air. Even his studio was unlike that of most painters – it was orderly, even fastidious, with paints and bottles lined up in rows on the shelves. He never had a spot of paint on him while working, and used to joke that he could paint in evening dress.

Kandinsky's allowance meant that he had no immediate need to sell his work, and so was free to experiment with his painting. It also enabled him to indulge in his passion for traveling in order to discover what was happening in other European artistic centers. In 1902, Kandinsky met the painter Gabriele Münter, who became his pupil. After the breakdown of his marriage, she became his mistress. The couple would spend months at a time touring the world, visiting Italy, Switzerland, and even Africa.

BREAKTHROUGH INTO COLOR

During his travels, and also in Munich, Kandinsky carefully studied the work of avant-garde artists. He was inspired by the brilliant, luminous colors of the Fauves – the "wild beasts," a group of French artists who used violent color and distorted shapes – and he began painting landscapes in broad, simplified masses of color that echoed the work of the leading Fauve, Henri Matisse (*see page 954*). These experiments with color marked a breakthrough in Kandinsky's style. Increasingly, he concentrated on reworking the same few motifs, simplifying and abstracting them so that line and

BACKGROUND

The Bauhaus School

"Let us create a new guild of craftsmen without class distinctions that raise an arrogant barrier between craftsman and artist." With these words, Walter Gropius founded the radical new school at Weimar in 1919.

The life of this school was shortlived, however, due to the political unrest at the time. During the 1920s, the new right-wing German government regarded the Bauhaus as a dangerous organization bent on anarchy. Kandinsky, who worked at the school for a short while, and his Russian wife were doubly suspect, and were unjustly denounced in a newspaper as being dangerous agitators. During this unstable period, the entire Bauhaus community elected to move to the more sympathetic climate of Dessau. In 1931, however, the Nazis gained power in the Dessau city council, attacking the Bauhaus as "un-German," cosmopolitan, and Jewish.

In September 1932, the city council voted to shut the school down. On the same day, mobs of Nazis rampaged through the building, breaking up furniture and destroying tools and paintings. The director of the school at this time, architect Mies van der Rohe, tried to transfer the Bauhaus to Berlin, but as Hitler and the Nazis consolidated their power across Germany, all forms of political and cultural opposition to their rule were violently suppressed. On April 11, 1933, the Bauhaus was finally closed.

color, rather than the objects themselves, became the vehicles for emotional expression.

Kandinsky's radical move toward abstraction was a major development in the history of art. According to the artist, however, he discovered the true worth of abstract art by accident. One evening he returned to his studio and was overcome by a beautiful, radiant image that was devoid of any recognizable object. Approaching it, he realized the painting was one of his own, standing on its side. At that moment, he understood that the realistic depiction of objects was no longer important in his art.

CONDEMNED BY THE CRITICS

Kandinsky painted his first completely abstract painting in 1910. His rejection of realistic form dismayed the Munich critics and even some of his friends. Undeterred, in 1911, he founded a new artistic group called Der Blaue Reiter – The Blue Rider – together with the German painter Franz Marc. This new organization was dedicated to encouraging a variety of exciting artistic styles, including abstract painting.

Although by now Kandinsky's paintings were exhibited in many countries, savage attacks on his work continued. When some of the artist's *Improvisations* paintings were shown at the Salon des Indépendants in 1912, a reviewer commented that the works looked as if a dog had dipped its feet or its tail, or both, in the palette, and walked across the canvas. To counteract the growing criticism, and to clarify his intentions, Kandinsky decided to publish a book explaining his color theories and his prophecies for the future of abstract art. *On the Spiritual in Art* has since been regarded as one of the most important writings to influence the emergence of abstract art.

In 1914, with the outbreak of war in Germany, Kandinsky was given just 24 hours to flee the country. Leaving Gabriele behind, he traveled to Russia, where he remained until 1921. In 1917, the Russian Revolution broke out. Over the next years, Kandinsky suffered extreme poverty and hardship, only tempered by his mar-

riage to a young and beautiful Muscovite named Nina de Andreewsky in 1917.

During this turbulent period, Kandinsky produced few paintings. Instead, he busied himself with reorganizing the artistic life of the new communist state. But his ideals of spiritual rejuvenation through the arts were shattered when the communist government clamped down on the Russian avant-garde and demanded cheap art for the proletariat. Feeling alienated, Kandinsky realized he was out of sympathy with communist ideals, and in 1921 he returned to Germany.

TEACHING AT THE BAUHAUS

The outlook in Germany was depressing; Kandinsky was poverty-stricken and two of his close friends – Franz Marc and August Macke – had died during the war. But in 1922, his old friend Paul Klee succeeded in finding the artist a job teaching life classes and mural painting at the

KEY DATES

1866	*born in Moscow*
1886-92	*studies law at Moscow University*
1896	*marries Anja Chimiakin; moves to Munich to study art*
1902	*meets Gabriele Münter*
1910	*first abstract painting*
1911	*co-founder of Der Blaue Reiter*
1912	*publishes* On the Spiritual in Art
1914	*returns to Russia*
1917	*marries Nina de Andreewsky*
1921	*returns to Germany*
1922	*secures post at Bauhaus*
1933	*Bauhaus closes; moves to Neuilly, near Paris*
1944	*dies in Neuilly*

Railroad near Murnau: Wassily Kandinsky (1922)
*This work is composed in patches of color, but is not totally abstract; the railroad, train,
telegraph poles, and even a little girl waving her handkerchief can be recognized.*

Bauhaus, Walter Gropius's radical new school, which aimed to promote the unification of crafts with functional design. The progressive outlook of the Bauhaus school stimulated Kandinsky, and he began to experiment with the varied and even humorous effects he could achieve using the simple geometric elements of the circle, the triangle, and the square. He analyzed the ways in which these elements could be combined, how they reacted to each other, and the responses they evoked in the viewer. These observations and theories were published in his 1926 book, *Point and Line to Plane*.

Kandinsky's newfound preoccupation with geometry marked a crucial turning point in his career, and he began to paint with an increased vigor. But his days at the Bauhaus were numbered, since the Nazi regime ruling Germany regarded the organization as a den of anarchy, and in 1933 forced its closure. Due to the tense political situation, Kandinsky moved to Neuilly, near Paris. Here he saw mostly foreign artists working in Paris such as Jean Arp and Piet Mondrian (*see page 966*).

Kandinsky's move to Neuilly coincided with the final change in his abstract style. The years he spent here are seen as his most controversial. He invented a whole new repertoire of forms. Strange, amoeba-like microbes float in bright background colors. The artist became increasingly reclusive, though he was painting with great exuberance. When World War II broke out in 1939 and materials were hard to get, he gave up large canvases for pieces of wood and cardboard. Throughout a five-year illness, he continued to plan new paintings. But on December 13, 1944, Kandinsky died of sclerosis.

Toward Abstraction

Kandinsky was one of the first artists to consciously reject naturalistic images in his art, relying instead upon the emotional qualities of color. He claimed that objects and narratives were distractions that interfered with the viewer's intuitive response, and concluded that only through abstraction could a totally pure art be achieved. The dilemma he faced was how to replace the object.

Kandinsky believed the true answer lay in the subjective nature of color. Like Monet and the 19th-century English artist J.M.W. Turner (*see page 4:558*), the Russian painter found that color could be used expressively in its own right, rather than merely to depict form. He went one step further, and maintained that color evoked a spiritual response from the viewer. Through color, the artist aimed to awaken a meditative feeling within the spectator. He considered that unless art evoked a deep response from the viewer, it was merely decorative.

Art for Kandinsky was essentially a deeply spiritual experience. He passionately believed that each color had its own characteristic, both physical and spiritual. In his book *On the Spiritual in Art*, he outlined his theories on color. "Color is the keyboard, the eyes are the hammers, the soul is the piano with many strings. The artist is the hand which plays, touching one key or another, to cause vibrations in the soul."

From his early childhood, Kandinsky reacted with unusual sensitivity to color. He possessed abnormally strong visual reactions, and could visualize shape, color, and form at will. He claimed to feel colors as vividly as others feel sound, and even maintained that on occasion he heard hissing sounds coming from his colors. Like the Symbolists, he believed in the "synesthesia" theory, in which colors could be heard and sound could be seen. Kandinsky wanted art to be like music, appealing directly to the senses and having no need to tell a story. Influenced by the composer Arnold Schoenberg (*see page 978*), who was similarly moving toward abstraction in his radical concept of atonality, Kandinsky believed color could be used in the same way as sound.

Today, it is hard to comprehend what an enormous step the artist was taking when he decided to upset the conventions of painting and completely reject the object. But with his bold new language of abstraction, Kandinsky was able to transport the observer into a completely different world of sensation and emotion. This new approach would radically change the course of 20th-century art.

> It is hard to comprehend what an enormous step Kandinsky was taking when he decided to upset the conventions of painting and completely reject the object

Paul Klee

Hailed as one of the most inventive and influential figures in 20th-century art, Paul Klee was a highly original painter, a skilled graphic artist, and one of the finest art teachers of the 20th century.

Innocence is a word that is frequently applied to Klee's art. His dual interest in "naive" and Asian art enabled him to develop a childlike vision, which could transform reality into a magical world of music and poetry. Yet, behind this whimsical facade, Klee was a serious-minded man, and the teaching program that he introduced at the Bauhaus — the revolutionary art college set up in Germany in 1919 — has been widely influential.

A MUSICAL CHILDHOOD

Paul Klee was born on December 18, 1879, at Münchenbuchsee, near Berne in Switzerland. His father was the son of a German organist and music teacher, his mother a talented singer. Paul's childhood was therefore dominated by music. With his mother's encouragement, he became an accomplished violinist, and music — particularly that of Mozart — was to be a constant source of inspiration and delight throughout his life.

At school, Paul showed some ability as a poet, but it rapidly became clear that his main interest lay in painting. In 1898, at the age of 19, he moved to Munich, which was the most important artistic center in the region. There, he took drawing lessons at Edwin Knirr's private art school before studying under the imperious Franz von Stuck at the academy. Klee was unimpressed with the latter's ponderous classical style. A lengthy tour of Italy between 1901 and 1902 played a greater part in forming his youthful style.

Between 1902 and 1906, Klee was back in Berne, largely restricting himself to the materials and techniques of the graphic arts. He produced black-and-white prints and drawings in a crisp, linear style. There were few buyers for his work, however, so he earned extra money by playing with the city's orchestra. In 1906, he married the pianist Lily Stumpf and moved back to Munich. There, Klee felt he could keep in touch with the latest artistic trends. The couple had a son, Felix, the following year. Lily was to be the main breadwinner during the early years of their marriage.

THE BLUE RIDER

By 1911, Klee was in close contact with one of the city's leading avant-garde groups, Der Blaue Reiter—The Blue Rider. This circle, which included artists such as Wassily Kandinsky (*see page 924*), August Macke, and Franz Marc, was committed to an expressive use of color, inspired by music and by mysticism. Klee was particularly interested in their theory that color could be orchestrated like a passage of music. He displayed several works in their second exhibit in 1912. His interest was further stimulated by a meeting with the French artist Robert Delaunay later in the year. In his "window paintings," Delaunay was attempting to analyze the way that light could be broken up into

Paul Klee
A photograph shows the artist in 1911.

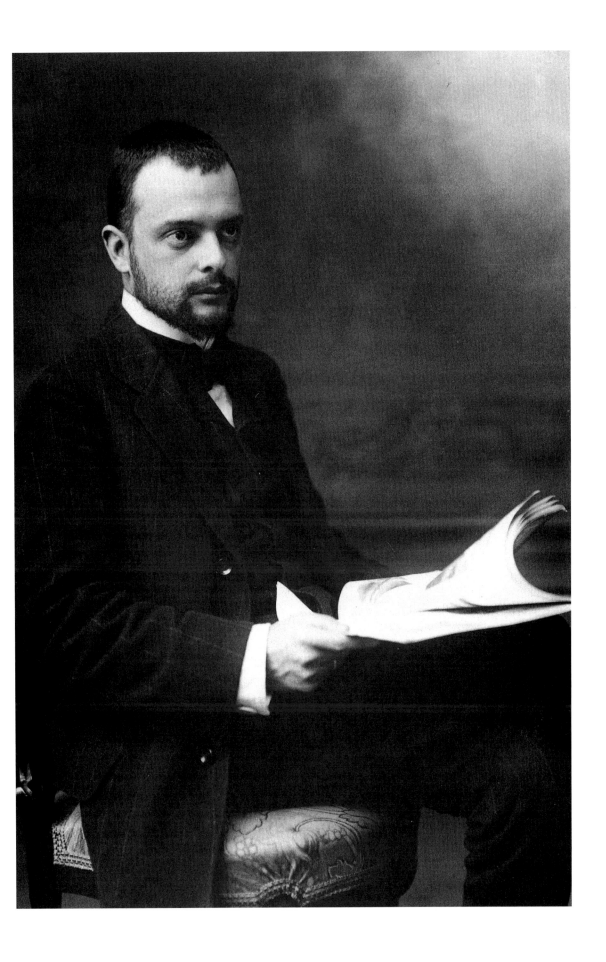

BACKGROUND

"*Degenerate Art*"

In common with many of the progressive artists of the time, Klee was persecuted by the Nazi regime. The closing of the Bauhaus – condemned as a hotbed of "cultural Bolshevism" – in 1933 heralded the start of an increasingly bitter campaign against all modernist trends. This took the form of a series of exhibits of "Degenerate Art," the largest of which was staged in Munich in 1937. Works by artists such as Pablo Picasso, Max Beckmann, and Wassily Kandinsky were placed alongside works by residents of insane asylums. The idea was not just to ridicule modern art, but also to show that the "diseased minds of its perpetrators" were entirely incompatible with Fascist ideals of purity, as represented by the heroic realism of the paintings at a nearby exhibit of official Nazi art. As propaganda, the attack on "degenerate art" proved a success. More than two million visitors attended the Munich exhibit, and the pictures were then sent on a tour throughout Germany. Many of these works are now recognized as masterpieces of the 20th century.

delicate color squares – "polished stones," as Klee called them – as if they were being seen through a prism that refracted the light.

THE IMPACT OF COLOR

The full impact of color on Klee's work became apparent after his trip to Tunisia in April 1914. In the company of two other painters, Louis Moilliet and Macke, he visited Tunis, Hammamet, and Kairouan. The shock of the intense light and color, combined with the fairytale spectacle of mosque towers and palm trees, was an overwhelming experience. "Color possesses me," he wrote. "I no longer need to pursue it; it possesses me forever, I know. That is the revelation of this blessed moment. Color and I are one. I am a painter."

Inspired by these sensations, Klee launched into a series of brightly colored watercolors and oils. Indeed, he was so busy that he seemed untouched by the outbreak of World War I. But the deaths of two of his closest friends from the Blaue Reiter group, Macke and Marc, soon plunged him into a deep depression. A week after Marc's death in 1916, he was conscripted into the German army himself. Since he was 37, Klee was assigned to comparatively light duties, spending most of the war as a clerk at a training school for pilots. This enabled him to continue with his painting.

When the war was over, Klee finally began to receive the recognition he had been seeking for so long. By 1920, three books had been written about his work and, in the same year, a retrospective exhibit in Munich was warmly received. At the same time, he was also offered a teaching post at the Bauhaus. This was a revolutionary art college set up in 1919 in Weimar, Germany. The appointment brought Klee financial security, together with the gratifying sense of community spirit that came from working closely with fellow artists. He particularly enjoyed the company of his friend Kandinsky.

HAILED BY THE SURREALISTS

In 1925, one of Klee's works was purchased by a public gallery. In the same year, the artist took part in the first exhibit of Surrealist art in Paris, where he was hailed by André Breton, the French Surrealist poet, as an ally of their movement. This

was not strictly true: by the mid-1920s, Klee's painting had developed unique qualities that set it apart from any artistic school. For one thing, his prolific output contained no real unity of style. Klee did not adhere to a limited agenda or allow any restrictions of iconography or style to limit his creativity. Nevertheless, he was adamant that nature should be "the essential point of departure for all artistic creation."

He passionately believed that the painter's function was to act as an instrument through which larger, more elemental forces were being channeled. In doing so, the physical appearance of the objects he portrayed might be transformed. Klee likened this to the growth of a tree: "Just as the crown of the tree visibly spreads in all directions, so it is with the work. It would occur to no one to insist that the tree shape the crown like the roots. Everyone will understand that there can be no exact mirror relationship between bottom and top."

IMAGES AND INSPIRATION

Many of the recognizable objects in Klee's paintings, therefore, originated from things he saw in his everyday life. The strange, twittering birds and luminous fish he represented so idiosyncratically stem from the artist's love of visiting zoos and aquariums; other forms can be traced to the pebbles, fossils, and pressed leaves that he stored in his studio. The curious hieroglyphics, and the vague hints of desert landscapes and ruined cities, reflect his love of travel. After 1924, Klee often traveled abroad, journeying to such places as Italy, Corsica, and Brittany.

The place that exerted the greatest influence on his art was Egypt, which he visited in the winter of 1928 and 1929. The visit was short, lasting only three weeks, but the experience was decisive. The effect of the light, the open desert landscape, and the ruined monuments to ancient gods and rulers combined to create a powerful impression on the artist's mind. These were the inspiration for some of his finest paintings, including *Monument in a Fertile Country* of 1929.

KEY DATES	
1879	*born near Berne, Switzerland*
1898	*moves to Munich to study art*
1901-02	*visits Italy*
1906	*marries Lily Stumpf*
1907	*birth of son, Felix*
1911	*meets Blaue Reiter group*
1914	*visits Tunisia*
1916	*conscripted into army*
1920	*retrospective in Munich*
1920-31	*teaches at Bauhaus*
1928-29	*visits Egypt*
1933	*dismissed from Dusseldorf Academy by Nazis; moves back to Switzerland*
1935	*major retrospective exhibit in Switzerland*
1937	*17 paintings shown in exhibit of "Degenerate Art"*
1940	*dies at Muralto*

Increasingly, though, Klee's career was overshadowed by events closer to home. A change of management at the Bauhaus made him dissatisfied, and in 1931, he accepted a new post at the Düsseldorf Academy. This seemed ideal, as it gave him more time to concentrate on his painting, but the political climate was rapidly deteriorating. Two years later, when the Nazi swastika was raised over the school, Klee was forced to resign, and by the end of 1933, he decided to leave Germany.

By this stage, it was clear that the Nazi regime was determined to suppress all forms of modern art. Its supporters were hounded from their posts and their works were held up to ridicule in the infamous exhibit of "Degenerate Art," held in Munich in 1937. Seventeen of Klee's paintings were hung alongside the work of leading figures in the German avant-garde. In the face of such hostility, Klee returned to Switzerland in 1933, where the enforced retirement from teaching

Fish Magic: Paul Klee (1925)

When he traveled to Italy, Klee was fascinated by the aquarium at Naples, and fish often figured in his paintings. The teeming variety of marine life formed a counterpart to his own fertile visual imagination.

allowed him to devote more time to his own work. Klee's later years were productive, and he enjoyed a new celebrity in his native country following a major retrospective exhibit in 1935. But his happiness at this success was clouded by the onset of illness. Initially diagnosed as bronchitis, it was later found to be a rare, debilitating disease called scleroderma. Klee was still able to work, but the mood of his final pictures was somber. In place of his usual playfulness and humor, the images were stark and tragic.

Occasional visitors lightened the burden of these last years: in 1937, Picasso (*see page 972*), Georges Braque, and the German Expressionist painter Ludwig Kirchner, whose work had fea-tured in the Munich exhibit, came to see the artist, giving him a valuable sense of still being in contact with the outside world.

DEATH AT MURALTO

Klee's condition deteriorated as Hitler's tanks rolled into western Europe. In May 1940, he entered a nursing home. He was moved to a clinic at Muralto, where he died on June 29. An extract from his diary was engraved on his gravestone: "In this world I cannot be wholly understood, for I am as much at home with the dead as with those yet unborn — a little nearer to the heart of creation than is normal, but still too far away."

Klee and the Bauhaus

The years that Klee spent working at the Bauhaus were among the happiest and most productive of his career. After so many years of financial uncertainty, the post provided him with a stable environment in which he could work and experiment freely. It also offered him a spacious four-room apartment with a studio, where he lived with his wife and son, and the opportunity to meet and exchange ideas with a wide variety of colleagues.

These colleagues included Kandinsky, his friend from the Blaue Reiter, with whom he shared a house when the school later moved to Dessau. But other contacts were less harmonious. The Bauhaus was home to a number of domineering and quarrelsome personalities, and Klee's refusal to become involved in their back-biting earned him the ironic nickname, "the heavenly father."

On a purely artistic level, however, the Bauhaus could not have been more stimulating. This unique institution, founded in Weimar in 1919 by the architect Walter Gropius, aimed to unite the arts and to forge a link between craftsmanship, design, and modern industrial techniques of mass-production. Its pupils were more like apprentices than academic students, and theory was always closely linked to practice.

Architecture was the main discipline at first, but teachers at the college were expected to be proficient in several fields. Klee's initial tasks were to supervise lessons on the making of stained glass and weaving. Painting was not on the original curriculum, and Klee only taught it in later years. The emphasis on different media proved to be a positive factor, as the various disciplines left their own mark on Klee's art.

In the mid-1920s, for example, Klee began using intricate motifs – known as "lace effects" – which are thought to have derived from his experience in the textile studios. And some of his abstract arrangements of the period have an architectural quality, comparable to the severe and geometric style of architecture that developed at the Bauhaus. The teaching environment was also invaluable to Klee, because it forced him to analyze and define his own working methods. He published these in his *Pedagogical Sketch Book* in 1925, which became a standard textbook in art schools around the world.

The Bauhaus moved to Dessau in 1925, following a dispute with the local authorities, and three years later, Gropius left to resume his career as an architect. The character of the school changed, and Klee felt less comfortable there. Unimpressed with Gropius's successors, and concerned at the college's involvement in left-wing politics, Klee quit in April 1931. The Bauhaus was closed down two years later by the Nazis.

> This unique institution aimed to unite the arts and to forge a link between craftsmanship, design, and modern industrial techniques

D.H. Lawrence

To his admirers, he was a visionary and a prophet. To his enemies, he was a minor talent with a "diseased mind." Lawrence's life was beset by controversy, but today his reputation as a writer is beyond dispute.

After Lawrence's death, the novelist E.M. Forster described him as "the greatest imaginative novelist of his generation." By the 1950s, the distinguished critic F. R. Leavis was referring to him as "the great genius of our time." Yet while he was alive, Lawrence's novels were suppressed by outraged moralists, and he was scorned and reviled in his own country.

EARLY LIFE

David Herbert Richards Lawrence was born on September 11, 1885, in Eastwood, a small coalmining town outside Nottingham, England. His father, Arthur, was a robust miner whose habit of spending too much money in the local tavern led to angry scenes with his wife, Lydia. Bert, as he was known to his family, had two brothers and two sisters. He was a frail child with a delicate constitution, which inclined him toward intellectual pursuits rather than rough-and-tumble games. From an early age, he showed a love of nature and a preference for the company of girls.

Determined to keep him out of the mine, his mother encouraged his studies. In 1898, at the age of 13, the boy won a scholarship to Nottingham High School. After three years, he took a job as a clerk at a firm in Nottingham, but was forced to leave after three months when an attack of pneumonia brought him close to death. Lydia nursed him back to health, lavishing love upon him and forming a powerful bond between them.

As part of his convalescence, Lawrence started visiting his friend, Alan Chambers, who lived on nearby Haggs Farm. The farm became a second home to him. The Chambers family were fond of Lawrence and delighted in his playful manner; Mr. Chambers said: "Work goes like fun when Bert's here." Lawrence was closest to Alan's sister, Jessie, with whom he went for long walks in the country and spent hours reading great works of literature. It was Jessie who first encouraged Lawrence to become a writer, and their relationship lasted nearly 12 years. Mrs. Lawrence disapproved of the farm girl, whom she saw as a rival.

When Lawrence was fully recovered, he became a pupil-teacher at the British School in Eastwood, undertaking the teaching of "savage collier lads" while receiving instruction himself. In 1905, he took the King's Scholarship Examination and received the highest mark in the whole of England and Wales. After another year, he had saved enough money to take up studies at Nottingham University College in 1906, where he completed a two-year teaching course. He found college disappointing, and later said it "had meant mere disillusion, instead of the living contact of men."

In 1908, he began teaching in Croydon, London. A few months after he started work, Jessie sent some of the poems he had been writing since he was 17 to Ford Madox Hueffer — later and better

D.H. Lawrence
This photograph shows the restless, passionate writer.

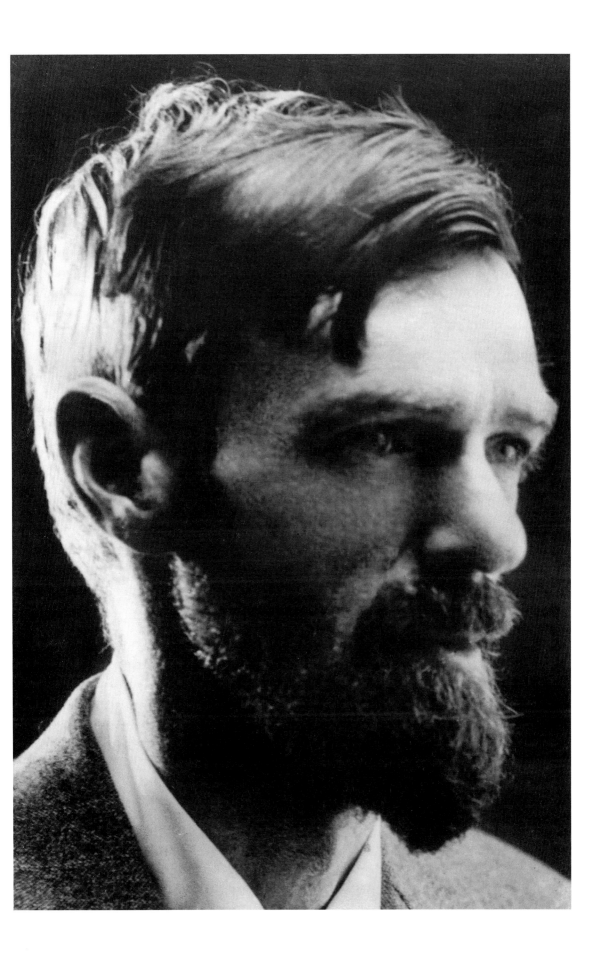

BACKGROUND

Mexico

Lawrence visited Mexico in 1923. He was captivated by the country, writing: "The Indian, the Aztec, old Mexico – all that fascinates me and has fascinated me for years. *There* is glamour and magic for me … It seems to me my fate."

Beneath the surface color, "the brilliant sun … on the hibiscus flowers …," lay an inner aspect of darkly mystical people and places. Mexico City contained appalling slums, yet the countryside was littered with architectural marvels in the form of pyramids and temples. Lawrence was both excited and repelled. He felt that England could be rejuvenated by a transfusion of the "dark volcanic blood" of the Mexican people. Mexico's old religion celebrated the sort of vital life-force that Lawrence so often wrote about. His Mexican novel, *The Plumed Serpent*, deals with the conflict between ancient and modern cultures, and seems to advocate a return to the primitive and instinctive values which have been lost in the process of civilization.

known as Ford Madox Ford – editor of the *English Review*. Hueffer published the poems in 1909, and introduced Lawrence to other writers, including the poet Ezra Pound (*see page 8:1040*).

TRAGEDY AND SUCCESS

This success was marred by the death of his mother from cancer in December 1910. Lawrence was too upset to enjoy the publication of his first novel, *The White Peacock*, the following month, and subsequently referred to 1911 as his "sick year." In an effort to overcome the trauma, he became engaged to Louie Burrows, "a glorious girl … swarthy and ruddy as a pomegranate." But Lawrence broke off the engagement at the end of the year.

In the spring of 1912, after Lawrence had left London to return to Eastwood, he visited his old professor, Ernest Weekley. He met Weekley's wife, who was the daughter of a German aristocrat, von Richthofen. The 32-year-old Frieda was vivacious, passionate, and bored with provincial life. She had been married for 12 years, but within two months of meeting Lawrence, she eloped with him.

Lawrence was 27 when he met Frieda, and although their relationship was stormy with infi-

delities and arguments, he stayed with her for the rest of his life. He wrote: "She's got a figure like a fine Rubens (*see page 2:252*) woman, but her face is almost Greek." She was strong-minded and refused to let him dominate her. Her influence on his work was profound, and Lawrence often explored their tempestuous relationship in his work.

In 1912, Lawrence and Frieda left England and traveled to Germany, before crossing the Alps into Italy, where he finished his third novel, *Sons and Lovers*, on the shores of Lake Garda. His second, *The Trespasser*, had been published earlier that year, but it was not well-received.

By contrast, *Sons and Lovers* won critical acclaim when it appeared in 1913. The most directly autobiographical of his novels, it is based on his life in Eastwood. Paul Morel, the son of a hard-drinking collier and a possessive mother, is drawn to Miriam Leivers, a shy farm girl. Morel rejects her "spiritual" love and seeks fulfillment with a married woman. The conflict between his mother and his childhood friend Jessie provided Lawrence with valuable material. Jessie made suggestions which he incorporated into the novel, but after reading the final version, she was so hurt by the portrait of Miriam that she never spoke to him again.

Frieda was divorced in 1914, and she and Lawrence were married in London. The outbreak of World War I that year heralded a difficult period for them. They were trapped in England, where Frieda's nationality and the couple's bohemian ways made them objects of suspicion. The publication of *The Rainbow* in 1915 added to their troubles. The novel concerns the emotional history of three generations of the Brangwens, a farming family, and contained controversial passages. A month after its publication, the book was declared obscene and the destruction of all existing copies was ordered.

CONTINUED PERSECUTION

The Lawrences moved to Cornwall feeling embittered and disillusioned. But here Lawrence completed *Women in Love*, which he felt to be his finest novel. It continued the story of Ursula Brangwen, and again was controversial. It was not published until 1920 — and then only in America.

The Cornish locals suspected the Lawrences of being German spies and they suffered both official and unofficial persecution. Eventually, in October 1917, they were ordered to leave their cottage and to report regularly to the police. This completed Lawrence's sense of alienation, and he was never again able to feel comfortable in England. He believed the people had been dehumanized by industry, and needed to return to a more natural way of living. He yearned for a Utopian community where he and like-minded individuals could "live out of the world — make a sort of Garden of Eden of blameless but fulfilled souls."

In 1919, Lawrence traveled to Italy, and a year later, the couple settled at a villa in Sicily. Lawrence worked prodigiously, producing travel books, poems, and fiction. But his wanderlust drove him on, and in September 1922, after traveling in Ceylon and Australia, the Lawrences arrived at an artists' colony in Taos, New Mexico.

Lawrence had been invited there by Mabel Dodge Sterne, a wealthy American. She seems to have been attracted to Lawrence, but the feeling was not mutual. He wrote of Taos: "Too much Mabel Sterne and suppers and motor drives and people dropping in." But he fell passionately in love with New Mexico. Describing the morning after his arrival, he said: "The moment I saw the brilliant, proud morning shine high up over the deserts of Santa Fé, something stood still in my soul, and I started to attend."

He learned to ride and reveled in the scenery. He and Frieda moved to a log cabin in the mountains outside Taos. In spring 1923, they moved to Mexico City and then Chapala, where Lawrence began *The Plumed Serpent*. Frieda grew tired of the heat and persuaded Lawrence to return to England. He reluctantly agreed. On the way they quarreled, and Frieda sailed alone in August 1923. Lawrence delayed joining her for three months, only to find that neither enjoyed Europe now.

They returned to America in March 1924, accompanied by a recruit for the utopian colony that Lawrence hoped to establish in the New

KEY DATES

1885 *born in Eastwood*

1898 *starts Nottingham High School*

1906-08 *Nottingham University College*

1908 *teacher in Croydon*

1909 *poems published in* English Review; *meets Ezra Pound*

1910 *mother dies*

1911 The White Peacock *published*

1912 *meets Frieda Weekley*

1913 Sons and Lovers *published*

1914 *marries Frieda*

1915 The Rainbow *published*

1920 *Women in Love* published

1922 *visits Ceylon, Australia, and New Mexico*

1928 Lady Chatterley's Lover *published in Italy*

1930 *dies at Vence, south of France*

The Rainbow (1915)
*The cover of Lawrence's fourth novel hints at the intense
passions contained within. After publication, it was
seized by the police.*

Mexican mountains – Dorothy Brett, a young painter. The three stayed at a ranch, Kiowa, that Mabel Sterne had given Frieda. Lawrence then traveled back to Mexico, where he finished *The Plumed Serpent*. The trip proved disastrous, with Frieda forcing Brett to leave and Lawrence being diagnosed as tubercular after a terrible illness.

In September 1925, Lawrence left America for the last time. He spent most of the rest of his life in Italy, where the climate suited his consumptive condition. He continued to write poetry and essays but completed only one more novel, the notorious *Lady Chatterley's Lover*. Although not Lawrence's best work, it is the best-known, mainly because of the furor over his use of four-letter words. It

was printed in Florence, Italy in 1928. It was 30 years after the book was finished before the first complete edition was printed in America.

Lawrence's infamy was increased by an exhibit of his paintings at a London gallery in 1929. Police removed 13 of the paintings, which were judged obscene. The nudes narrowly escaped being burned.

By now Lawrence was "living by sheer force of will and by nothing else," according to the writer Aldous Huxley. On February 6, 1930, he was admitted to a sanatorium in Vence, in the south of France. He left on March 1, and died the following day. Frieda was by his side. He was buried in the local cemetery until 1935, when his ashes were removed to Kiowa and placed in a chapel.

Lawrence and Love

Lawrence has been justly praised for his lyrical accounts of rural life and his vivid descriptions of the natural world, but his great fame rests upon the sexual content of his work. At a time when it was thought improper for women to feel desire, Lawrence's belief that sexual fulfillment was essential to the happiness of both men and women was, in itself, a radical notion. And his bold and frank descriptions of lovemaking caused sheer outrage.

The Rainbow caused a storm of protest. Reviewers were shocked by the candid account of the love affairs of the main character, Ursula Brangwen. Although the references to intimacy are oblique rather than explicit, they were seized upon by moralists and the book was suppressed within six weeks of publication.

In the sequel, *Women in Love*, Ursula and her sister, Gudrun, have become teachers in a mining town. Ursula is involved with Rupert Birkin, a school inspector. Birkin expresses some of Lawrence's most deeply felt sentiments when he tells Ursula: "What I want is a conjunction with you … an equilibrium, a pure balance of the two single beings." Gudrun becomes caught in a destructive relationship with Gerald Crich, a mine-owner. Crich represents the inhuman mechanization and industrialization which Lawrence felt was so damaging to human relationships. Finished in 1916, the book was condemned as obscene and not published until 1920.

> ## Lawrence's belief that sexual fulfillment was essential to the happiness of both men and women was radical

Lawrence believed sex was a powerful primitive force capable of transcending barriers of class and social distinction. In his short story, *The Virgin and the Gypsy*, a young girl from a respectable family has her desire awakened by a gypsy. Yvette yearns to break free from the conventions of the time, and strains against her "stifling" family. The gypsy represents a means of escape.

Lawrence returned to this subject in his most famous book, *Lady Chatterley's Lover*. Constance Chatterley is married to a wealthy mine-owner, Sir Clifford, whose war wounds have left him paralyzed. Chatterley lets his wife have an affair so that she can get pregnant. She finds satisfaction with Oliver Mellors, a lowly gamekeeper. But when she becomes pregnant, her husband's tolerance disappears in the face of class prejudice. The blunt language used to describe lovemaking and the use of four-letter words created an uproar. Lawrence's aim was to rehabilitate these words and cleanse them of sordid connotations, but his readers were shocked.

Lawrence was accused of being obsessed with sex. In fact, he was opposed to permissiveness and simply believed that sex was a healthy, natural, even therapeutic, activity, and not something shameful. He said, "I can only write what I feel pretty strongly about … the relation between men and women." His erotic writing is now seen as a celebration of life and vitality.

Thomas Mann

No novelist depicted the unrest of early 20th-century German life more vividly than Thomas Mann. An outspoken advocate of freedom, he had to go into exile when the Nazi Party came to power in the 1930s.

While many of Thomas Mann's themes mirror the interests of the German people as a whole, the writer was also interested in the relationship of art to life, and sought to balance the two. Much of his work is autobiographical, but it also shows a grasp of history and myth that lends it a more universal significance.

EARLY YEARS

Thomas Mann was born on June 6, 1875, in Lübeck, northern Germany. His family was prominent in the shipping industry. His father's family was German, but his mother was born in Brazil to Portuguese-Indian and German parents. It was to this mixed ancestry that Mann later attributed his passion for the arts and literature.

Thomas was the second of five children, having two brothers and two sisters. When Thomas was 16, his father died and the family business was liquidated. His mother moved to Munich with her three youngest children, and Thomas joined them there in 1893, at the age of 18.

In Munich, Thomas worked briefly for an insurance company before leaving to meet his brother Heinrich in Italy. Here, when he was 21, he successfully published *Little Herr Friedemann* (1896). This story introduced a theme of struggle which would reappear constantly in his work. The protagonist, an outcast hunchback, strives to lead a life of peace, but he is disrupted by a beautiful woman whose callousness leads to his destruc-

tion. Throughout his own life and work, Mann would continually strive to reconcile this struggle of private life with public life, passion with reason, art with life. His studies of the renowned philosophers Arthur Schopenhauer and Friedrich Nietzsche would also profoundly influence the thematic content of his works.

Returning to Munich, Thomas began work with the satirical journal *Simplicissimus*, in which he published many articles. In 1900, his first major novel, *Buddenbrooks*, was completed. Published a year later, the book sold more than 10,000 copies in its first year and gave Mann a place in the literary world. Nearly 30 years later, Mann would be awarded the Nobel Prize in recognition of this first major work.

BUDDENBROOKS

In many ways *Buddenbrooks* is an autobiographical work, and Mann consulted with members of his family in the process of writing it. This novel traces four generations of a merchant family from a town in Germany, and narrates their descent from prominence in the business world. Over the years, family members fail hopelessly in direct proportion to their lack of practicality. Once a character in the novel indulges in the arts, religion, or higher education, he plants the seeds of his decline.

Thomas Mann
This photograph shows the writer in 1930, at 55.

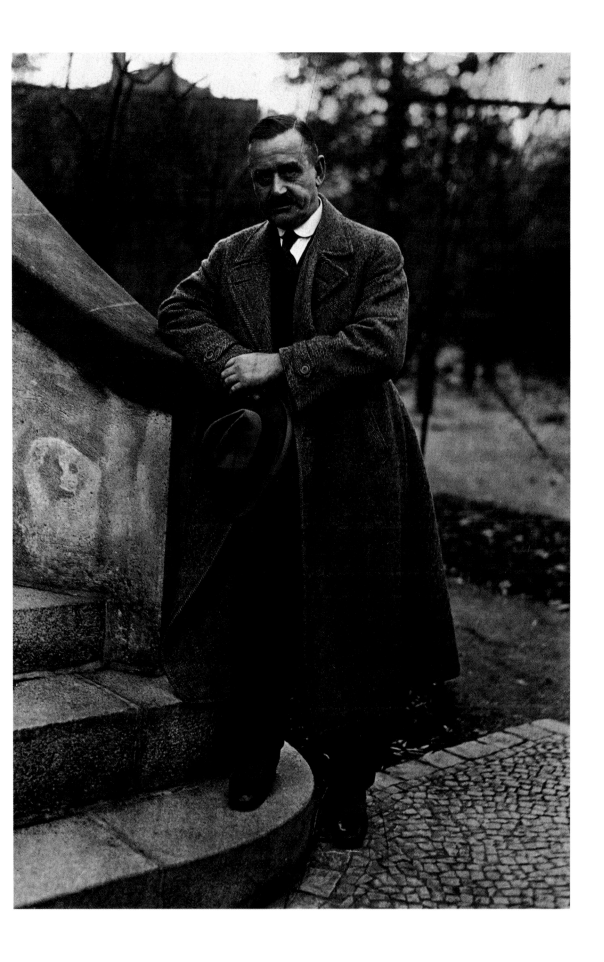

BACKGROUND

Schopenhauer and Nietzsche

The philosophies of Arthur Schopenhauer and Friedrich Nietzsche had an enormous impact on the life and work of Thomas Mann. Schopenhauer, a German philosopher who lived from 1788 to 1860, believed that the will is driven by sexuality, and that conflicts between people arise because their wills vary in intensity. To avoid these conflicts, it is necessary to supplant sexuality with the intellect. This theme is most thoroughly explored by Mann in *Death in Venice*. The protagonist of the book, Gustave Aschenbach, is unable to achieve the necessary sublimation of his physical desires, however, and dies as a result.

Nietzsche (1844–1900) was tormented by physical ailments all his life, and eventually contracted syphilis. He believed that in order to be in touch with the people of an era, one had to be directly in touch with their bodily suffering also. Thus he made his illnesses the basis for much of his philosophy. Only when a man is ill, he argued, can he have a complete perspective on humanity and its present needs. This idea that disease might be beneficial is a common theme in many of Mann's works, and is most vividly present in *The Magic Mountain*.

Though a chilling pessimism pervades the story, it is also warmed with humorous irony. Some of the characters' mannerisms even border on the comical. In *Buddenbrooks*, the theme of reconciling art with life is central, as is the theme of the trials of a family in decay.

LUST FOR FAME

Around the time Mann finished *Buddenbrooks*, he wrote a poem titled "Monolog," in which he dreamed of being adorned with a laurel crown for his achievement. The prospect of fame obsessed him, and he took every measure to achieve and maintain it. After the first favorable reviews of *Buddenbrooks*, he wrote: "It contains so much that is personally revealing that it will really give me a profile at last." With fame, Mann believed, he would have the means available to reconcile his private and public lives. His stories, which were laden with autobiographical content, were a mode of revealing his very human, sometimes fragile side. By exposing this vulnerable side, he hoped to win the hearts of his readers, and ensure their respect for him as a human being.

This foresight proved valuable, for in the public eye, Mann was always praised highly for his rectitude and apparent ease. He would go on to lecture throughout his career and earn honorary doctorates from Harvard, Princeton, Rutgers, Berkeley, and Oxford. Later in his career he wrote: "I am at my best if I can give a performance." The anxiety created in reconciling his private and public lives was overcome by his integration of them in works of art. In 1929, he was awarded the Nobel Prize, mainly for *Buddenbrooks*, the novel which made him famous.

IN PRAISE OF MALE BEAUTY

Many of Mann's short stories show an explicit appreciation of male beauty. And his letters and diaries reveal clear parallels between these stories and his own life. The theme of male beauty influenced Mann's literature in the early short story "Tonio Kröger," which, like many of his

works, dealt primarily with the nature of the artist. The story opens at the end of a school day when Tonio, a boy of 14, and his schoolmate, Hans Hansen, walk home together. Hans is described as "uncommonly handsome and well built," and it is soon revealed that Tonio truly loves him, in spite of their obvious differences. Hans is popular and unenthused with his friend's love of literature, while Tonio is awkward, lonesome, and introspective. At the end of school, the death of Tonio's father separates them for more than 13 years, when Tonio goes to live in Munich. On a return trip to his home, Tonio by chance views in the distance the figures of both Hans and Inge, an attractive girl from his schooldays. Thus his feelings of longing and love return.

DEATH IN VENICE

Mann deals with the theme of male beauty most eminently and famously in the novella, *Death in Venice* (1913). Aschenbach, the protagonist, is a prominent literary figure vacationing in Venice. Immediately upon seeing Tadzio, a Polish boy of 14, Aschenbach feels passionate desire for him. Throughout the story, he follows the boy, obsessed with his "perfect beauty." Even when the news of a cholera epidemic is at hand, Aschenbach remains in Venice, relentlessly following Tadzio in solemn worship. In the end, Aschenbach dies alone, sitting on the beach, watching the solitary boy wading in the water.

At the age of about 24, Mann befriended a young painter, Paul Ehrenberg, with whom he spent nearly five years, obsessed with winning his affection. In his early diaries, Mann rejoiced in their friendship. Upon meeting his future wife, Katja Pringsheim, in 1905, however, Mann's relationship with Paul ended abruptly and mysteriously. He married Katja that same year.

LATER WORKS AND EXILE

Mann began work on what he considered his greatest novel, *The Magic Mountain*, in 1913, but did not complete it for another 11 years, distracted in particular by the outbreak of World War I in 1914. The scope of this novel is epic, simultaneously operating on personal, familial, political, and global levels of significance. Hans Castorp, an engineer by trade, visits his sick cousin in a remote sanitarium in the Swiss Alps. His original plan is to stay three weeks, but he is detained there for seven years, due to circumstances including falling ill himself, falling in love, and acquiring an education. In the end, his cousin dies, a fellow inmate commits suicide, and World War I breaks out. Mann later wrote of Castorp's

KEY DATES	
1875	*born in Lübeck, Germany*
1893	*moves to Munich*
1896	Little Herr Friedemann *published*
1901	Buddenbrooks *published*
1905	*marries Katja Pringsheim*
1913	Death in Venice *published; begins* The Magic Mountain
1924	The Magic Mountain *published*
1929	*awarded the Nobel Prize for literature*
1936-38	*exiled from Germany; moves to United States*
1943	Joseph and his Brothers *published*
1944	*becomes a U.S. citizen*
1947	Dr. Faustus *published*
1952	*returns to Europe; buys home in Switzerland*
1954	*writes* The Confessions of Felix Krull, Confidence Man; *awarded honorary membership of German Academy of Arts in Berlin*
1955	*dies of thrombosis*

experience: "What develops in the young man, from experience of disease, death, and decay, is the idea of man, the 'sublime structure' of original life." The irony of the story echoes the ideas of Nietzsche: Castorp has arrived at a semblance of normality by deviating from the norm.

Mann was originally a man of fairly conservative opinions concerning politics, as expressed in his *Observations of an Unpolitical Man* of 1918. But he later caused surprise by quickly lending his public support to the Weimar Republic, the new government of Germany formed in 1919.

WORLD WAR II

The two world wars had a tremendous impact on Mann. Though he supported Germany's cause in World War I, he was vocal in his opposition to the rising tide of German fascism which led to World War II. This opposition was to cost him greatly. In 1936, his doctoral degree from the university at Bonn, an honor which he cherished above any, was revoked. More drastically, his German citizenship was also revoked. He was warned by the Nazi government never to return to Germany. He spent the next year in Austria and Switzerland, before leaving in 1937 for the United States. The writer was welcomed to America with open arms, as were such eminent contemporaries as the composers Arnold Schoenberg and Igor Stravinsky (*see pages 978 and 990*) and the conductor Bruno Walter. Almost immediately, Mann embarked on a cross-country lecture tour. He became a U.S. citizen in 1944.

JOSEPH AND HIS BROTHERS

Mann eventually settled with Katja in Pacific Palisades, California, where ideas for a new novel, *Dr. Faustus*, soon began to germinate. He was also working at this time on the final volume of his tetralogy – a work of four volumes – *Joseph and his Brothers*. The basis for this work was the biblical story of Joseph from the books of Genesis and Exodus. But Mann was not merely writing a

religious treatise. Using the Bible and several other ancient mythical texts for inspiration, he intended to explore the foundations of human behavior. The work displayed both elaborate symbolism and political allegory. Upon completion, Mann would describe the tetralogy as "a humorous and mythical poem about mankind."

The tone of *Joseph and his Brothers*, published in 1943, was humorous. *Dr. Faustus* (1947), Mann's next novel, was by contrast surprisingly morose. In the story, a composer sells his soul to the devil in order to enliven his dormant creativity. On one level, the novel is a meditation on Mann's fatherland, Germany, and its cultural and political destruction at the hands of a fascist government during World War II. This accounts for the deeply personal, tragic tone of the work, which Mann considered his "wildest" novel. The hero, Adrian Leverkühn, is a brilliant composer whose violent energies finally destroy him. Mann's last work, *The Confessions of Felix Krull, Confidence Man*, written in 1954, was another humorous work.

RETURN TO EUROPE

Mann continued to write and publish important new works during his exile, and could now count on an audience which spanned all of Europe and the United States. During the years after World War II, he had an intense longing to return to his homeland, however. In 1952, less than a decade after war reparations were underway, he returned to Europe with his wife.

ILLNESS AND DEATH

The Manns bought a home in Zurich, Switzerland, in 1952, but scarcely lived in it, since Mann continued to work and give lectures throughout Europe. In 1954, he was awarded honorary membership of the German Academy of Arts in Berlin. A year later, he was awarded the highest German order: Pour le Mérite. Two days after accepting the award, on August 12, 1955, Thomas Mann died of thrombosis. He was 80 years old.

Praise and Persecution

In 1929, Thomas Mann was awarded the Nobel Prize, primarily for his novel *Buddenbrooks*, published nearly 30 years earlier. The Swedish Academy praised the work as a masterpiece. Though its subject was only one family, the novel's strife paralleled the concurrent strife of Germany and all of Europe. It was truly uncanny in its resemblance to the economic instability suffered by Germany in the 1920s.

Mann was reticent about accepting the award. He was surprised that *Buddenbrooks* was acknowledged, rather than his novel, *The Magic Mountain* (1924): he considered the latter his greatest work. After accepting the prize, he spoke in praise of the many authors whose works he felt deserved equal recognition.

Mann later discovered that a literary professor of the Swedish Academy had panned *The Magic Mountain* as "an artistic monstrosity." Though his harsh words had a damaging effect on Mann, he put the award into perspective and used it to his advantage. The popularity and acclaim it won would help him in his quest to promote ideas of freedom in Germany. It was what he called "war service with the weapon of thought."

At this time, Mann was trying to maintain a low profile in the political sphere but without compromising his integrity. His traveling lectures endorsed freedom. He warned of the inherent dangers of nationalism, which was the prevailing sentiment in Germany at the time. This did not win him popularity among German nationalists, and he was afraid of their retribution. He feared his diary might fall into Nazi hands, saying: "Something terrible, even fatal, might happen."

As Nazism gained a stronghold on his country, Mann endured ever more vitriolic slander from the nationalists. Eventually, in 1936, he was forced to flee when his citizenship was revoked. By the beginning of World War II, he was residing in the United States.

Here he had the freedom to exercise the power of his stellar reputation, and make his influential voice heard. As he pronounced in 1937, "Freedom and serenity! Time to insist on my right to them." During the war, Mann taped a series of broadcasts condemning the Nazi regime. Made in collaboration with universities and the BBC, these tapes were broadcast on radio in London and Germany. Though no one can say for sure what the impact of these broadcasts was, Mann should be regarded as a champion of freedom for his efforts to help the Allied cause.

> The popularity and acclaim the prize won would help him in his quest to promote ideas of freedom to his people. It was what he called "war service with the weapon of thought."

947

Katherine Mansfield

Drawing on her childhood in New Zealand, Katherine Mansfield introduced a new kind of short story into English literature, in which subtleties of atmosphere and feeling are more important than plot.

Katherine Mansfield's literary career lasted little more than a dozen years, during which time she was plagued by serious illness and unresolved emotional problems. Her chosen medium, the short story, perfectly suited her poetic, concise style and her interest in the small, poignant moments of human existence, which she illuminated with tenderness and insight.

A DIFFICULT CHILDHOOD

Katherine Mansfield was born Kathleen Mansfield Beauchamp in Wellington, New Zealand on October 14, 1888. She later dropped her surname and changed her first name to Katherine to assert an identity separate from her family. Her father had made a fortune in business and he prospered as Katherine grew up. Colonial life in New Zealand was then marked by nostalgia for England, the mother country, 12,000 miles away. A snobbish division existed between old established families and those with "new money," like Katherine's.

The material comfort Katherine enjoyed was not matched by any emotional warmth from her parents. Her mother actually reinforced Katherine's sense of her "being the odd one out" of four daughters. Once, returning from abroad, Mrs. Beauchamp remarked, "Well, Kathleen, I see that you are as fat as ever." The one bright light in Katherine's early life was her maternal grandmother, Granny Dyer. Feeling isolated, Katherine began to write at an early age. At her high school, she produced

the school magazine, but the headmistress dismissed her as "imaginative to the point of untruth." In 1903, with her elder sisters Vera and Charlotte, she went to board at Queen's College in London. On Katherine's first day there she met Ida Baker, who was to become a lifelong and devoted friend.

On her return to New Zealand in 1906, Katherine became involved with another woman, the artist Edith Bendall. She missed the culture of London, however, and in 1908, sailed back there. Three weeks after her arrival, she fell in love with Garnet Trowell, a musician from her home town. Garnet and Katherine became engaged, but his parents disapproved and they had to separate. But Katherine was already pregnant. She at once engineered a marriage of convenience with George Bowden, a bachelor who taught singing. She refused to consummate the marriage and left her bemused savior to join Garnet, who was on tour.

When Katherine's mother heard about this scandal in 1909, she set off for England and whisked Katherine away to Bavaria in Germany, leaving her alone there. Katherine had a miscarriage shortly afterward. Later that year, Mrs. Beauchamp disinherited her. Katherine was marked for life by her mother's harshness. She began writing of her experiences in Germany, and that summer met Floryan Sobieniowski, a Polish writer who was on vacation in Bavaria. He introduced her to the short

Katherine Mansfield: Anne Estelle Rice
The writer was painted in 1918, at the age of 30.

948

stories of the Russian Anton Chekhov, who was then barely known in Europe. Almost certainly Katherine contracted gonorrhea from Floryan. It made her infertile and led to secondary illnesses: arthritis, pleurisy, and a weak heart. Most significantly, it left her vulnerable to tuberculosis.

Katherine broke off the affair without any explanation, to Sobieniowski's fury. After an attack of peritonitis, she returned to London a chronic invalid, where the saintly George Bowden took her in. He also found her a publisher. Struck by the originality of her Bavarian stories, he introduced her to A.R. Orage, editor of *The New Age*, a magazine of politics and literature.

Orage accepted Katherine's stories for publication, the first one being a tale of a servant girl who is so desperate for sleep she smothers the baby she is looking after. Called "The-Child-Who-Was-Tired," it plagiarized a Chekhov story. These stories were published as a collection, *In a German Pension*, in 1911. They drew on Katherine's stay in a boarding house in Bavaria, satirizing the habits of her fellow lodgers. Her vivid pictorial style was already present, but she later came to reject these stories. During World War I, when there was strong anti-German feeling, a publisher suggested that a new edition of *In a German Pension* would be profitable. Katherine refused to consider the idea.

GAINING A REPUTATION

By now, Katherine was beginning to acquire a reputation as a talented writer. She shared an apartment with Ida near *The New Age* offices. In December 1911, she met John Middleton Murry, co-editor of a new arts magazine, *Rhythm*. He had established himself as an outstanding scholar and literary editor. Murry was to have a greater effect on Katherine's emotional life than on her work, though he did help to find outlets for her stories. She began to contribute to his magazine, so incurring the anger of those at *The New Age*. Murry moved into Katherine's apartment as her lodger and they soon became lovers.

In 1913, Katherine and Murry met D.H. Lawrence (*see page 936*) and Frieda Weekley. There

KEY DATES

1888 *born in New Zealand*

1903 *attends Queen's College, London; meets Ida Baker*

1908 *involved with Garnet Trowell*

1909 *mother takes her to Bavaria; writes first stories*

1911 *meets John Middleton Murry*

1913 *meets the Lawrences*

1915 *brother Lawrence killed*

1918 *marries Murry; "Prelude" published*

1920 Bliss and Other Stories *published*

1923 *dies in Fontainebleau, France*

was an immediate rapport between the two couples. Katherine and Lawrence felt a bond which would probably have lasted longer but for complications with their partners. Katherine said of her first meeting with him, "All I remember is sunshine and gaiety." Lawrence shared her bold irreverence, her delight in the natural world, and her passion. They influenced each other's work – Lawrence used her as a model for several characters, and Katherine planned to write a novel along the lines of *Sons and Lovers*.

The outbreak of World War I in 1914 made little impact on Katherine and Murry – their world belonged solely to literature. But when Katherine's brother, Leslie, was killed in action in 1915, she was deeply affected. Katherine and Murry's relationship was destined to be problematic. Lawrence thought they would be better off apart but, despite their frequent separations, they were unable to stay apart for long. Perhaps Katherine's failing health made her more dependent on Murry than she would have otherwise been.

Meanwhile, Katherine's struggle to perfect her art continued. A key story in her development is "The Aloe," begun in 1915 and reworked until it reached its final form as "Prelude" in 1918. It was

published by Leonard and Virginia Woolf (*see page 996*), who had recently set up the Hogarth Press, and were part of the literary circle called the Bloomsbury Group. Leonard found Katherine entertaining, and wanted to help her career. Virginia Woolf admitted to feelings of rivalry with Katherine, but the two also admired each other.

Katherine's work progressed slowly. Part of her method was to read aloud a story to make sure it rang true. Of "Miss Brill" she wrote, "After I'd written it I read it aloud — numbers of times — just as one would play over a musical composition — trying to get it nearer and nearer to the expression of Miss Brill — until it fitted her." Her and Murry's relationship also features in her work. In "Je ne Parle pas Français," the events are fictional but describe a triangular relationship between the weak Dick (Murry), the depraved Raoul (Francis Carco, a poet with whom Katherine had had an affair), and the narrator, Katherine herself.

Once Katherine was diagnosed as suffering from tuberculosis, she searched desperately for a cure.

Despite the war, she traveled to France, where Ida joined her. The bombardment of Paris trapped them there, and in the space of three months she wrote 50,000 words to Murry, anticipating a joyful reunion. They got married after her return in May 1918, but Katherine was convinced he wanted to get rid of her. He forgot to pay her for reviews she wrote and even forgot her birthday. He was increasingly involved with the Bloomsbury Group and Katherine wrote sadly: "He ought not to have married. There never was a creature less fitted by nature for life with a woman."

MEMORIES OF NEW ZEALAND

The completion of "Prelude" made Katherine realize that she had a "perfect passion" for the country she had once been so desperate to leave. From now on, memories of New Zealand became one of the most powerful forces in her writing. In 1920, she published another collection, including one of her most famous stories, "Bliss." This

BACKGROUND

The British Suffragette Movement

Women in Katherine Mansfield's native New Zealand had won the vote in 1893. In England, however, they were still disenfranchised, or denied the vote. By the time Mansfield arrived in 1908, women of the middle and working classes had united in associations to fight for the right to vote. The most militant and far-reaching of these, the Women's Social and Political Union, had been founded in 1903 by Emmeline Pankhurst and her daughters, Sylvia and Christabel. Their aim was "immediate enfranchisement by political means." They chose winning the vote as a tangible target and symbol of emancipation, and were labeled the "suffragettes" in a sneering article in a British newspaper.

When peaceful demonstrations proved useless, the suffragettes became militant, burning churches and smashing windows. Women clashed with police as they tried to present petitions to parliament. On one occasion, "bloody Friday," the women met with extreme brutality. Many were imprisoned, and the force-feeding of those on hunger strike in prison was notorious. They suspended their campaign during World War I. Women won partial voting rights in 1918, and full rights in 1928.

Tea with Sickert: Ethel Sands (c.1920s)
Mansfield's stories about relationships often show the tension, fragility, or instability
behind the conventions. Even teatime, shown here, might be fraught with meaning.

earned her a substantial sum for the first time, and she traveled to Switzerland. Her former lover, Sobieniowski, chose this moment to blackmail her, in return for some letters which referred to the Chekhov story she had plagiarized. Katherine paid up, not wanting Murry to know.

By October 1922, Katherine was very sick and sought the help of a charismatic Greek-Russian, George Gurdjieff, who ran a clinic in Fontainebleau, France. He claimed to heal his patients by simple communal living. Katherine happily did her share of peeling vegetables, wrapped in her fur coat against the bitter cold. She found some form of peace – a remission from fear and isolation if not from her disease. She sent for Murry and sat with him, fantasizing about the simple rural life they might lead together. On January 9, 1923, she died after a sudden hemorrhage. She was 34 years old.

A New Kind of Story

Katherine Mansfield is one of the few major writers to have worked exclusively in the medium of the short story. She was a true innovator who broke the established tradition that made plot and characterization the overriding concerns of fiction. "No novels, no problem stories, nothing that is not simple, open" was her aim. She explores the unspoken, private experiences of people who do not have a voice, such as children or lonely working women.

The circumstances of her characters sometimes differed from her own, but she conjures up their isolation and the struggle for survival from her own experience. One of her strengths is her ability to enter into the minds of her characters and convey a sense of mood or pathos through the skillful blending of interior monologue and descriptive prose.

Mansfield was an admirer of the Russian writer Anton Chekhov, who was one of the outstanding dramatists of the late 19th-century and one of the greatest short-story writers ever. She was influenced by him, but it was an influence she finally absorbed rather than merely reproduced. Toward the end of her life, she was often called "the English Chekhov" – high praise indeed, although it did not do justice to her originality.

Another source of inspiration was her childhood in New Zealand. Katherine Mansfield's stories are intensely personal. For example, her greatest story, "Prelude," is based on her early family life, and this source never ceased to fascinate her. The very difference between the two worlds of her past and present probably provided the

> "As far as I know, it's more or less my own invention."

stimulus. "I want to write about my own country till I simply exhaust my store … Oh, I want for one moment to make our undiscovered country leap into the eyes of the Old World."

"Prelude" has all the qualities of Mansfield's mature art: a plunge straight into the story; a strong visual quality; fragmentary episodes; objects that take on a symbolic significance; and a sense of sensations at play behind external events. One friend asked her, "What form is it?" Her reply was, "As far as I know, it's more or less my own invention."

Mansfield was equally interested in the complex, fraught, and often treacherous relations between men and women, as reflected in "Bliss." In it, a young, dashing couple have a perfect life together. Bertha, the young wife, is overcome "by a feeling of bliss – absolute bliss! – as though you'd swallowed a bright piece of that later afternoon sun and it burned in your bosom." But there are subtle hints that things are not as they seem, and the sting in the story's tail is sharp.

With the exception of her New Zealand writings, Mansfield's stories tend to be set in boarding houses, trains, or cafés, often in continental Europe, reflecting her own rootless existence and her travels in search of a cure. In her journal she recorded the pleasure she took in observing fellow passengers and the places she saw. She revised her work endlessly, altering the length and sound of sentences to fit a character "and to fit her on that day at that very moment." It was such dedication, she felt, that kept her alive.

Henri Matisse

In the simplicity of his line and the boldness of his colors, Matisse stands unrivaled among his contemporaries. He and Picasso were the most innovative artists of the 20th century.

Although he struggled early in his career, Matisse found wealthy patrons when he was in his 30s and was able to devote the rest of his life to developing and refining his radiant art. His dazzling experiments with color marked a turning point in the history of art, and formed the basis for many subsequent artistic movements. Even when bedridden in old age, he created works that pulsate with life and color.

FROM LAW TO ART

Henri Emile Benoit Matisse was born on December 31, 1869, in the northern French town of Le Cateau. His parents, Emile and Anna, had met in Paris when he was a draper's assistant and she was a milliner. Soon after Henri's birth, the family moved to the nearby village of Bohain-en-Vermandois, where Emile set up shop as a druggist and grain merchant. Henri was an intelligent boy and did well at school. In 1887, aged 17, he went to Paris to study law. Two years later, Henri started attending early morning drawing classes before setting off for a day's drudgery as a lawyer's clerk. In 1890, when he was convalescing from an operation for appendicitis, he took up painting. It came as a revelation: "When I started to paint, I felt transported into a kind of paradise."

His father was dismayed at the idea of his son giving up the secure profession of law for such a precarious one as painting, but eventually he gave his permission for Henri to become a full-time art student. His decision was influenced by the fact that Henri was going to study under Adolphe William Bouguereau, one of the most successful and respected academic painters of the day. Bouguereau's approach seemed mechanical and superficial to Henri, however, and in 1892, he found a more congenial teacher in Gustave Moreau, a popular instructor at the School of Fine Arts, which was the most prestigious art academy in France.

Moreau was an open-minded teacher who encouraged his students to develop their personal talents. He urged Matisse not only to copy Old Masters in the Louvre, but also to go out into the streets and draw, taking his subjects from everyday life. Like most students, Matisse was poor, living on a small allowance from his father.

In 1896, at 26, Matisse had his first modest success in the Paris art world when four of his pictures were exhibited at the Paris Salon. At this time his paintings were mainly still lifes and landscapes painted in rather somber tones. Two years later, in 1898, Matisse married Amélie Parayre. She believed in his talent and set herself up as a milliner to help support him as he struggled to make a living from painting. They had two children – Jean and Pierre, born in 1899 and 1900.

By this time, Matisse's style had changed considerably, for he had discovered the joy of color.

Self-portrait: Henri Matisse
Matisse drew this portrait in October of 1939.

954

At first he had adopted the lighter tones of the Impressionists. Then, in 1899, he began to experiment with Neo-Impressionism, in which small areas or dots of pure color are placed close together on the canvas to create a brilliant and vibrant effect. In June 1904, Matisse had his first one-man show at the gallery of Ambroise Vollard – a picture dealer renowned for his support of forward-looking artists – but it was not a success.

KING OF THE WILD BEASTS

Later the same year, Matisse changed his style again. He began using even brighter colors and composing in bold, flat areas. Sometimes he used color non-naturalistically to create striking pictorial effects: he even painted a portrait of his wife in which a green stripe runs down the center of her face. Some of his friends and associates were beginning to handle color in the same bold way,

KEY DATES

1869	*born in Le Cateau, France*
1887	*studies law in Paris*
1889	*begins drawing classes*
1890	*takes up painting*
1892	*joins Moreau's studio*
1896	*pictures shown at Paris Salon*
1898	*marries Amélie Parayre*
1905	*exhibits Fauvist works at the Salon*
1916	*begins to spend winters at Nice*
1921	*French government begins to buy Matisse's work*
1925	*awarded Legion of Honor*
1931-32	*works on* The Dance *in Nice*
1937	*starts working in paper cut-outs*
1948-51	*works on Chapel of the Rosary*
1954	*dies at Nice*

and in the fall of 1905, they exhibited together at the Salon in Paris. Their work was mocked by most of the critics and they were given the name Fauves, French for "wild beasts."

But the exhibit proved to be an important turning point in Matisse's career. The painting that attracted the most insults was his *Woman with a Hat*, but it was admired by Gertrude and Leo Stein, an American brother and sister who lived in Paris and were to be among the first collectors of modern art. They decided to buy it, and then bought more of Matisse's work, becoming his first noteworthy patrons. A year or so later, a rich, cultivated Russian collector, Sergei Shchukin, followed the Steins' example. This patronage freed Matisse from the financial insecurity that had previously dogged his career and meant that he could afford to travel. He went to Germany, where his work was becoming popular and influential, and also further afield to Morocco, Spain, and Russia.

The outbreak of World War I in 1914 put a stop to his travels for the time being. At 44 he was too old to enlist, but he was continually worried about the fate of friends: Georges Braque, one of his Fauve colleagues, was wounded while serving in the French Army in 1915. Matisse painted little for the next few years, concentrating instead on etching and playing the violin. He joked that it was insurance: if his eyesight failed, he could always play for money.

Although the war slackened Matisse's output, it did not have any perceptible effect on the appearance of his paintings; unlike many of his contemporaries, he was not interested in reflecting the events going on around him. He continued to be concerned with aesthetic problems: "to study separately each element of construction; drawing, color, values, composition; to explore how these elements could be combined into a synthesis without diminishing the eloquence of any one of them by the presence of the others." Summing up the principle of his work, he said: "What I dream of is an art of balance, of purity, and serenity, devoid of troubling or disturbing subject matter ... something like a good armchair in which one rests from physical fatigue."

From 1916 onward, Matisse spent most of his winters on the French Riviera, mainly at Nice. The dazzling light, with its play on the white stucco buildings and the clear sea, was irresistible to an artist for whom color had become of paramount importance. He painted radiant still lifes, interiors, and female nudes. The curvaceous nudes are usually shown in relaxed poses, a reflection of the intimacy between painter and model.

THE HEIGHT OF SUCCESS

During the 1920s, Matisse began to gain official recognition in France, and examples of his work entered collections all over the world. In 1921, the French government purchased one of his paintings, and in 1925, he was created a chevalier of the Legion of Honor. By the 1930s, his reputation as one of the great figures of modern art was unassailable, and he was the subject of a succession of books, articles, and exhibits. Between 1930 and 1931, for example, there were major exhibits of his work in Basel, Berlin, New York, and Paris.

Since he had begun spending his winters in Nice, Matisse had rarely done any traveling other than the journey between Paris and the south of France. During the 1930s, however, he began to travel extensively again. In 1930, he went to America. While he was there, he traveled to Merion, Pennsylvania, to meet Dr. Albert C. Barnes, the country's foremost collector of his work.

Barnes commissioned him to paint a large-scale mural decoration for his museum. Matisse carried this out in Nice during 1931 and 1932, working in an abandoned film studio since a normal studio was not big enough. When *The Dance* was delivered to Barnes, it was discovered that Matisse had been given the wrong measurements, and consequently the work did not fit the intended space. Matisse started again and painted *The Dance II*, which is now displayed in the Barnes Foundation as originally planned.

Even though he was now rich and famous, Matisse continued to work prodigiously and passionately. In addition to paintings, he produced a wide range of other work, including sculpture, book illustrations, and designs for stage decor.

By this time, World War II was imminent. Matisse considered emigrating, but decided to stay in France. The Germans captured Paris in June 1940, but they did not yet occupy the south of France, where Matisse now made his permanent home, living in a suite of rooms in the Hotel Regina in Nice. He was looked after by Lydia Delektorskaya,

BACKGROUND

The German Occupation

The Germans invaded France in May 1940, and captured Paris the following month. An armistice was signed between the two countries and the French government withdrew to Vichy in central France. The Germans then controlled the northern half of the country, while the southern half was governed from Vichy. This situation lasted only until November 1942, when Hitler annulled the armistice and occupied all of France. The Vichy regime maintained a shadowy existence as a German tool. Many artists and intellectuals left France as soon as they could after the German invasion, though some, including Picasso, remained defiantly in Paris throughout the war. The city was liberated by Allied troops on August 25, 1944, and the Vichy government, which had never been recognized by the Allies, collapsed in 1945.

La Tristesse du Roi (The Sorrow of the King): Henri Matisse (1952)
This bold and original work is an example of Matisse's paper cut-outs. "The paper cut-out," he said, "allows me to draw in the color. It is a simplification for me."

a Russian woman who had modeled for him in the 1930s and who now became his housekeeper, secretary, and confidante.

In 1941, Matisse had two operations for duodenal cancer. Surprised to find he had survived them, he felt he had been granted another life, and although he was increasingly confined to bed or a wheelchair, he continued working indomitably. As the war progressed, Nice became a potential target, and in 1943, Matisse moved to the more secluded town of Vence, where he lived until the beginning of 1949.

When he was convalescing from his operations, Matisse had been nursed by a woman who afterward became a nun in a convent in Vence. In thanks for the care he had received, Matisse designed a chapel for the nuns – the Chapel of the Rosary. Matisse began work in 1948 and the chapel was consecrated in 1951. Matisse said the chapel expressed "the nearly religious feeling I have for life." It was the finest work of his old age.

Matisse was too frail to attend the consecration of the chapel, but he still continued to work with enthusiasm. His final creations include large and exuberant abstract works made by cutting out shapes of brightly colored paper and pasting them on a background — Matisse did the cutting himself and directed assistants as to where he wanted them placed. He first started working on these "paper cut-outs" in 1937. The colors were so dazzling that Matisse's doctor advised him to wear dark glasses. Matisse died peacefully at Nice on November 3, 1954, and the world mourned the passing of one of the century's greatest artists.

King of the Wild Beasts

Matisse was the leading figure of a group of painters who caused a sensation when they first exhibited their work together at the Paris Salon in the fall of 1905. They shocked the public by using color with a ferocious intensity that had not been seen before, and by distorting and flattening their forms. Rebelling against the formal and unemotional compositions of Neo-Impressionism, these artists used line, color, and pattern to express their feelings. They were influenced by the way in which van Gogh and Gauguin used color (*see pages 5:630 and 635*). A critic named Louis Vauxcelles made a derogatory remark about wild beasts – *fauves* in French – and the name stuck. The artists were subsequently known as the Fauves.

Matisse, in particular, came in for a good deal of abuse, which hurt him greatly. He was dubbed the "king of the wild beasts." Yet Matisse said he wanted to "exalt all colors together, sacrificing none of them."

Others in the group included Georges Braque, André Derain, Albert Marquet, Georges Rouault, and Maurice de Vlaminck. They were never a particularly coherent group, and did not have written theories or set programs. Instead, they banded together temporarily, mostly out of rebellion against the academic system, and also because their brightly colored works could not be hung in any other company.

All the Fauves went on to have distinguished careers, although this must have seemed unlikely when abuse was being poured on their pictures. One critic of the 1905 exhibit wrote of the "formless confusion of colors … some splotches of pigment crudely juxtaposed; the barbaric and naive sport of a child who plays with the box of colors he just got as a Christmas present."

Fauvism was a short-lived movement, for by 1907, the members were drifting apart and developing in different artistic directions. Braque, for example, became the joint founder of Cubism with Picasso. By 1908, the Fauves had fallen apart as a group.

Fauvism was extremely important in the history of 20th-century art. It was the first of a series of radical movements that challenged traditional ideas about art in the period leading up to World War I, and it set the agenda for many subsequent developments. It had a powerful influence on Expressionism in Germany between 1906 and 1913, for example. In this movement, artists such as Ludwig Kirchner used violent, acidic colors, and distorted shapes to express their disgust at World War I.

Henri Matisse (1948)
This photograph shows Matisse working on his papier découpés – paper cut-outs – at the age of 79.

Amedeo Modigliani

A fiercely original painter and sculptor, Amedeo Modigliani lived a bohemian existence in Paris. He spent his short, unsettled, and tragic life in poverty, consoled by drink, drugs, and a succession of lovers.

Although he was talented as both a painter and sculptor, Modigliani sold little during his lifetime. Limiting his range of subjects to portraits and nudes, the Italian developed his own highly individual style, and now ranks among the great artists of the 20th century. Yet he was a self-destructive character; weakened by poverty and his lifestyle, he was only 35 when he died.

A LIVELY CHILDHOOD

Amedeo Clemente Modigliani was born on July 12, 1884. His family, who lived in the Italian Mediterranean port of Livorno, were rumored to have had connections with bankers to the popes. But in the year Amedeo was born, his father Flaminio's business failed and he was forced to travel widely, leaving his wife to run the household.

Both Flaminio and Eugenia were Sephardic Jews, descendants of the Jewish settlers in Spain. As part of their faith, the Modigliani family respected their ancient traditions and valued a liberal education. Eugenia wrote literary articles and did translation work to support her family.

Amedeo, the youngest of the family, grew up in a lively and stimulating environment, and soon developed a variety of cultural interests way beyond his years. His mother introduced him to a range of poetry and his aunt taught him the philosophy of the German philosopher Friedrich Nietzsche, who wrote of the artist exiled from society by his creative genius and intuitive nature.

Modigliani was a spoiled and capricious child, partly because he was a beautiful-looking little boy and partly because of his poor state of health. In the summer of 1895, he developed pleurisy, and in 1898, he suffered a serious attack of typhoid. In the same year, he began art classes, but these finished in 1900, when tuberculosis put an end to his studies. During a period of convalescence, Modigliani traveled around Italy. With his health restored, he left Livorno in 1902 to study first in Florence and then in Venice, where he made many friends, including Umberto Boccioni (*see page 882*), one of the founders of Futurism.

A BOHEMIAN IN PARIS

In January 1906, Modigliani went to Paris, hoping to earn his living as a portrait painter. The young man enthusiastically adopted a bohemian lifestyle. He used stimulants, mostly hashish and alcohol, perhaps in an attempt to overcome his shyness. He appears to have lived in conditions of extreme poverty soon after his arrival in Paris. He began a nomadic existence, living in a succession of cheap rooms in lodging houses in Montmartre, then finding even cheaper lodgings south of the Seine River in Montparnasse. The small allowance his mother sent was insufficient to support a life spent increasingly in bars and brothels. Often there

Self-portrait: Amedeo Modigliani
An undated painting of the artist.

was not enough money to buy art materials or to pay his bills. Modigliani was notorious for his drinking bouts and was a familiar sight in many Parisian cafés and bars, where he would make sketches for a few francs in order to buy something to eat.

His lifestyle made him feel alienated in Paris, and he became more aware of his Jewish origins. He began to identify with the group known as the *peintres maudits* – accursed painters – who were mostly Jewish, stateless, and poor. Unlike these artists, Modigliani had been trained and had the advantages of a liberal upbringing. But he shared their insecurities in a foreign city that did not welcome destitute artists, especially Jewish ones.

From the beginning, Modigliani limited his subject matter to portraits and nudes; he painted only a few landscapes. He was not concerned with portraying realistic appearances but with expressing the feeling and mood of his models. In his portraits, sloping shoulders and slender necks support gently tilting heads in which small mouths, long noses, and dark, introspective eyes are caught in a hypnotic expression. He used elongation of the head and neck to enhance the expressive quality of his line, and distorted features to show up certain characteristics of the sitter.

KEY DATES

1884	*born in Livorno, Italy*
1900-1	*tuberculosis forces him to give up studies; tours Italy*
1902-06	*studies in Florence, then Venice*
1906	*arrives in Paris*
1909-14	*concentrates on sculpture*
1914	*meets Beatrice Hastings*
1917	*meets Jeanne Hébuterne; Zborowski, his dealer, arranges first solo exhibit*
1918	*travels to south of France*
1919	*daughter born*
1920	*dies; Jeanne commits suicide*

Modigliani's confident use of line characterizes the countless drawings he made through his career, but for him drawing was primarily the preliminary to painting. He painted quickly and intensively, usually completing a picture in only one sitting. The act of painting required an immense emotional investment from the painter, and a friend noted that he worked best in a rage, stoked by cheap alcohol, moving about, sighing deeply, and often crying out in frustration.

A DECADENT ARTIST

Modigliani's behavior began to deteriorate. He was living out a decadent image of the artist, always wearing "chestnut corduroy with a brilliant scarf around his neck and with a broad-brimmed felt hat." His continual financial hardships made him unreasonable; he became aggressive in artistic discussions, and even tried to destroy the work of other painters. Modigliani seemed to be conforming to his adolescent literary inspirations and also to Nietzsche's ideas of alienated genius. He felt that: "People like us have different rights from other people because we have different needs which put us … above their morality."

In 1907, a memorial exhibit of Cézanne's (*see page 5:594*) work influenced Modigliani, and soon he was imitating Cézanne's way of suggesting form and space through color. This new preoccupation with form led to his first work in sculpture. Between 1909 and the outbreak of war in 1914, he produced few paintings; instead he devoted most of his energies to sculpture. He carved wood and stone, often using stone blocks removed from construction sites by night or lifted from the road surface. He finally abandoned sculpture in 1914.

This change marked a vulnerable period in Modigliani's life. He was gradually giving up sculpture, his first love, and he was often ill. His allowance from home ceased and he was exploited by unscrupulous speculators. His depression was heightened as a result of World War I, as he missed many of his friends who had gone to fight. This vulnerable period in his life coincided with Modigliani's first sustained relationship. When

BACKGROUND

The Dreyfus Affair

When Modigliani first went to Paris in 1906, the talk of the city was the ending of a spy scandal that had rocked France for more than ten years.

In 1894, Captain Alfred Dreyfus, a Jewish army officer, was convicted of betraying military secrets to Germany. As Dreyfus was a wealthy man who had no motive for such an action, people became suspicious that there had been a miscarriage of justice. New evidence pointed to a Major Esterhazy as the culprit, but the Army refused to admit its error. The deputy chief of the Secret Service committed suicide when he was shown to have tried to preserve "the honor" of the Army by a series of forgeries and cover-ups. It became obvious that Dreyfus was the innocent victim of political intrigue and anti-Semitism, and he was pardoned by the French president. But it took another seven years before a court of appeal declared, on July 12, 1906, that Dreyfus had been wrongly convicted. He was reinstated, decorated, and fought for France in the First World War. He died in 1935.

Beatrice Hastings, a South African journalist, met the artist in 1914, it was not his art but his appearance that attracted her. She and the "pale ravishing villain" embarked on a stormy and destructive affair, in which they drank and took drugs together.

A MASTER OF NUDES

The artist was encouraged at this time by the dealer Paul Guillaume, who bought all his works and rented a studio for him. It was here that Modi — as other artists called him — painted his famous series of nudes. Preferring to use unprofessional models, he always painted nudes in series, showing he was working on them exclusively over a period of time. Modigliani's nudes are blatantly erotic, sensual, and self-confident, and place him among the masters in this field, including Titian, Goya (*see pages 1:126 and 4:5120*), and Renoir.

Modigliani and Beatrice continued their tempestuous and violent affair. Their arguments often deteriorated into physical fights, and on one occasion the artist actually threw his lover out of the window. By 1916, their relationship was completely exhausted.

In July 1917, Modigliani met Jeanne Hébuterne, a talented 19-year-old student at the Académie Colarossi. He painted her portrait numerous times, and she bore him a daughter, Jeanne, in 1919. Their affair was stormy. Jeanne was timid and devoted, however, and suffered his abuse and infidelities.

Success remained elusive for Modigliani. Yet his portraits achieved harmony and greater insight during the war years. His new agent, Leopold Zborowski, tried to stimulate the growing market for Modigliani's work by taking canvases round Paris on foot to collectors. In December 1917, Modigliani's first one-man show was staged at the Berthe Weill gallery, where Zborowski, anxious to attract visitors, put several nudes in the window. The police branded the display obscene and closed the exhibit on its opening day.

Despite selling little of his work, the agent gave Modi a small allowance, and in April 1918, organized a trip for the artists he represented to the south of France. Jeanne accompanied Modigliani, as did other artists, including his friend Chaim Soutine. Here Modigliani rediscovered his admiration for Cézanne and also painted his first landscape since his student days in Italy.

Jeanne Hébuterne: Amedeo Modigliani (c.1918)
*In this stylized portrait of his mistress, Modigliani elongates
the face and neck, creating a sense of grace and elegance.*

On his return to Paris that year, Modigliani became more superstitious and uncertain, perhaps reflecting the lack of success which threatened his self-respect. His drinking bouts in bars usually ended in the early hours of the morning. Contemporaries described him on these occasions as "very drunk, abusive, and terribly emaciated." January 1920 was bitterly cold and Modigliani contracted pneumo-nia. He collapsed in the studio he shared with Jeanne, and the terrified girl watched him struggling without thinking of sending for a doctor. On January 24, he died of tubercular meningitis. He was 35. The following day, Jeanne, pregnant with their second child, committed suicide by throwing herself from a fifth-floor window. They were buried together at Père Lachaise cemetery in Paris.

The Painter-Sculptor

Modigliani always considered himself a painter-sculptor, which is is how he introduced himself on his arrival in Paris in 1906. Having made his first sculpture at Carrara in Italy – close to the marble quarries that had provided Michelangelo (*see page 1:96*) with stone – in 1902, he decided to realize his deep ambition to be a sculptor.

Between 1909 and 1914 he produced barely 20 pictures. Inspired by the Rumanian sculptor Constantin Brancusi (*see page 917*), whom he met in 1909 and next to whom he had a studio for a couple of years, Modigliani concentrated instead on carving in wood and stone. He created a series of heads which were influenced by the boldness and power of African and Oceanic sculpture. These works integrate his concern for mass, volume, and form. The force of the mysterious, haunting faces lies in their inscrutable expressions and in their monumentality: the viewer is always aware of the rough-hewn limestone block from which they have emerged.

Unlike Rodin, Picasso, and Matisse (*see pages 5:672, 8:972, and 954*), Modigliani was never interested in modeling in clay, which he regarded simply as "too much mud." He reputedly stole supporting beams from the new subway line nearby for wood to carve, and many of his figures were created from stone blocks which he removed from construction sites by night, or lifted from the road surface, which was cobbled.

Head: Amedeo Modigliani

Modigliani carved this elegant stone sculpture between 1909 and 1914.

Modigliani had never received any training in sculpture, however, and possessed neither the discipline nor the strength – the dust irritated his lungs – to complete his most ambitious project: to construct a temple to humanity adorned with pillars in the form of caryatids, or draped female figures. Unable to find materials in wartime, he stopped sculpting in 1914, but the experience fed his art, giving him a sure sense of form. In fact, his painting began to take on the characteristics of his sculpture, especially the modeled faces of his last portraits. The regret at his failure to continue with sculpture must have been intense. Carving combined aggression and finesse, giving Modigliani perhaps the best vehicle for his art of personal feeling.

Modigliani's contribution to modern art lies in his individuality. He submitted to the influence of only one painter, the French 19th-century artist Paul Cézanne. Cézanne's work paintings address the same concern for mass, volume, and form. Modigliani was not concerned with the artists of the avant-garde, such as Picasso, but instead developed his own highly individual style based on the integrity of form in keeping with the tradition of the past. Yet his modernity is reflected in his use of compositional devices which make his portraits appear new and unique; it is impossible to confuse his work with that of any other artist.

Piet Mondrian

One of the most important figures in the development of abstract art, Piet Mondrian invented a way of painting for modern life. His enormous influence has even been felt in graphic and industrial art.

Mondrian produced paintings that exemplify all that is profound and optimistic in 20th-century art. Yet he always believed that he continued the tradition of the Old Masters from whom he learned his craft. He only found his distinctive style of abstract painting – in which all pictorial references to people, objects, three-dimensional space, and texture are absent – after years of experiment and struggle. For the Dutchman, such dedication required solitude; in many ways, his life mirrored his art.

A DIFFICULT CHILDHOOD

Piet Mondrian was born on March 7, 1872, in the quiet Dutch town of Amersfoort. He was given his father's name, Pieter Cornelis Mondriaan, but later simplified it. Pieter senior was the headmaster of the local elementary school and a lay preacher. A Protestant extremist, he saw the widespread poverty and unemployment of the 19th-century Netherlands as signs of impending doom. He would leave Piet at home with his three brothers and elder sister, Johanna, while he traveled the countryside addressing religious gatherings. Their mother was often sick, so Piet and Johanna looked after the household from an early age.

The dual influences of premature responsibility and his father's puritanism were to influence Piet throughout his life. During his teens and into his 20s, he was introverted and found it difficult to make friends. Emotional stress often brought

on bouts of illness and a sense of despair. At times, it was only his love of drawing and painting that sustained his psychological stability. His father had taught him to draw when he was a small child. Together, they would copy pictures from prayer books for Pieter senior to use in his preaching.

In 1892, Piet enrolled in the Amsterdam Art Academy. In accordance with his father's wishes, he had already obtained his elementary and high school teaching certificates. He did not join in student life in bustling Amsterdam, but lodged with friends of his father's, a wealthy and deeply religious family. At this time, the young man also became a member of the highly conservative Dutch Reformed Church.

PAINTING LANDSCAPE

In 1897, at the end of his studies, Mondrian went to live with his brothers in the countryside. There he began to record scenes of traditional rural life in sketches, which he worked up into gentle, pastoral watercolors. In the following years, Piet applied twice for the coveted Prix de Rome travel scholarship, but failed on both occasions. The judges said that he could neither draw well nor inject a picture with liveliness. Mondrian now directed his landscape painting along the path of Dutch and German masters, such as Caspar David

Piet Mondrian
This photograph shows the artist in 1922, at 50.

BACKGROUND

The Theosophical Society

Mondrian encountered the ideas of the Theosophical Society in 1903, and became a member six years later. Theosophy was a spiritual and philosophical movement founded by the Russian-born Helena Blavatsky (1831–1891), who sought to create an accessible, intellectual religion for modern times. After moving to America in 1873, Blavatsky founded the first branch of the society in New York City, together with Henry Steel Olcott. The movement combined ideas from a number of religions, including Christianity and Buddhism. Meditation was the route to achieving inner peace.

In relation to art, Theosophy emphasized the search for harmony and order, and its adherents accordingly adopted a geometric approach to design. This was represented by vertical and horizontal lines, which stood respectively for the male spirit force and the female material force. When these two lines intersected, they formed a cross – the sign of rebirth. Mondrian was an articulate exponent of Theosophical ideas applied to art. "It is painting," he wrote, "that is so well suited to show equilibrium and happiness."

Friedrich (*see page 4:498*). Windmills, night scenes, and seascapes began to predominate. He became interested in the artifice of a painting, rather than in depicting naturalistic scenes.

Around 1908, Mondrian made a breakthrough. He had seen work by Kees Van Dongen, a Dutch artist who belonged to the avant-garde French group, the Fauves. These artists painted in vivid, non-naturalistic colors. Mondrian began applying bright color straight from the tube. His *Windmill in Sunlight* of 1908 is made up of bold yellow, blue, and red. By 1909, Mondrian was a leader of the modern art movement in Holland. His work was exhibited and sold in the Netherlands. That same year, however, the explosion of color was subdued by two events. His mother died unexpectedly. This in turn probably ended his engagement to a young Dutch woman, Greet Heybroek.

Mondrian adopted a flatter, colder style. His paintings began to reflect his interest in Theosophy, a spiritual program which combined Christian mysticism with eastern meditative exercises. He joined the Theosophical Society in 1909. The new work held secret and symbolic meanings. But critics now turned against the artist, caustically noting the connection between Mondrian's paintings and his membership in "The Brotherhood."

A DECISIVE MOVE

Mondrian decided to leave the Netherlands for Paris, which was then the world's leading art center. In 1911, he moved into a studio overlooking the railroad station in the Montparnasse quarter. He sought to create a modern art idiom which could be described as "momentous," yet which lay within the tradition of the great masters. Although he admired the Cubist works of Pablo Picasso (*see page 972*) and Georges Braque, he did not attempt to meet them. He was content just to live and paint in "their" city. As if to mark a new beginning, he altered his name to Piet Mondrian.

At this time, the Dutch composer Jacob van Domselaar visited Mondrian's studio, and remarked that he saw "Trees. Nothing but trees." With his tree motif, Mondrian was adapting the ideas of Cubism to his own style. Uniquely, Mondrian went further than his contemporaries in decen-

tralizing the composition from the picture space. He evoked the form of a tree with black lines and patches of color that seemed to have a life of their own. At the same time, Mondrian recognized — from observing the crumbling, poster-covered walls around Montparnasse — that the external world also settled into abstract patterns without any help from artists. This was important to him, for he had no wish to advance to abstraction by turning his back on nature.

RETURN TO PARIS

When World War I broke out in 1914, Mondrian returned to Amsterdam. For the first time in his life, he involved himself in society. At the age of 44, he bought his first tuxedo and painted himself wearing it. His influential new acquaintances included the art historian H.P. Bremmer, who persuaded a rich family of collectors, the Kröller-Müllers, to pay the artist an annuity in return for his most important works. Meanwhile, his painting had lost any reference to identifiable objects.

The aims of abstraction coincided for Mondrian with those of Theosophy; the movement advocated austerity and quietude as the means to spiritual knowledge. Mondrian covered his canvases with colored squares and rectangles bisected by little dashes of black line. He saw these patterns as edifices, and sometimes compared his work to the medieval building of cathedrals.

Mondrian's work excited the interest of many leading Dutch modernists working in design and architecture. He collaborated with the painter Theo van Doesburg. They produced a journal, *De Stijl — The Style —* in 1917, in which they put forward their new ideas about design. Yet Mondrian's art again began to alienate his public, who could enjoy abstract painting only if it had a decorative quality. In 1918, his revolutionary *Lozenge with Grey Lines*, shocked its audience with its emphasis on mathematical precision. The artist lost the support of Bremmer and the Kröller-Müllers.

On returning to Paris in 1919, Mondrian discovered that his own advances in painting had not been matched in his favorite city. He felt

isolated and despaired about his next move. He even told van Doesburg of his intention to give up painting and go to work in a vineyard in the south of France. Mondrian remained in Paris, however, and began painting single flowers against bright red or yellow backgrounds. Such works represented a return to his spiritual roots, which coincided with the death of his father in 1921. These two episodes seem to have given the artist the impulse to combine all the advances he had made toward abstract art.

From now on, Mondrian arranged his canvases in a grid of black lines, filling in selected squares and rectangles with black, gray, white, and primary colors. Having found the form for his expression, Mondrian spent the next 20 years perfecting it. On showing a new canvas to a friend, he would ask: "Don't you think, all the same, that it's just a little bit further on?" His output, formerly prolific, slowed down. His new method required constant over-painting, and a canvas might take months to complete. The nature of his work dictated an almost total withdrawal from society. His life was apparently as devoid of messy detail as his paintings.

In the early 1930s, Mondrian's painting became less full of color, while the white space and bisecting black lines came to dominate. The colored

KEY DATES

1872	*born in Amersfoort*
1892	*enters Amsterdam Art Academy*
1909	*joins Theosophical Society*
1911	*moves to Paris*
1914	*returns to Amsterdam*
1917	*co-founds* De Stijl *journal*
1919	*returns to Paris*
1921	*father dies; begins grid paintings*
1940	*settles in New York*
1944	*dies in New York*

Broadway Boogie Woogie: Piet Mondrian (1942–43)

This colorful painting suggests both the clarity and order of the New York street system, and the bustle and energy of its traffic, including the famous yellow taxis. The picture is carefully balanced and has a pulsating rhythm.

rectangles were squeezed to the paintings' sides or eliminated altogether. Mondrian achieved a sense of peace – his life's aim – in these late works.

In 1940, after a stay in London to escape World War II, he made the second major move of his life – to New York. Mondrian loved the city and was perhaps truly happy for the first time in his life. In America, his work took on the rhythms of the jazz he loved to listen to while painting, as in *Broadway Boogie Woogie* (1942–43). He replaced the black bisecting lines with rhythmic lines of broken color bordering white spaces – a reference to the flickering city lights of a few blocks in New York City. Mondrian was at work on the follow-up, *Victory Boogie Woogie*, when he fell sick with pneumonia. He died on February 1, 1944.

The Power of Line

Piet Mondrian was a founder member and constant contributor to the artistic journal *De Stijl – The Style –* from its first publication in 1917 until 1927. The group that congregated around the magazine was also known as De Stijl. It included the artists Theo van Doesburg, Bart van der Leck, and Vilmos Huszar, the Belgian sculptor Georges Vantongerloo, and the architect Gerrit Rietveld. They held the view that the visual arts and architecture should share a unified approach to design. One of the group's major influences was Dr. M.H.J. Schoenmaekers, whose books, *The Image of the World* and *Principles of Plastic Mathematics*, were published around 1916. These writings, which were linked to the Theosophic movement, became the cornerstone of the group's ideas.

> De Stijl's projects always relied on the exclusive use of the straight line, and bold primary color with black, white, and gray

De Stijl served as an artistic manifesto, stating the group's principles and acting as a forum for their work. For three years, the group created a nonindividualized form of art in which each project could have been done by any group member. Mondrian wrote in the magazine that "only when the individual no longer stands in the way can universality be purely manifested." Individual characteristics did re-emerge, however, sometimes causing fierce argument and division. Despite this, the influence of De Stijl throughout the 1920s and 1930s was enormous, particularly in architecture and the applied arts.

De Stijl's projects included designs for theater, buildings, and furniture, and always relied on two essential elements: the exclusive use of the straight line, and bold primary color with black, white, and gray. Originally, their manifesto was to have been called simply *The Straight Line.* Mondrian was influenced by van der Leck, whom he met in 1915, and whose studies led him to believe that only primary color could express "the serene emotion of the universal." Mondrian named this unified approach to color and composition "Neoplasticism."

De Stijl artists were concerned with the geometry of space, and their work had a mathematical edge. But this did not mean that painters such as Mondrian viewed their work in a dispassionate way. Completely free of clutter, Mondrian's studio in Paris was itself more like a laboratory for researching the artistic future than a conventional artist's studio. His working methods too were almost scientific in their precision. Mondrian did not work at an easel but on a sheet of white waxed canvas laid across a low table. It was only after months of arranging and finely adjusting transparent cut-out shapes that he finally applied paint to canvas. Each minute change to his design was jotted down in his notebook. For Mondrian, the position of the black lines and the rectangles of white paint was all-important.

Pablo Picasso

With his fertile imagination, extraordinary natural ability, and remarkable versatility, Picasso revolutionized modern art. He remains one of the most influential painters of the 20th century.

A legendary figure, Picasso dominated the artistic avant-garde up until World War II, and few artists escaped his influence. Picasso's inventiveness encompassed many different styles and media. His most significant contribution was the development of Cubism, with Georges Braque, which paved the way for the abstract art of recent decades. Picasso continued to work until the 1960s.

A PRECOCIOUS CHILD

Pablo Ruiz Picasso was born on March 25, 1881, in Málaga, then a quiet port in southern Spain renowned for its bullfighting. It was a difficult birth – the baby apparently had cigar smoke blown up his nostrils to force his first few breaths in the world. Picasso's father, José Ruiz Blasco, was a struggling artist, who also taught drawing and was curator of the local museum. Picasso later adopted the name *Picasso* from his mother, Maria Picasso Lopez, since *Ruiz* was common in the area. He was the only boy in the family. With his good looks and precocious nature, he was spoiled by his many relatives in Málaga.

Picasso never wanted to do anything but paint. He refused to stay at school unless he could keep some paintbrushes and one of his father's pigeons with him. His parents recognized their son's talent at an early age, and encouraged his artistic ambitions. His father taught him the traditional academic techniques; Picasso later said that as a child he could "draw like Raphael."

In 1895, the family moved to Barcelona, where Picasso's father had taken a teaching post at an art academy. Barcelona was an artistic center receptive to the ideas of the European avant-garde. Picasso enrolled at the academy and was put into the advanced classes. But Picasso soon broke with the academic tradition there. He thrived on the intellectual and bohemian atmosphere in Barcelona, and began visiting the city's cafés, where he often joined the discussions of avant-garde artists.

Barcelona was merely a stepping stone: the cultural center of the avant-garde was Paris. Picasso arrived in the French capital in 1900. He settled at the Bateau-Lavoire, a ramshackle wooden building in Montmartre. He spent his days studying classical sculpture at the Louvre. He also studied the works of the artists of the day, such as Cézanne and Toulouse-Lautrec (*see page 5:594 and 696*).

Picasso lived with the poet and journalist, Max Jacob. It was a period of poverty and despair. Picasso had to burn bundles of his drawings for warmth. This hardship was reflected in the haunting pictures of Picasso's first independent style – the Blue period of 1901 to 1905. Its subjects, inspired by the beggars on the streets of Paris, represent themes of poverty and despair. The gaunt figures are rigid against empty backgrounds of cold blues.

It took a statuesque woman to banish the Blue period from Picasso's work. She was Fernande

Pablo Picasso
This photograph was taken in September 1955.

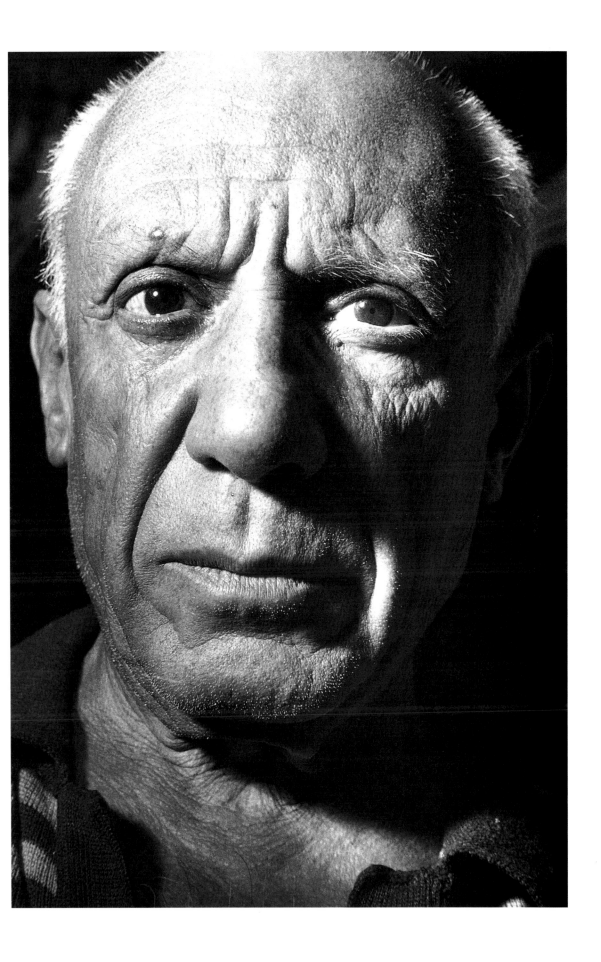

Olivier, with whom Picasso had an affair until 1912. The Rose period paintings of 1905 to 1906, with their graceful serenity and sensuality, were the result of his new security. His subjects were acrobats, dancers, and harlequins. Picasso was working hard at night, going to bed at dawn and getting up for breakfast at four in the afternoon.

MEETING MATISSE

A group of painters soon gathered around Picasso and Jacob. One of these was Henri Matisse (*see page 954*), who was the leader of the Fauves. The name means "wild beasts," and was given to them after their scandalous exhibit of 1905. Picasso was wary of the urbane Frenchman: "North and South poles" was his own description. Despite his respect for Matisse, Picasso had little interest in the Frenchman's abstract use of color. Color was less important to Picasso than form and composition.

By 1907, Picasso had met the wealthy American collectors Leo and Gertrude Stein, who became regular patrons, and the art dealer David-Henri Kahnweiler, who exhibited his work regularly. The artist began to enjoy moderate financial security.

In 1906, a trip to a primitive region of the Spanish Pyrenees, with its Romanesque church carvings, helped mold his new style. Volume and sculptural effects became increasingly important, reinforced by African and Polynesian sculpture. In 1907, Picasso painted one of his most revolutionary paintings – *Les Demoiselles d'Avignon*. This painting shocked even his friends: it overthrew conventional perspective and rejected traditional beauty.

This painting overwhelmed the artist Georges Braque when he saw it. He and Picasso became friends, and together they set out to deconstruct the basis on which western art had rested since the Renaissance. The result of their collaboration was the radical movement named Cubism. The outbreak of war in 1914 halted the partnership. Braque enlisted, but Picasso, as a Spaniard, was exempt. Other friends also enlisted and Picasso felt isolated, finding it difficult to work.

But two years later, the author and artist Jean Cocteau took Picasso to Rome to design the scenery

KEY DATES

1881	*born in Málaga, Spain*
1895	*family moves to Barcelona*
1900	*moves to Paris*
1901-05	*the Blue period*
1907	*paints* Les Demoiselles d'Avignon; *develops Cubism*
1918	*marries Olga Koklova*
1925	*paints* The Three Dancers
1927	*meets Marie-Thérèse Walter*
1936	*meets Dora Maar*
1937	*paints* Guernica
1943	*meets Françoise Gilot*
1946	*moves to south of France*
1961	*marries Jacqueline Roque*
1973	*dies in Provence*

and costumes for a ballet, *Parade*. There Picasso studied Michelangelo and Raphael. He also fell in love with Olga Koklova, a dancer. Olga and Picasso were married in July 1918. With her encouragement, Picasso became a society artist and moved to a desirable area of Paris. He was feted by socialites and lost touch with his old bohemian friends.

Rome opened Picasso's eyes to the bittersweet *commedia dell'arte* — Italian stylized comedy — and he began to paint harlequins again. He was also producing Cubist landscapes and still lifes. When Olga became pregnant, he began a series of monumental mother and child paintings. Their son, Paulo, was born in February 1921.

Throughout the 1920s and 1930s, Picasso frequently changed his style. He was aware of new developments in art, but nothing distracted him from his search for new means of expressing the human form and condition. Picasso continued to distort his female figures, culminating in *The Three Dancers* (1925). This was perhaps a reflection on his marriage. The artist had grown dissatisfied with his lifestyle. In 1927, Picasso began an affair with Marie-Thérèse Walter. When she became preg-

nant in 1935, Picasso asked Olga for a divorce. Even after their marriage ended, Olga remained in the background of his life until her death in 1955. She wrote him abusive letters, and would turn up at exhibits to scream insults at him.

No sooner had Marie-Thérèse given birth to a girl, Maia, than Picasso found a new love in Dora Maar, a photographer. Dora was temperamental, however, and their relationship was stormy. From 1936 onward, Picasso subjected her to the most violent distortions in his art.

GUERNICA

In 1936, Picasso was in Spain when civil war broke out. He threw himself into the defense of the republic against Franco's uprising. He accepted the directorate of the Prado Museum in Madrid, and the government commissioned him to produce a mural for the International Exhibit in Paris. Picasso took the 1937 destruction of the little town of Guernica by Nazi bombers as his subject. He painted the vast canvas in just a month.

By this time, he was back in Paris, where he remained throughout World War II, mocking the occupying Germans by handing them postcards of *Guernica* as a memento. In 1943, Picasso met the 21-year-old model Françoise Gilot. Their relationship aggravated Dora's disturbed mental state, prompting a breakdown.

In 1944, after the liberation of Paris, Picasso emerged from his studio to immense popular acclaim. Two years later, he moved to the south of France, where he became a celebrated star. Françoise, however, hated the lack of privacy there. The birth of two children, Claude and Paloma, failed to keep their relationship alive. In 1953, Françoise left. Jacqueline Roque quickly took her place. Picasso married Jacqueline in March 1961.

Picasso needed the stimulus of other artists and intellectuals. But after 1945, the center of modernism had moved to New York, while Picasso remained in Europe. After 1939, he would not even visit Spain, for Franco's totalitarian regime was anathema to him. Cut off from these stimuli, Picasso retreated from the avant-garde.

Picasso had become one of the richest artists in history, selling hundreds of works for huge prices each year. He bought a château in Provence, where he became a virtual recluse. Eventually, two operations and failing eyesight halted his painting. On April 8, 1973, Picasso died at the age of 91.

BACKGROUND

The Spanish Civil War

In July 1936, the vicious antagonism between the Spanish right wing and the left-wing Republicans – who won the year's general election – exploded into civil war. General Franco, with the army, the aristocracy, Nazi Germany, and Fascist Italy behind him, led a military uprising that threw Spain into two and a half years of bloody fighting that cost the lives of more than 750,000 people.

On April 26, 1937, Nazi bombers destroyed the Basque town of Guernica, leaving 2000 dead and thousands more wounded. The event outraged the world and inspired Picasso to produce a mural for the Republican government. The Republicans eventually collapsed as Franco's troops captured the major cities of Spain. The war ended in March 1939, with the surrender of Madrid and Valencia to Franco, who became dictator of the country until his death in 1975.

The Three Dancers: Pablo Picasso (1925)

This was among the first of Picasso's paintings to show violent emotion and extreme distortion of the figure. These human "monsters" continued to appear throughout the late 1920s and 30s.

The Cubist Revolution

In the summer of 1908, Braque produced a series of still lifes and landscapes which reflected his technique of breaking up objects and presenting their forms as bold, geometric shapes. When Braque showed these works at the 1908 official Salon exhibit, a critic remarked that Braque "reduced everything to cubes." From this point onward, Braque, Picasso, and their followers were referred to as Cubists.

Picasso and Braque did not see Cubism as a movement, or even a coherent style. The paintings they created were largely painted to satisfy their own interests. "During those years," Braque later wrote, "Picasso and I discussed things which nobody will ever discuss again, which nobody else would know how to discuss, which nobody else would know how to understand."

Because of the private nature of their art, neither artist wrote a manifesto of Cubism. Their own views about their art are largely unknown – the only comment on art that Picasso ever wrote down was: "Painting is stronger than I am. It makes me do what it wishes."

But two things are clear. Firstly, Cubism was not intended to be an abstract art. However difficult they may be to decipher, true Cubist paintings were always intended to reproduce the real world. Secondly, both artists rejected the assumption that a painting should represent the world exactly as it appears. They did not want to produce a mere likeness of the world, but wanted to represent it in a less literal, more conceptual way. Picasso wanted to express the essence of the subject, even if that meant abstracting or taking away unnecessary elements.

> "Painting is stronger than I am. It makes me do what it wishes."

Between 1909 and 1912, Picasso and Braque created the first distinctive phase of Cubism, known as Analytical Cubism. The artists dissected, or "analyzed," the objects they painted, to try to find a set of forms that could suggest the reality of the whole. They then "reconstructed" the object in patterns of overlapping shapes, with recognizable parts – a fragment of lettering, a bottle, a violin – scattered throughout the picture.

In 1912, Braque and Picasso, realizing that Analytical Cubism was becoming very abstract, adopted a new approach, now known as Synthetic Cubism. The most important aspect was the introduction of collage. Instead of breaking down their objects into facets and reconstructing them, the artists started with a set of ready-made fragments – wallpaper, newspaper, and oilcloth – which they built up, or "synthesized," into more concrete images.

Despite their numerous followers, Picasso and Braque accepted only one other artist as a true Cubist – the Spaniard Juan Gris, who, from 1911, was painting "analytical" works in a highly geometric style with bold accents of color. While artists such as the French painters Robert Delaunay and Fernand Léger adopted Cubist forms and structures in their paintings, their works moved increasingly away from the representation of objects toward the development of a purely abstract art.

Arnold Schoenberg

Schoenberg was the most influential musical modernist of the 20th century. He showed immense creative courage and commitment to his ideals in the face of tremendous personal and artistic adversity.

Schoenberg is one of the most misrepresented of all composers. During his lifetime, performances of his music triggered outrage. Even today his reputation remains that of a radical revolutionary who overthrew existing musical laws.

Schoenberg inherited from his predecessors a musical language which was exhausted. Many late-Romantic composers looked for ways out of the dilemma, but Schoenberg made the most daring move. It was he who first ventured into the realm of atonality, seeing in it the next logical step in a great Austro-German musical tradition.

Atonal music is written without reference to the traditional system of major and minor keys, thus wiping out the basic principles of previous musical compositions. Yet among Schoenberg's atonal works is some of the most haunting, beautiful music ever written – music in which can truly be heard the dawning of a new age.

EARLY LIFE

Arnold Schoenberg was born in 1874, into a poor Jewish family of Eastern European descent in Vienna. His father owned a small shoe shop. At eight years old, Arnold had violin lessons, but his father was unable to afford formal musical training for his son. His early death in 1890 forced the 15-year-old to find work in a bank.

Schoenberg was, therefore, almost completely self-taught. Working at the bank by day, he spent his evenings discussing music with a widening circle of friends. He read voraciously, and taught himself the cello. On joining a local orchestra, he became firm friends with its conductor, the composer Alexander Zemlinsky.

TO THE BRINK

Working closely with Zemlinsky, Schoenberg produced a stream of songs, piano pieces, and chamber works. He left the bank and began to eke out a living by conducting small choirs and orchestrating operettas.

In 1901, he married Zemlinsky's sister, Mathilde. Moving to Berlin in December, Schoenberg eventually got a teaching post in composition at the Stern Conservatory the following year. The composer Richard Strauss (*see page 984*), impressed when Schoenberg showed him Part One of the score of his cantata, *Gurrelieder*, had recommended him.

By 1903, however, he was back in Vienna, still wracked with the financial difficulties which would dog him through most of his career. But his composing progressed rapidly over the next few years, culminating in his single-movement masterpiece, the First Chamber Symphony, in 1906.

From 1904, Schoenberg took on private composition pupils, including Anton Webern and Alban Berg. Both pupils became great composers in their own right, and were a vital source of sup-

Arnold Schoenberg: Man Ray
The famous photographer took this portrait in 1930.

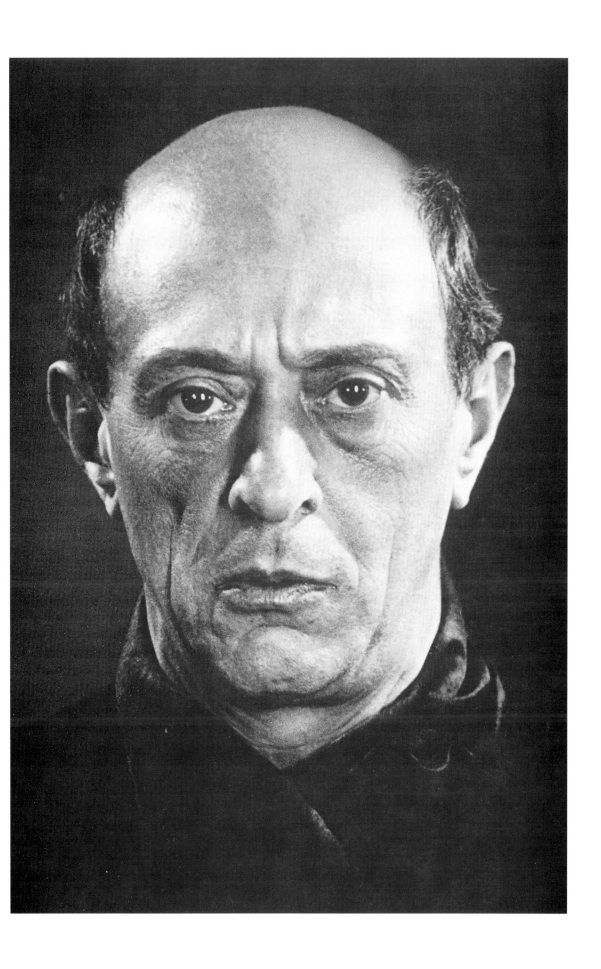

BACKGROUND

Artistic Exiles in America

In moving to America in the years before World War II, Schoenberg was part of a stream of German artists and intellectuals persecuted and disillusioned by the spread of fascism in Europe. The United States, which did not enter the war until after the Japanese attack on Pearl Harbor in 1941, represented a haven from oppression.

Schoenberg's fellow German, the composer and violist Paul Hindemith (1895 – 1963), suffered Nazi persecution from 1934 because he performed with Jewish musicians and composed "atonal music," which was thought to be decadent, unpatriotic, and undesirable. In the face of an increasingly hostile climate, Hindemith had no choice but to leave his country. He arrived in New York in 1940.

This ideological tension went beyond Germany. Béla Bartók (*see page 876*), the Hungarian nationalist composer, registered his disgust for fascism by forbidding broadcasts of his music in Germany and Italy from 1937. He, too, left his threatened homeland for America in 1940.

For other émigré composers like Igor Stravinsky (*see page 990*) and Erich Korngold, America was simply a land of greater musical opportunites. In return, the arrival of Europe's finest musical talent on their shores in the late 1930s was a great encouragement and an inspiration to a whole generation of young American composers.

port for Schoenberg. Gustav Mahler (*see page 5:648*) was another ally, although he confessed to being baffled by the direction of Schoenberg's work. Others were less supportive: Schoenberg stopped speaking to Strauss when he heard that the German thought Schoenberg would be better off shoveling snow than scribbling on music paper.

THE CRISIS OF ATONALITY

In the summer of 1908, Schoenberg began a series of songs drawn from the poems of Stefan George. They were destined to become the final movements of his String Quartet No. 2 (1907-08) and the song-cycle of 1908 and 1909, *Das Buch der hängenden Gärten — The Book of the Hanging Gardens*. These were his first experiments in atonality, and a leap into the dark. Schoenberg's journey is beautifully illustrated in his String Quartet No. 2: the first two movements are written in a conventional major-minor style, but the somber

third movement gradually cuts loose from these moorings and drifts into atonality.

A flood of atonal compositions followed in a burst of creative energy, before Schoenberg fell musically silent for seven years. It is as if he needed this time to come to terms with his actions. He later recalled: "I had the feeling as if I had fallen into an ocean of boiling water ... it burned not only my skin, it burned also internally."

MUSICIAN AND PAINTER

Schoenberg's early atonal works reflect his growing interest in Expressionism, a movement which swept through the early 20th-century artistic scene as artists attempted to find ways to describe the inner, subconscious world. By 1907, Schoenberg was taking painting lessons from his friend Richard Gerstl, a high-strung young artist. In October 1910, he presented an exhibit of his pictures. The paintings won him admiration from Expressionist

artists such as Wassily Kandinsky (*see page 924*) and the Blaue Reiter – Blue Rider – group.

When he returned to music, Schoenberg's work embraced his new interests. In his stage piece, *Die glückliche Hand – The Fortunate Hand –* of 1910-13, he not only provided the words, music, and scenic and costume designs, but also gave instructions for colorful lighting closely linked to the music. In his harmony textbook of 1911, Schoenberg set out his influential notion of *Klangfarbenmelodie* (tone-color-melody), whereby the tones of different instruments are used to "color" a melody or sustained harmony. This is reflected in the third of his Five Orchestral Pieces Op. 16 (1909), which is called "Farben" – "Colors." In 1912, he composed his revolutionary *Pierrot Lunaire*, one of his most important works.

While Schoenberg was writing his String Quartet No. 2 in the summer of 1908, Mathilde left him and moved in with Richard Gerstl. Webern managed to persuade Mathilde to return, and shortly afterward, Gerstl killed himself. For the next few years, Mathilde slipped in and out of depression. Schoenberg's Expressionist music was in part a search for a personal means of expressing this private torment. Nowhere is this more evident than in the nightmarish monodrama *Erwartung – Expectation –* of 1909.

THE BEGINNINGS OF SERIALISM

Schoenberg had developed such a cynical view of the fickle Viennese musical public that when the 1913 premiere of the more traditionally written *Gurrelieder* was greeted with rapturous applause, he would not acknowledge the ovation. Sure enough, at the next performance of his more radical music, the critics returned to criticizing him.

Schoenberg had a period of military service after the outbreak of World War I, but was discharged due to his asthma. It interrupted work on his major composition of this period, the oratorio *Die Jakobsleiter – Jacob's Ladder –* which was left uncompleted at his death.

By 1920, a new development was taking shape in Schoenberg's mind – serialism. He had always

KEY DATES

1874 *born in Vienna*

1890 *begins work as a bank clerk*

1901 *marries Mathilde Zemlinsky*

1902 *teaches at Stern Conservatory*

1906 *writes First Chamber Symphony*

1908 *composes first atonal works*

1910 *exhibits Expressionist paintings*

1912 *composes* Pierrot Lunaire

1923 *Mathilde dies*

1924 *marries Gertrud Kolisch*

1925 *appointed to Prussian Academy of Arts*

1933 *emigrates to America*

1936 *appointed professor at UCLA*

1947 *composes* A Survivor from Warsaw

1951 *dies in Los Angeles*

been troubled by the total freedom in atonal music; serialism provided a missing sense of order. Placing the 12 notes of the chromatic scale in a fixed order, he created a 12-note row which could be used as basic raw material, just as composers of the past had used a particular key and its related harmonies. To generate new ideas, the row could be moved up or down to begin on any note, turned upside-down, played in reverse, stretched or contracted, or combined to make chords. But the fact that, throughout these transformations, the row remained essentially unaltered gave serial music an inner coherence.

Schoenberg was overjoyed to discover in serialism an atonal foundation that was comparable with the classical formality he always respected but had given up. It drew from him a rich body of instrumental music between 1920 and 1936. There are few composers since who have not at some point explored serialism in their own music.

Ode to Napoleon: Arnold Schoenberg (1942)

Schoenberg's score for his opus 41, a setting for the unusual combination of string quartet, piano, and speaker of an ode by the 19th-century English poet Lord Byron.

In 1923, Mathilde died. The following year, Schoenberg married the sister of one of his pupils, Gertrud Kolisch, a beautiful young woman who was half his age. In 1925, he was offered a prestigious teaching post at the Prussian Academy of Arts in Berlin. Several happy years followed. But the rising tide of anti-Semitism began to cause difficulties. In 1933, his contract was abruptly terminated. Having secured an offer of teaching work in Boston, the Schoenbergs sailed for America. By 1934, Schoenberg had settled in California. In 1936, he was appointed music professor at UCLA.

Schoenberg was deeply shocked and depressed by the progress of the war in Europe. His pain at the plight of his people was crystallized in the cathartic work, *A Survivor from Warsaw*, in 1947, the most powerful, passionate music he ever wrote.

In August 1946, Schoenberg had a severe heart attack during which his heart stopped beating. The sensations of the experience are instilled in his String Trio, written just days after his recovery. Schoenberg died in Los Angeles on July 13, 1951. Shortly before he died, he was heard to murmur the words, "Harmony ... harmony...."

Pierrot Lunaire

Written at the height of Schoenberg's Expressionist and first atonal phase, *Pierrot Lunaire* is a milestone in 20th-century vocal writing. In 1912, the actress Albertine Zehme sent a volume of poems to Schoenberg, asking him to write music for her to recite them to. Schoenberg went one step further, however, calling for the poems to be delivered in *Sprechgesang* – speech-song. This is a cross between singing and speaking whereby the words are recited in a voice which touches only approximately the notated pitches but follows precisely their rhythm. In the score, such passages are notated using "x"s instead of conventional note-heads.

Pierrot represented the violent lunatic, and the artist struggling with his impulses

Sprechgesang was invented by the German composer Engelbert Humperdinck (1854–1921) in 1897, in his opera *Königskinder*. *Pierrot Lunaire*, however, represents the most extended early use of the technique. Schoenberg also used it in *Die glückliche Hand* (1910-13) and *Moses und Aaron* (1930-32). The result is an electrifying form of heightened speech, technically demanding, but sensitive to fleeting emotional nuances and full of dramatic impact. *Pierrot Lunaire* can be seen as a musical ancestor to works like Luciano Berio's *Sequenza III* (1966), where the solo soprano explores a broad gamut of vocal timbres, including whispering, laughter, and tongue clicks.

The book of poetry given Schoenberg by Zehme was a collection of 50 poems, also entitled *Pierrot Lunaire*, written in 1884 by the Belgian poet Albert Giraud and translated into German. Schoenberg selected 21 and worked intensively on them. He aimed to strike "a light, ironic-satirical tone," while creating sounds "practically animal-like in the direct expression of sensuous and spiritual emotions." His miniatures evoke an atmosphere at times grotesque and bizarre, and at other times sentimental and beautiful. The device of parody is important in numbers like "Valse de Chopin" (*see page 4:480*). Though the music mimics the melodic mannerisms of Chopin's waltzes, it remains within the Schoenbergian sound world.

The moonstruck character of Pierrot is a disturbing and ambiguous figure. For Schoenberg, he represented the violent lunatic and the creative artist struggling with his artistic impulses, symbolized by the moon. In Schoenberg's score, Pierrot moves through three vivid stages, each expressed in seven songs.

In Part I, Pierrot revels in the moonlight, the symbolic source of poetry, suggesting the riotous rebellion of the modern artist. In Part II, Pierrot cowers under the moon in a despairing, frenzied derangement of the senses, as the horrors of night and the specter of poetic martyrdom descend to torment him. In Part III, he finally makes a peaceful but illusory homecoming, achieving a reconciliation with the artistic past.

In the final number, Pierrot has learned to master his artistic powers and use them to communicate for the good of others, reflected musically by the emergence of something resembling the key of E major.

Richard Strauss

A serious man, often accused of being more interested in money than music, Strauss nevertheless brought an imagination and Romantic sensibility to opera which ensured his lasting popularity.

Strauss's outward conservatism and reactionary behavior hid a remarkable talent which brought him great acclaim and made him one of the most talked-about composers of his time. A master of the orchestra and of voice, Strauss composed spectacular works which saw him acknowledged as one of the greatest post-Romantic composers.

EARLY MUSICAL TALENT

Richard Strauss was born in Munich on June 11, 1864. His father, Franz, was a horn player in the Munich Court Orchestra and ran an amateur orchestra which sometimes rehearsed at the house. Life was comfortable, thanks to the wealth brought by Franz's second wife, Josephine Pschorr, whose family had made their fortune from brewing.

Strauss began piano lessons when he was four, and by the age of six was composing small pieces. During his teens, he wrote works of increasing skill and maturity, culminating in his Symphony in D minor. The work was premiered in 1881 by the Munich Court Orchestra.

In 1882, Strauss went to the university in Munich to study philosophy, but his main interest was music and he left after only two semesters. In 1883, he visited Berlin. He attended the opera, made several important friends, and met the celebrated conductor Hans von Bülow. Von Bülow was struck by Strauss, describing him as "an uncommonly gifted young man – by far the most striking personality since Brahms" (*see page 5:588*).

Von Bülow's support was vital to Strauss. He commissioned a piece for 13 instruments, the Suite in B-flat, and invited Strauss to conduct its first performance in Munich. The venture was a success and, in 1885, von Bülow appointed Strauss his assistant at Meiningen. There, Strauss met the violinist Alexander Ritter, who was related by marriage to Richard Wagner (*see page 5:708*). Ritter introduced Strauss to the music of Wagner and Franz Liszt (*see page 4:522*). Strauss later described their profound influence on him: "New ideas must search for new forms – this basic principle of Liszt's symphonic works, in which the poetic idea was really the formative element, became the guiding principle for my own symphonic work."

Strauss's professional partnership with von Bülow was short-lived. Von Bülow resigned from his post and Strauss decided to return home to Munich. Unsatisfied with the work he found there, he turned increasingly to guest conducting for orchestras throughout Germany. The tours introduced him to new influences. In Leipzig, Strauss met Gustav Mahler (*see page 5:648*), with whom he struck up an immediate friendship. He became an ardent champion of the other composer's work.

In the summer of 1887, Strauss met Pauline de Ahna, a soprano who had studied in Munich. Strauss fell in love with her. He was determined to help her in her singing career; when he was appointed

Richard Strauss: Wilhelm Victor Krausz
Krausz painted Strauss conducting in 1929.

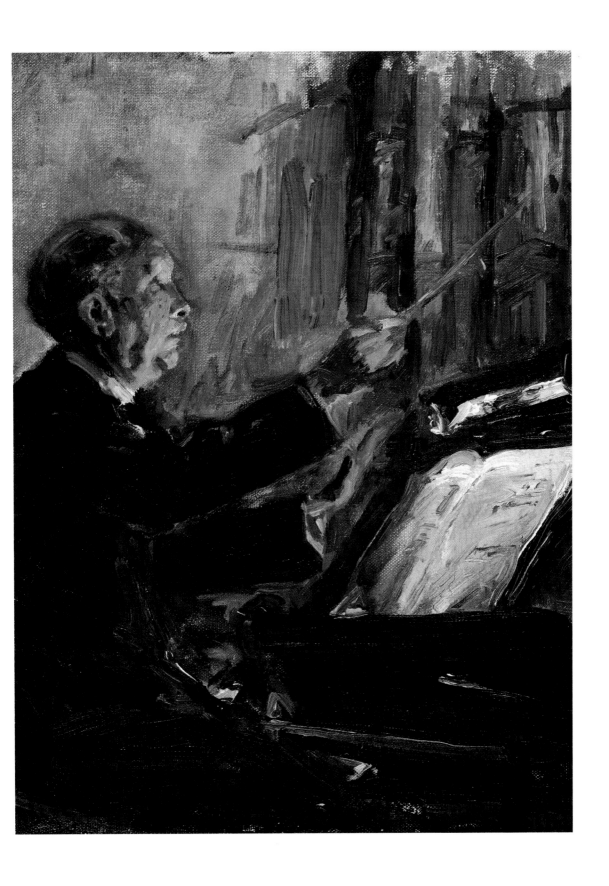

assistant conductor in Weimar in 1889, he took Pauline with him.

Strauss's employers in Weimar were impressed by their new conductor. In November 1889, he gave the premiere of his orchestral work *Don Juan*, the first of his remarkable tone poems — orchestral works based on a narrative, a poem, or some other "program." The piece's enthusiastic reception established Strauss as a major new German composer.

MUSICAL ACCLAIM

Meanwhile, he had also just completed his first opera, *Guntram* (1894). The piece was very difficult, and it was a problem to find suitable singers. Pauline, now Strauss's fiancée – they married the same year – was cast in the leading role. Rehearsals were stormy: the orchestra disapproved of Pauline, and referred to the opera as a "scourge of God." Despite such problems, Strauss was enjoying a period of great creativity. Between 1894 and 1898, he wrote four of his best-known orchestral works: the tone poems *Till Eulenspiegel*, *Thus Spake Zarathustra*, *Don Quixote*, and *A Hero's Life*. Rather than follow strict classical form, the structure of these "program pieces" comes more from an underlying idea or theme. Strauss drew on varied sources: the story of *Till Eulenspiegel* came from folklore, while *Thus Spake Zarathustra* was inspired by the work of the German philosopher Friedrich Nietzsche. The results were highly imaginative and displayed great skill at orchestration. They were also an early attempt to express dramatic ideas in instrumental music, a technique Strauss was to use to great effect in his operas.

APPOINTMENT IN BERLIN

Meanwhile, Strauss's reputation as a conductor was also growing. In 1898, he was offered chief conductorships in Berlin and New York. Both posts offered good salaries, but Strauss chose Berlin: the Royal Court Opera offered longer holidays and a better pension. Critics often accused Strauss of making decisions based on financial rather than

KEY DATES

1864	*born in Munich*
1883	*meets von Bülow in Berlin*
1887	*meets Pauline de Ahna*
1889	*first performance of* Don Juan
1894	*completes* Guntram; *marries Pauline de Ahna*
1898	*becomes chief conductor of the Royal Court Opera in Berlin*
1905	*premiere of* Salome
1909	*composes* Elektra
1911	*first performance of* Der Rosenkavalier
1919	*appointed artistic director of the Vienna Opera House*
1933	*nominated president of new state music bureau*
1942	*completes* Capriccio
1945	*writes* Metamorphosen
1948	*writes* Four Last Songs
1949	*dies in Garmisch*

artistic grounds. The composer's response was defiant: "Once the pleasure of creation has passed, then the annoyance of performance and those blessed criticisms begin, and only a good stipend can compensate one for that ... I merely say out loud what other 'idealists' think to themselves."

OPERATIC SUCCESSES

At first, the Berliners reacted cautiously to Strauss: they found his colossal tone poem *A Hero's Life* over-personal and egocentric. If Strauss had difficulty finding acceptance for his orchestral works, however, he was more successful with opera. In 1905, the Dresden premiere of *Salome* – based on a play by the Irish writer Oscar Wilde – received enthusiastic reviews. Soon another 50 opera houses wanted to perform it, though in some cities it was censored for its erotic content. *Salome* established

Strauss as a major composer throughout Europe. With the royalties he earned, he built a villa at Garmisch, where he moved in 1908 with Pauline and their son, Franz.

Salome was followed by the opera *Elektra* in 1909, and numerous invitations to conduct abroad. More success was to follow with the opera *Der Rosenkavalier*, which was first performed to enormous acclaim in 1911. It was staged 50 times within the year; special trains brought audiences from Berlin to the opera house in Dresden to attend it.

Der Rosenkavalier marked the peak of Strauss's creativity. His next opera, *Ariadne auf Naxos*, was not a success (though its 1916 revision became one); a ballet score he wrote for the Russian dancer Diaghilev did little better.

Partly, Strauss was the victim of events he could not control. Anti-German feeling was growing throughout Europe. In June 1914, an assassin killed the Austrian archduke Francis Ferdinand. The event signaled the start of World War I. As a consequence of the outbreak of hostilities between Germany and Britain, Strauss lost a large part of his life savings, which he had deposited in London.

The end of the war in November 1918 left Europe dramatically changed. A new generation of artists challenged traditions that they associated with the values that had led to war. In music, the lead was taken by composers such as Béla Bartók, Arnold Schoenberg, Igor Stravinsky (*see pages 876, 978, and 990*).

Strauss also found his position in the operatic world challenged. In 1919, he became artistic director at the Vienna Opera House, to the anxiety of the staff, who protested against his high salary. Strauss was often absent, and granted long leaves of absence to singers so that they could perform in his operas elsewhere. The atmosphere grew more acrimonious until he resigned in 1924.

Meanwhile, Strauss was composing virtually nothing. In 1929, his usual librettist died, and he began working with another, Stefan Zweig. Zweig was Jewish, and as Adolf Hitler's Nazi party began a systematic persecution of all Jews, Zweig fled to Switzerland. Strauss tried to distance himself from the political scene, but in 1933 he agreed to conduct Richard Wagner's *Parsifal* at the Bayreuth opera festival. Wagner's work had nationalistic

BACKGROUND

The Jewish Question

Although Strauss tried to avoid politics, the rise of Adolf Hitler's extreme right-wing Nazi Party during the 1930s could not be ignored. To Germans who felt humiliated by their country's defeat in World War I and the harsh peace settlement imposed by the victors, Hitler promised to restore national pride. He identified two scapegoats: communism and the Jews. He promised to rid Germany of both.

As the Nazis gained power, the persecution of the Jews became systematic. In 1935, laws denied them German citizenship, barred them from many professions, and banned marriage between Jews and Christians. Violence against Jews became common. In 1938, Nazis vandalized Jewish homes, shops, and synagogues during "Crystal Night," named for the amount of glass that lay broken in the streets. By World War II, Hitler's policy had culminated in the mass murder of millions of Jews in concentration camps. Despite Strauss's efforts to distance himself from the Nazis, some people saw his acceptance of an official post as a mark of his tacit approval.

Costume for Salome: Leon Bakst
*The famous artist Bakst designed this costume for Salome's
Dance of the Seven Veils in a 1908 performance of Strauss's opera.*

overtones, and Strauss became linked with the Nazi regime. He was made president of a state music bureau, though the post was withdrawn when the Nazis intercepted a sympathetic letter he wrote to Zweig.

By the outbreak of World War II in 1939, the 75-year-old Strauss had retreated to his villa in Garmisch. The music he composed there is quiet and introspective, and included *Capriccio* (1942), his last opera. To him, the wartime destruction of the great German opera houses was a tragedy. He poured out his grief in one of his most profound instrumental works, *Metamorphosen* (1945).

When war ended in 1945, Strauss went into exile in Switzerland. There he wrote his last work, four haunting songs for voice and orchestra. He returned to Garmisch in 1949, and died there on September 8. The *Four Last Songs*, published posthumously in 1949, have a solemn profundity that made a fitting end to a remarkable career.

Strauss's Operas

Although never a purely operatic specialist like Giuseppe Verdi (*see page 5:702*) or Richard Wagner, Strauss was intimately connected with opera. For almost 60 years of his career he was always working on at least one operatic project, either as a conductor or as a composer. After theater trips to see the operas of Weber and Wagner, Strauss was fascinated by every aspect of the form, from the music to the scenery. As artistic director at the Vienna Opera House, he supervised every detail of each production. Wagner became his operatic hero. In 1892, when he was asked to conduct Wagner's opera *Tristan and Isolde*, he called it "the most beautiful day of my life."

> Salome caused a controversy ... shocked singers handed their parts back at the first rehearsal

Strauss's own reputation as an outstanding operatic composer was confirmed by the success of *Salome* (1905) and *Elektra* (1909). *Salome* – based on the biblical character who, as her price for dancing before King Herod, demands the head of Saint John the Baptist – caused an instant controversy. One scene featured a severed head; another, the erotic Dance of the Seven Veils. The shocked singers handed back their parts at the first rehearsal; the leading lady proclaimed she would not be part of such an "indecent" production. When the opera went ahead, the publicity helped make it a success not only in Germany but throughout Europe.

Elektra marked the first collaboration between Strauss and the young librettist Hugo von Hofmannsthal. It was the beginning of a long association, although the two men were very different. Hofmannsthal always chose the subject of the operas, rejecting Strauss's suggestions: "Your taste and mine are miles apart," he wrote to the composer. But Hofmannsthal appreciated Strauss's genius for adapting his music to each subject. "It is good to find a man like you determined not to stand still and get stuck in a rut," he wrote, "and it is good to know that you and I can occasionally instruct each other in a world where everyone else rushes madly on."

The two men collaborated on Strauss's greatest operatic success, *Der Rosenkavalier* (1911). In response to Strauss's wish to tackle something "Mozartian," Hofmannsthal produced a mixture of romance and farce set in 18th-century Vienna. The setting was an excuse for Strauss to include a number of waltzes, which soon found popularity independent of the opera. The opera was a success, despite critics who dismissed its "banal tunes" and "morbid and unnatural" plot.

Following Hofmannsthal's death in 1929, Strauss formed shorter collaborations with other writers. He noted, "In 50 years I've only found one Hofmannsthal." There were successes, however, particularly *Capriccio* (1942), Strauss's last opera. The music is elegant and thoughtful, the plot debates the relative importance of words and music in opera. Strauss himself described the piece as "... the best conclusion to my life's work in the theater."

Igor Stravinsky

Igor Stravinsky shocked the musical world with his startling, dynamic compositions. He soon came to be acknowledged as one of the greatest composers of the era.

Igor Stravinsky was the composer who, more than anyone, completed the break with the Romantic traditions of the 19th century and led music into the modern world. He lived a Frenchman and died an American, but he was born a Russian, and during years of exile, his music harked back to the country of his birth. Despite his reputation as a rule breaker, his Russian Orthodox faith gave him a lifelong fascination with ritual and order and a respect for convention. He himself declared that he could never be "even the nicest anarchist."

A RUSSIAN CHILDHOOD

Igor Stravinsky was exposed to music from the day he was born near St. Petersburg on June 17, 1882. His father, Fyodor Ignatievitch, was an opera singer; his mother, Anna Kyrillovna, sang and played the piano. At nine, Stravinsky began to study piano and music theory, but he preferred improvising his own pieces to practicing. He made few friends at school. Music banished his loneliness.

In 1901, he followed his parents' advice and enrolled in the St. Petersburg University to study law. Soon, however, music began to dominate his life. His early efforts at improvisation led to serious experiments in composition. He began to think about enrolling in the St. Petersburg Conservatory.

In 1902, Stravinsky met the renowned Russian composer Nikolai Rimsky-Korsakov. Rimsky-Korsakov advised Stravinsky not to enroll at the Conservatory, where he might be discouraged by a rigid academic approach. "Instead," Stravinsky recalled, "he made me the precious gift of his unforgettable lessons." The relationship developed into a close friendship. Rimsky-Korsakov played a fatherly role in Stravinsky's life, particularly after Fyodor Stravinsky died in 1902.

A FATEFUL ENCOUNTER

Stravinsky left the university in 1905 without graduating. Now 23, he was ready to make two important commitments. The first was to marry his cousin, Katerina Nossenko, in 1906; their son, Fyodor, was born in 1907, a daughter, Ludmilla, the following year.

The second commitment was to devote his life to music. Early in the summer of 1908, Stravinsky completed an orchestral fantasy called *Fireworks,* to honour the forthcoming wedding of Rimsky-Korsakov's daughter. Stravinsky mailed the manuscript to the older composer for his approval. It was returned unopened: Rimsky-Korsakov had died before he could read it.

Stravinsky was grief-stricken by the death of his mentor. *Fireworks*, however, received a successful first public performance in St. Petersburg in 1909. Among those in the audience was the impresario Sergei Diaghilev. Diaghilev was planning to introduce Russian ballet to Paris. On

Igor Stravinsky: A. Speranski
A 1993 painting based on early photographs.

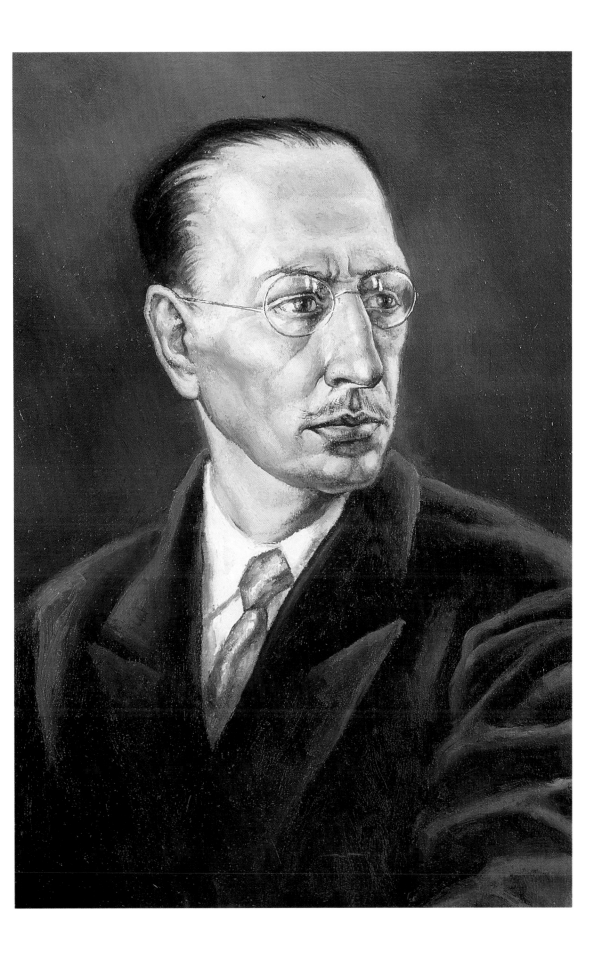

hearing *Fireworks,* he decided that Stravinsky was the composer he needed to complete his company, the Ballets Russes.

For his first season with Diaghilev, Stravinsky orchestrated other composers' music. In 1910, however, when Diaghilev found himself without a composer for a new ballet based on the Russian legend of the firebird, which rises from the ashes, Stravinsky created a score that made him the toast of Europe. The 1910 premiere of *The Firebird* was greeted ecstatically by the Paris audience.

TWO GREAT WORKS

The name "Petrushka," or "little Pierrot," came to Stravinsky one day while he was walking by the sea. He pictured "a puppet suddenly endowed with life, exasperating the patience of the orchestra with diabolical cascades of arpeggios." On June 13, 1911, *Petrushka* — the story of a clown who survives murder to taunt and jeer at the audience — was premiered in Paris with even greater success than *The Firebird.* The French composer Claude Debussy (*see page 5:600*) told him: "You will go much further than *Petrushka*, it is certain, but you may be proud of the achievement of this work."

Early in 1910, while he was working on *The Firebird*, Stravinsky had the idea for a ballet based on prehistoric rites celebrating the arrival of spring. He imagined "a solemn pagan rite: wise elders seated in a circle watching a young girl dance herself to death." The composition proved difficult: Stravinsky set himself the task of conveying in music the forces of nature and the most primitive instincts of humanity. Yet by January 1912, the first half of the score was almost completed.

Diaghilev entrusted the choreography of the ballet to Vaslav Nijinsky, the dancer who had created the role of *Petrushka*. The choice displeased Stravinsky, who was alarmed at the dancer's relative inexperience as a choreographer and his ignorance of music. He was even more displeased when, having completed the score in time for the 1912 Paris season, he was told by Diaghilev that production would be delayed until the following year because Nijinsky was unwell. The dancer was

KEY DATES	
1882	*born near St. Petersburg*
1901	*enrolls in law school*
1905	*marries Katerina Nossenko*
1906	*completes* Fireworks
1908	*premiere of* The Firebird
1909	*meets Diaghilev; joins Ballets Russes*
1910	*premiere of* Petrushka
1911	*premiere of* The Rite of Spring
1913	*settles in Switzerland*
1914	*moves to France;* Pulcinella
1920	*marries Vera de Bosset*
1939	*moves to America*
1945	*becomes U.S. citizen*
1971	*dies in New York*

also finding it difficult to choreograph such a rhythmically complex work. By way of compensation, Diaghilev promised to increase the size of the orchestra, enabling Stravinsky to utilize far larger musical forces that he had planned.

The score eventually required a larger orchestra than Stravinsky would ever use again — an augmented wind and brass section, balanced by an increased string section. Only the percussion section is smaller than one might imagine, given the rhythmic nature of the piece. The premiere of *The Rite of Spring* in Paris in May 1913 was one of the musical events of the century. In only three years, the 30-year-old Stravinsky had written three works that put him at the forefront of 20th-century music.

With the outbreak of World War I in 1914, Stravinsky and his family moved to Switzerland. Commissions from the Ballets Russes dropped off, Stravinsky's publishers were out of reach in enemy territory, and he could no longer depend on income from his Russian estate. "Throughout the whole period when we were waiting to go back to Russia it was my Russian past which pre-

occupied me most," the composer declared. A stream of Russian-inspired compositions resulted, including *The Soldier's Tale* (1918), based on a Russian folk tale, and *Mavra*, a comic opera based on a story by the writer Aleksander Pushkin.

TRAVEL AND SADNESS

In 1920, Stravinsky moved his family to the countryside outside Paris. His life now involved constant travel – in 1921, he visited Spain, England, and the United States – and he had little time to devote to the Ballets Russes. He accepted no more commissions from them after *Pulcinella* (1920). Diaghilev was unhappy to lose his protégé, and was not mollified by the present of one of Stravinsky's greatest works, *Oedipus Rex* (1927), which he called "a very macabre gift." There was little time to heal the rift: in August 1929, Diaghilev died in Venice. Stravinsky was mortified: the two had been close friends for more than two decades.

In 1934, Stravinsky took French citizenship, but he was beginning to realize that his future lay not in France but in America, where his music was finding the most sympathy. He toured America in 1935, and received a commission to compose *The Card Game,* "a ballet in three deals," for the newly formed American Ballet. Other instrumental commissions rolled in. They came at a significant point in Stravinsky's life: Europe was again heading for war and Stravinsky had been shaken by the deaths from tuberculosis of his daughter, his wife, and his mother, all within months of each other. Stravinsky overcame his grief by throwing himself into his work. In 1940, he moved to Hollywood, having married Vera de Bosset, an actress and old friend in 1939. Together they began a period of happiness that was to last until Stravinsky's death.

In 1945, Stravinsky and his wife took U.S. citizenship. The same year he signed an exclusive contract with the publishers Boosey & Hawkes, ending a history of copyright and financial problems. He could now afford to work without the constant need for commissions, and devoted the next three years of his life to a full-length opera.

The new work was inspired by *A Rake's Progress*, a set of engravings by the 18th-century English artist William Hogarth (*see page 3:366*) showing a

BACKGROUND

The Ballets Russes

The dancers of the world-famous Ballets Russes – the Russian Ballet – owed their success as much to the creative and organizational skills of their founder, Sergei Diaghilev, as they did to their own dancing. In the 20 years between his first presentation of the Ballet Russes in Paris in 1909 and his death in 1929, Diaghilev revolutionized modern dance. His vision brought together a remarkable range of talent from across the arts: among his composers were Stravinsky, Erik Satie, and Claude Debussy; his sets were designed by renowned artists such as Georges Braque and Pablo Picasso (*see page 972*); the dancers included Nijinsky and Anna Pavlova, both outstanding performers. Such talents put the Ballets Russes at the forefront of modern creativity in the early decades of the 20th century.

Diaghilev's genius lay in fusing those diverse skills to create a synthesis of music, art, and dance. He is often remembered as an impresario who liked to shock. He saw himself, however, as updating and developing artistic traditions.

The Rite of Spring: Valentine Hugo (1913)
*A series of sketches suggest Nijinsky's controversial choreography
for Stravinsky's groundbreaking work.*

rich young man wasting his inheritance. Stravinsky asked the poet W. H. Auden and his partner, Chester Kallman, to write the libretto. Stravinsky conducted the premiere in 1951; it was a great success.

In 1948, Stravinsky began a long association with Robert Craft, a young musician. With Craft's help, Stravinsky once again began making conducting tours. Craft prepared the orchestra in advance for the aging Stravinsky's final rehearsals and performances. The two musicians, with Vera in attendance, traveled extensively.

In 1962, Stravinsky returned to Russia after nearly 50 years' absence. He received a hero's welcome: 30,000 people stood in line for his concerts in his home city of St. Petersburg, which had been renamed Leningrad until 1991. The acclaim of his countrymen meant a great deal to the composer.

By 1967, Stravinsky's health was failing. He conducted his last concert, a performance of the *Pulcinella* suite. On April 6, 1971, he died at his New York home; he was buried in Venice, near the grave of his friend and collaborator Diaghilev.

The Rite of Spring

The premiere of *The Rite of Spring* took place on May 29, 1913 at the Théâtre des Champs-Elysées, in Paris, and was without parallel in the history of music. Most of the audience consisted of the affluent, conservative, upper classes who had come expecting pretty music and traditional ballet. But among them was also a large contingent of artists and students who had been given free tickets by the impresario Diaghilev. They were determined to applaud anything new and shocking.

The conductor had scarcely begun the introduction before the protests began. The curtain rose to reveal the dancers, whom Stravinsky himself called a group of "knock-kneed and long-braided Lolitas jumping up and down." The storm broke. Catcalls filled the air and fights erupted, with the students howling their support and yelling insults at the traditionalists. Throughout the turmoil the performers continued, barely able to hear the music. They were urged on by the choreographer Nijinsky, who stood on a chair in the wings, pounding out the rhythm with his fists and screaming directions.

Stravinsky's music alone was enough to arouse the protests of the traditionalists in the audience; Nijinsky's revolutionary choreography only made things worse. It consisted largely of complex, awkward movements. It was never written down and was soon abandoned.

Stravinsky's biographer Roman Vlad explained the audience's reaction to the piece: "No one

> ## "It hit the public like ... some uncontrolled primeval force."

had ever heard music like it before: it seemed to violate all the most hallowed concepts of beauty, harmony, tone, and expression. Never had an audience heard music so brutal, savage, aggressive and apparently chaotic; it hit the public like ... some uncontrolled primeval force."

In *The Rite*, Stravinsky wanted the listener to focus on both the overall sound and the rhythms within it. He did this by breaking classical values of melody, harmonic progression, and the ordered, logical development of themes based on the major and minor key system. In their place, he utilized primitive, pounding rhythmic pulses, and replaced strings with woodwind and percussion as the dominant instrumental voices. In some later works, he would do away with strings altogether. Learning from his friend Claude Debussy, Stravinsky turned his back on the harmony of major and minor scales, which had governed European music from the Renaissance, and turned to the ancient modes of folk music, as did Bartók (*see page 876*) and other composers.

Once *The Rite of Spring* had broken the barriers in terms of rhythm, orchestration, and harmony, other composers were quick to take up new forms. Arnold Schoenberg (*see page 978*) had already done away with traditional harmony and was experimenting with atonality; other composers emphasized many percussion instruments. A single ballet score had ushered in an unprecedented diversity of music.

Virginia Woolf

Poised between exuberance and despair, between brilliance and the nightmare of madness, Virginia Woolf was one of the most innovative writers of the 20th century.

Virginia Woolf was fascinated by what she called "the inner reality" beneath the surface of her characters. In her novels, she moved away from conventional narrative to reveal her characters' thought processes and emotional states. This pioneering use of inner monologue, or "stream of consciousness," had a major impact on the novel's form.

EARLY LIFE

Virginia Woolf came from a distinguished and talented British family. She was born Adeline Virginia Stephen on January 25, 1882, in London, the third child after Vanessa and Thoby. The following year, her brother Adrian was born. From an early age, Virginia, as she was known, was immersed in an exciting and stimulating world in which she was encouraged to read, study, and express her ideas. Her father, Sir Leslie Stephen, was a noted critic and biographer, and her mother, Julia, was artistic. Virginia's imagination was further sparked by the family's annual vacations on the coast at St. Ives, Cornwall, in the far southwest of England.

Life was a series of adventures for the four Stephen children. When Virginia was nine, she set up a weekly paper with her brother, Thoby. It was named *The Hyde Park Gate News* after the fashionable part of London in which they lived. It was not long, however, before her idyllic childhood was shattered. Her beloved mother died in 1895, when she was 13, and the shock of the loss caused Virginia to have a nervous breakdown. Her suf-

fering was intensified by her father's response. Instead of protecting his children from the pain of their mother's death, Leslie inflicted on them his own inconsolable grief. The whole period became a nightmare for the family. An older half-sister, Stella, stepped in to look after the children, but then died suddenly herself.

From being lively and outgoing, Virginia became painfully introverted and shy. Only one more shock was needed to send her over the edge to madness, and this happened in 1904, when her father died of cancer. Virginia's rapidly declining nervous state was signaled by severe headaches. But with rest and physical care, she recovered.

BIRTH OF BLOOMSBURY

Now orphaned, the children left the family house in wealthy Kensington and moved to what was then an unfashionable and bohemian part of London: Bloomsbury. On February 16, 1905, Thoby, recently graduated from Cambridge University, invited a university friend over to their house for an evening chat. So began the regular Thursday evening gatherings of the Bloomsbury Group. The circle expanded to include other talented Cambridge graduates including Lytton Strachey and Clive Bell. But just as the Stephen family was starting to reconstruct their lives,

Virginia Woolf: Vanessa Bell
An undated portrait by Woolf's artist sister.

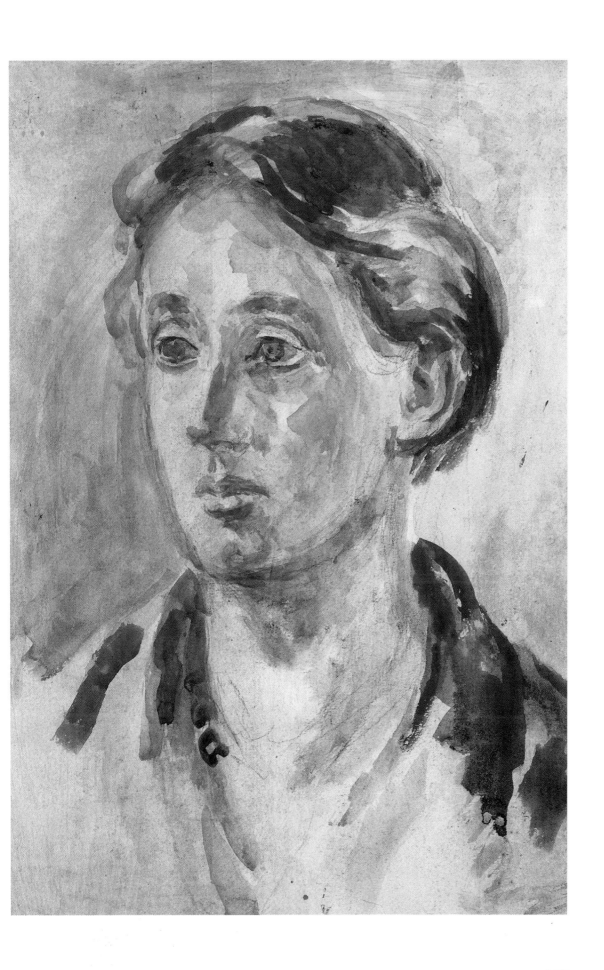

tragedy struck once again. In 1906, the family went to Greece, where Vanessa and Thoby fell ill. Vanessa recovered, but Thoby, who had contracted typhoid, did not. Virginia never entirely got over her brother's death. Nevertheless, the Bloomsbury world that he had started was beginning to take shape.

After Thoby's death, the group met at the house of Vanessa and her husband, Clive Bell. In the midst of this group of intellectuals, artists, writers, and politicians, Virginia started to regain her confidence and find her voice as a writer. She began writing book reviews for the weekly journal, the *Times Literary Supplement* and for *The Guardian* newspaper. At the age of 25, she started her first novel, *The Voyage Out*.

LEONARD AND THE HOGARTH PRESS

Almost two years later, in 1911, Virginia and her brother Adrian moved into a four-story house in Brunswick Square, also in Bloomsbury, which they divided among their friends. Virginia had the third floor and Leonard Woolf, who was to be the mainstay in her life, took two rooms on the top floor. By August 1912, they were married.

Captivated by Virginia's beauty and originality, Leonard abandoned his career in the colonial service for her. She loved him devotedly but felt no attraction to him. In childhood, she had been sexually abused by her half-brothers, George and Gerald. The abuse had left her frightened of men. She was unable to respond sexually to the tender, patient love of Leonard.

They honeymooned on the continent. On their return in 1913, Virginia completed *The Voyage Out*. The stress of finishing the book induced a period of severe depression and mental illness, which this time culminated in a suicide attempt. Leonard then, as in the future, played a major part in helping her through the crisis. He protected her from the outside world. To this end, he bought a small printing press to try and distract Virginia.

The Woolfs used their press to print their own work and that of their friends, calling their venture Hogarth Press. Their success was less the result

KEY DATES

1882 *born in London*

1895 *mother dies; first breakdown*

1904 *father dies*

1905 *first Bloomsbury meetings*

1906 *brother Thoby dies*

1912 *marries Leonard Woolf*

1913 *completes* The Voyage Out, *her first novel; attempts suicide*

1922 *meets Vita Sackville-West*

1925 Mrs. Dalloway *published*

1927 To the Lighthouse *published*

1928 Orlando *and* A Room of One's Own *published*

1941 *commits suicide*

of their business decisions, than the great talents of their friends. Lytton Strachey, Sigmund Freud, Vita Sackville-West, D.H. Lawrence, Katherine Mansfield, and T.S. Eliot (*see pages 936, 948, and 8:1038*), were all published by the Hogarth Press.

In addition to the press, Woolf was kept fully occupied by a busy social life and her varied writings. She wrote many essays and reviews, and was a prolific letter writer and assiduous diary keeper. In 1921, after a relatively peaceful and productive period, she had another severe breakdown. Aided by a long stay at their house in Sussex, on the south coast of England, which she and Leonard had bought in 1919, she gradually felt well enough to start work on what was to become her best-known novel, *To the Lighthouse* (1927).

NOVELS AND "HOLIDAY BOOKS"

Because the business of writing a major novel was mentally exhausting, Woolf usually followed an important work with a less demanding book, which she called a "holiday book." In 1928, she published *Orlando*, followed by the feminist essay, *A Room of One's Own*. *Orlando* is not just a witty novel that transcends conventions of time and

gender; it is also a veiled account of her sudden intense relationship with the writer Vita Sackville-West. The two women met in 1922, and Virginia eventually formed an intense passion for Vita, although Vita's wild reputation had made Virginia wary. There was speculation that Woolf might leave Leonard for Vita, who was also married. When she did not, Vita bitterly accused her of liking people "better through the brain than the heart."

By now, Virginia was a very successful writer. Her success brought wealth and new possessions. The Woolfs bought a car, refurnished their Sussex home, and began traveling abroad. She also had time to visit her adored nephews and nieces. She remained in close contact with her sister, Vanessa, who, after Leonard, was the most important person in her life.

Virginia's diary entry for October 11, 1929, sums up her position: "The press is booming – & this celebrity business is quite chronic – & I am richer than I have ever been ... If I never felt these extraordinarily pervasive strains – of unrest, or rest ... I should float down into acquiescence. Here is something to fight; and when I wake early I say to myself, fight, fight." Her "fight" continued with a highly ambitious novel, *The Waves*, which was published in 1931. Tired and weak after having worked so intensely on it, she had another breakdown. Praise for the book helped to nurse her back to health.

A DIVIDED LIFE

Now on the verge of her 50th birthday, Woolf divided her life into two distinct parts. In the country, she wrote, baked bread, gardened, and went for long walks; in London, she led a hectic social life, seeing a wide circle of friends and attending dinner parties at which she was the star attraction. Writing, however, remained her first love, and in 1933, she published her next "holiday" work, *Flush*, followed by an "essay-novel," *The Years*.

The anxiety and stress of constant rewriting induced Woolf's worst breakdown since her sui-

BACKGROUND

The Bloomsbury Group

During the 1920s, the Bloomsbury Group was at the heart of intellectual and literary London. A circle of friends who were writers, artists, philosophers, economists, and scientists, they took their name from the area in which the founding members, Virginia Woolf and her sister and brothers, lived. The Bloomsbury Group was united by a love of literature and the arts.

Rebellion against Victorian morality and traditional conventions, together with freedom of expression and discussion, were the founding principles of the group. They met every Thursday evening, in a tradition started by Virginia's brother Thoby, and carried out their conversations over coffee, whiskey, and cake.

One of the most radical aspects of the group was that women took a central and active part in the discussions. Freedom was the key note, as Vanessa Bell, Virginia Woolf's sister, explained: "You could say what you liked about art, sex, or religion; you could also talk freely and very likely dully about the ordinary things of daily life ... life was exciting, terrible, and amusing, and one had to explore it thankful that one could do so freely." Virginia thrived in this environment.

Virginia Woolf's Nonfiction

Woolf's 1929 essay A Room of One's Own *is a feminist classic, arguing for a woman writer's absolute need for her own space.* Three Guineas *was a follow-up in 1938. Woolf's diary details her own experiences as a writer.*

cide attempt of 1913. From April to June 1936, she suffered constantly. Her diary entry for June 23 reads: "A good day – a bad day – so it goes on." Excellent reviews on both sides of the Atlantic for *The Years* helped her recovery.

DESPAIR

Both Leonard and Virginia were alarmed by the rapid rise of fascism in Europe in the late 1930s. The Nazi leader, Adolf Hitler, now in power in Germany, was threatening his neighboring countries. In 1939, he invaded Poland, and the European allies were forced to declare war on Germany. Virginia and Leonard planned a suicide pact if Hitler were to invade England. Through 1940, the progress of the war increasingly appeared to favor a Nazi victory, and Virginia wondered if the time had come to carry out the pact. She contin-

ued to write, but in November 1940, Leonard recognized the signs of another imminent breakdown. In January 1941, her diary entries became preoccupied with death. Unusually, this time her despair was not connected with finishing a novel. Leonard was convinced that her condition was even more serious than it had been in 1913.

On March 28, Virginia suffered another crisis and wrote two farewell letters. Having written to the two people she loved most in the world, her husband and her sister, she walked out of her house and down to the river. There, with a large stone in her pocket, she drowned herself. It was three weeks before her body was found.

After her cremation, Leonard buried her ashes at the foot of a giant elm tree in the garden, one of a pair whose branches intertwined, and which they had named after each other. Two years later, a storm ripped one of the trees out of the earth.

Breaking New Ground

Virginia Woolf dedicated her life to writing, though it was a difficult, and at times dangerous, occupation for her. Apart from the struggle to create, she suffered agonies of self-doubt. "Few people can be so tortured by writing as I am," she wrote. Her fears would surface again after publication, as she awaited the verdicts of friends and reviewers. "The worst of writing is that one depends so much on praise."

Unlike most innovators, however, Woolf was rarely criticized. Her experimental and poetic novels were received with respect and sold well during her lifetime.

"Why admit anything to literature that is not poetry?" Woolf asked. She broke ground in her fiction by rejecting the "appalling narrative business of the realist: getting on from lunch to dinner: it is false, unreal, merely conventional." She freely criticized her predecessors, partly for their optimistic outlook which she, a natural pessimist, could not share. To her, in fact, the certainties of everyday life seemed to be "like a little strip of pavement over an abyss."

In her view, reality consisted of a series of mental events unlike the neat narratives of supposed realism. "Examine for a moment an ordinary mind on an ordinary day," she wrote. "The mind receives a myriad impressions – trivial, fantastic, evanescent, or engraved with the sharpness of steel. From all sides they come, an incessant shower of innumerable atoms … life is a semi-transparent envelope surrounding us from the beginning of consciousness to the end." For Woolf, it was the job of the novelist to convey this complexity and uncertainty through writing.

She achieved this aim by creating her own form of realism. In her novels *Mrs. Dalloway* and *To the Lighthouse*, Woolf perfected her technique for recording the mind's ramblings in interior monologues which represent a "stream of consciousness." The ramblings capture the fragmentary, discontinuous nature of experience, and the brilliant "moments of being" that she believed were often more important than dramatic outward events.

Although Woolf was primarily a novelist of the inner life, she also had a strong sense of place. The feel of England, of the countryside, and also of London permeates her work. She once described London as "the passion of my life."

Woolf also saw clearly that she was more independent than most women of her time. She was concerned with the prejudices and disadvantages that women writers had to overcome. She knew that, because of the Hogarth Press, she was "the only woman in England free to write what I like," but, equally significantly, she had economic freedom. In her groundbreaking feminist essay, *A Room of One's Own* (1929), she makes a witty onslaught on existing male privilege, pointing out how women have been handicapped by their inferior status and, in their writing careers, by the lack of privacy that goes with the roles of mother and housekeeper. Her remedy is "a room of one's own and £500 a year:" privacy and financial independence.

> "Why admit anything to literature that is not poetry?"

Glossary

abstract art Art which does not imitate or directly represent external reality. The term can be used strictly to describe non-figurative art, or more generally of art which is not representational though ultimately derived from reality.

absurdism A school of philosophy believing that the universe is meaningless and that an individual's search for order therefore brings him into conflict with the universe.

Art Nouveau An ornamental style of art prominent in western Europe and America between 1890 and World War II. It was a deliberate attempt to move away from the academic "historicism" of the 19th century, and its main feature was the use of asymmetrical flowing lines based on plant forms.

atonal music Music composed in no definite key.

avant-garde French for "advanced guard," this term was applied in the 19th century to artists and movements considered to be new, radical, and often revolutionary.

Bauhaus A school of design and architecture founded in Germany in 1919. Its philosophy was to unite form with function, which became a universal architectural principle and widely influenced American design.

Bloomsbury Group An influential set of writers and artists who lived near Bloomsbury Square in London in the early 20th century.

chamber music Intimate ensemble music originally intended for domestic and private, and frequently amateur, performance. The principle form of chamber music is the string quartet.

chord Theoretically, any simultaneous combination of musical notes; however, the term implies combinations of notes related to each other and making musical sense as such.

chromatic Used for music, the term means music based on the notes of the chromatic scale (all the black and white keys of the piano).

collage An artistic composition comprising different materials glued onto a backing. The collage became a popular tool of 20th-century art movements.

Cubism Pioneered by Pablo Picasso and Georges Braque, it was the first abstract style of art in the 20th century. The artists abandoned the centuries-old ideal that art should imitate nature, and traditional methods such as perspective, focusing instead on representing the solidity and volume of objects solely in a two-dimensional, geometric plane.

Dadaism Founded in 1915, the Dada movement was both a reaction to the self-satisfaction of contemporary European and American artists and writers, and a result of disillusionment caused by World War I. Dadaists attacked aesthetic preconceptions using techniques including nonsense poetry, collage, and outrageous theater.

Der Blaue Reiter German for "The Blue Rider," it was a group of loosely organized Expressionist artists in early 20th-century Germany with little coherent style, but a desire to incorporate symbolically in their work spiritual realities they felt were neglected by the Impressionists.

divisionism A term for one of the techniques of Neo-Impressionism, sometimes called pointillism.

existentialism A philosophy stressing personal responsibility and the individual's relation to the universe and God, especially expressive of the fear and despair felt by isolated individuals.

expressionism The search for expressiveness of style by means of exaggerations and distortions in color and form; a simplified style which abandons traditional rules and conventions of painting in order to express the artist's emotion. More specifically, an early 20th-century trend in art and literature maintaining that subjective feelings and emotions should be expressed through art using strong colors and simplified forms.

Fauves French for "wild beasts," this was a group of French painters working from 1903 to 1907 whose style emphasized intense colors and vigorous brushstrokes.

folk music The traditional music of a regional, national, or ethnic group, typically transmitted from generation to generation by performance and memory rather than by written notation.

Futurism An Italian art movement preoccupied with speed and the dynamic forces of mechanism. It advocated the destruction of cultural and historical strongholds, and glorified war and violence.

Impressionism The dominant movement in late 19th-century art, famous for its rise after the artists' initial rejection by the established art world. The Impressionists tried to capture the visual impression of a scene, usually a landscape, rather than its exact detail, and the changing effects of

light on color in a scene became an integral part of their work.

improvisation Musical performance based on spontaneous invention rather than written notation, and usually involving impromptu variation of a melody or a chord-pattern (like the "blues" pattern) previously learned. Sometimes used as a title implying such a performance.

jazz A kind of music originating among black Americans as a semi-improvised dance music with characteristic scales and syncopated rhythms. It expanded during the 20th century into a number of different types of music, almost all drawing on black-American virtuosos and styles.

kinetic art A broad term encompassing any art or art form suggesting movement, real or apparent.

libretto Italian for "booklet," in music libretto refers either to the text of a dramatic work, such as an opera or oratorio, or the printed version of such a text. Some composers write their own librettos; others turn to writers for them.

modernism Modern artistic or literary philosophy or practice, especially rejecting the past for new forms of expression.

monologue A dramatic sketch performed by one actor, or a literary composition written as a soliloquy.

opera A dramatic composition in which the characters sing the text, accompanied by an orchestra. The music is central in binding together the story, the themes, and the characterizations. The form arose in Italy around the beginning of the 17th century, and continues to reflect changing musical climates right up to the modern day.

operetta Italian for "little opera," this was originally a description of the short and generally entertaining forms of light opera in the mid-19th century; it gradually gave way to the genre known as musical comedy.

optical art A type of abstract art concerned with the optical phenomena that cause a form to seem to vibrate, pulsate, or flicker.

realism The use of subject matter drawn from actual life and experience. Specifically, it was a 19th-century movement in French art led by Courbet. It did not depict historical, mythological, and religious subjects, but instead showed unidealized scenes of modern life.

soliloquy A dramatic speech by one person potraying a series of unspoken reflections.

stream of consciousness A style of narrative which attempts to represent the thoughts of a character as they happen.

Surrealism A movement in art and literature between the two World Wars characterized by a fascination with the bizarre, incongruous, and irrational. It aimed to open up the subconscious, thereby freeing the constraints of reason.

Symbolism A literary movement started in late 19th-century France as a reaction to naturalism. Symbolists aimed to touch the spirit through poetic images, or symbols.

For Further Reading

Ades, Dawn, *Dalí and Surrealism*. New York: Harper, 1982.

Alexandrian, Sarane, *Surrealist Art*. New York: Thames and Hudson, 1985.

Bell, Quentin, *Virginia Woolf: A Biography*, 2 vols. New York: Harcourt, 1972.

Chipp, Herschel B., *Theories of Modern Art*. Berkeley: University of California Press, 1969.

Ellmann, Richard, *James Joyce*. New York: Oxford University Press, 1982.

Hayman, Ronald, *Thomas Mann: A Biography*. New York: C. Scribner's Sons, 1994.

Hunter, Sam, *Modern Art*. New York: Harry N. Abrams, 1992.

Meyers, Jeffrey, *D.H. Lawrence: A Biography*. New York: Alfred A. Knopf, 1990.

Morgan, Robert P., *Twentieth-Century Music*. New York: W. W. Norton, 1991.

Osborne, Harold, ed., *The Oxford Companion to Twentieth-Century Art*. New York: Oxford University Press, 1988.

Salzman, Eric, *Twentieth-Century Music: An Introduction*. 3rd ed. Englewood Cliffs: Prentice-Hall, 1988.

Thody, Philip, *Albert Camus*. New York: St. Martin's Press, 1989.

Tomalin, Claire, *Katherine Mansfield: A Secret Life*. New York: Alfred A. Knopf, 1988.

Watkins, Glen, *Soundings: Music in the Twentieth Century*. New York: Schirmer Books, 1988.

TIMELINE

1900	1910	1920	1930	1940
1901 Queen Victoria of England dies Marconi invents radio **1903** Suffragette movement begins in England, founded by Emmeline Pankhurst **1905** Revolution in Russia; the government of Czar Nicholas II comes into conflict with industrial workers and peasants Einstein's theory of relativity revolutionizes physics **1909** Louis Blériot flies across the English Channel	**1912-13** Balkan Wars fought between Serbia, Montenegro, Romania, Turkey, and Bulgaria for the possession of the remaining European territories of the Ottoman empire **1914-18** World War I **1917** Russian Revolution. The government of Nicholas II is overthrown and replaced by Bolshevik rule under Vladimir Ilyich Lenin **1919** Treaty of Versailles peace settlement ends World War I	**1920** League of Nations formed **1922** U.S.S.R. formed Benito Mussolini takes power in Italy **1924** Joseph Stalin replaces Lenin as leader of the Bolshevik Party **1926** First television transmission **1928** Women over 21 gain vote in Britain **1929-33** The Great Depression: a world economic crisis following the collapse of the New York Stock Exchange	**1930s** Rise of fascism in Italy and Nazism in Germany **1931** Spain becomes a republic **1933** Adolf Hitler becomes chancellor of Germany **1936-39** Spanish Civil War, a military struggle between left and right wing elements in Spain; some 700,000 die in battle **1939** World War II begins	**1941** U.S. enters war **1945** VE Day: Germany surrenders **1945-46** Nuremberg Trials, an international tribunal for Nazi war criminals **1946** Cold War begins between U.S. and the Soviet Union The Marshall Plan, a U.S. program to aid European recovery after war, is passed by Congress **1949** NATO formed

INCLUDED IN THIS VOLUME:

Conrad (1857–1924)
Strauss (1864–1949)
Kandinsky (1866–1944)
Matisse (1869–1954)
Mondrian (1872–1944)
Schoenberg (1874–1951)
Mann (1875–1955)
Klee (1879–1940)
Bartók (1881–1945)
Picasso (1881–1973)
Boccioni (1882–1916)
Joyce (1882–1941)
Woolf (1882–1941)
Stravinsky (1882–1971)
Modigliani (1884–1920)
Lawrence (1885–1930)
Duchamp (1887–1968)
Chagall (1887–1985)
Mansfield (1888–1923)
Dalí (1904–1989)
Camus (1913–1960)

THE 20TH CENTURY: EUROPE

| 1950 | 1960 | 1970 | 1980 | 1990 | 2000 |

1953 Stalin dies

1954-62 Algerian War of Independence manned

1955 Warsaw Pact, a military alliance between Soviet-bloc powers, signed

1956 Polish and Hungarian revolts

1957 Russia's Sputnik launched, the first artificial satellite to be placed in orbit

Treaty of Rome creates European Common Market

Civil war in Vietnam begins

1961 Berlin Wall built between East and West Berlin

U.S.S.R. launches first manned spacecraft

1962-65 Second Vatican Council assembles more than 2000 leading figures of the Roman Catholic Church

1968 Soviet Union invades Czechoslovakia

1969 Violence between Catholics and Protestants in Northern Ireland

Neil Armstrong is first man to walk on the moon

1972 Ireland, Britain, and Denmark become full members of the European Economic Community

1974 Turkey invades Cyprus

1977 Democratic elections held in Spain

1979 Margaret Thatcher elected prime minister of Britain

1980s Emergence of personal computers

1980 Solidarity movement emerges in Poland

1982 Britain fights Falklands War against Argentina

1985 Mikhail Gorbachev becomes last leader of Soviet Union

1986 Nuclear disaster at Chernobyl, U.S.S.R

1989 Berlin Wall brought down

1990 South African antiapartheid leader Nelson Mandela freed from prison

1991 Persian Gulf War

Collapse of the Soviet Union

1993 Maastricht Treaty signed, creating the European Union

1994 The Channel Tunnel opens, linking Britain to continental Europe

Index

Page numbers in *italic* indicate illustrations; page numbers in **bold** indicate biography.

Page numbers in *italic* indicate illustrations; page numbers in **bold** indicate biography.

Page numbers in *italic* indicate illustrations; page numbers in **bold** indicate biography.